7/97

The Soviet Photograph, 1924-1937

YALE UNIVERSITY PRESS NEW HAVEN AND LONDON

Margarita Tupitsyn

The Soviet
Photograph
1924-1937

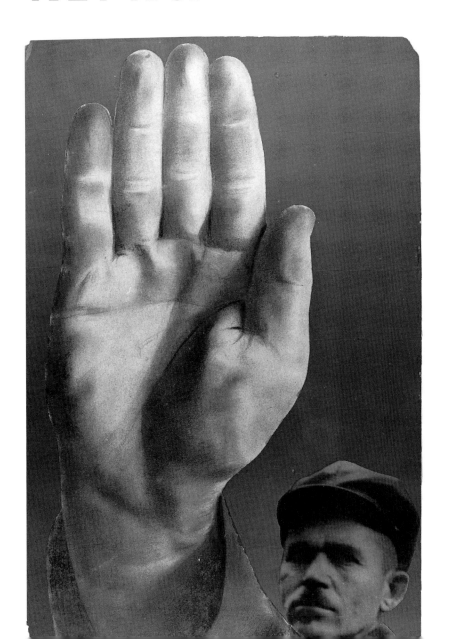

Designed by Nancy Ovedovitz and formatted in Futura type by Elsa Danenberg. Printed in the United States of America by Thomson-Shore, Inc., Dexter, Michigan.

The paper in this book meets the guidelines for permanence and durability of the Committee on Production Guidelines for Book Longevity of the Council on Library Resources.

10 9 8 7 6 5 4 3 2 1

Library of Congress Cataloging-in-Publication Data

Tupitsyn, Margarita.

The Soviet Photograph, 1924-1937/ Margarita Tupitsyn.

p. cm.

Includes bibliographical references (p.) and index

ISBN 0-300-06450-0 (alk. paper)

1. Photography—Soviet Union—History—20th century. 2. Art and state–Soviet Union.

I. Title.

TR85. T87 1996

770' .947' 09042—dc20 95-49373
 CIP

A catalogue record for this book is available from the British Library.

For Victor and Masha

Contents

Five

Acknowledgments

The idea of examining Soviet photography of the 1920s and 1930s emerged while I was engaged in writing about postmodernist art practices. Many postmodern artists and critics are concerned with sociopolitical issues, and they often articulate these concerns through photography. As I began exploring the roots of the connection between sociopolitical issues and photography, I found that this realm was rich in artistic achievement but had been neglected because of its political affiliations and its conflicts with purely formalist creation. By sheer chance, my project coincided with *Perestroika* in the Soviet Union. Without the political changes brought about by this reform movement, I might not have gained access to many resources in various public libraries and private archives. A grant from the Social Science Research Council enabled me to go to the Soviet Union for nine months in 1988.

Upon my arrival in Moscow, I discovered that scholars and artists there knew even less about Soviet photography than those

in the West. One exception was the Rodchenko family, who have maintained the Rodchenko/Stepanova studio and have perpetuated links to key people in Moscow photography circles. Liliia Isaakovna Ukhtomskaia played a decisive role by introducing me to the families of various photographers and to the archives of Sovetskoe foto. I would like to express my warmest gratitude to both Ukhtomskaia and Klavdiia Nikolaevna Ignatovich, the widow of Boris Ignatovich, for their extreme openness and willingness to share information and material available to them. Gustav Klutsis's son, Eduard Gustavovich Kulagin, gave me access to the rich archive of Klutsis's late work and to the artist's letters, as well as to the diaries of his mother, Valentina Kulagina. I would like to thank Kulagin for his support of my research, and his family for the warm receptions every time I visited them in Moscow. Una Sergeevna Sen'kina, the daughter of Sergei Sen'kin, shared important information about her father, including his unpublished notes.

My American and European colleagues also provided enthusiastic support for my research and ideas. I would especially like to thank Elisabeth Sussman, David Joselit, Matthew Teitelbaum, Christopher Phillips, Sally Stein, Maud Lavin, Jane Sharp, Allen Sekula, Ute Eskildsen, Hubertus Gassner, and Brian Wallis. My work on the exhibitions *Montage and Modern Life* for the Institute of Contemporary Art in Boston (1990) and *The Great Utopia* at the Guggenheim (1992) enabled me to develop and clarify many ideas expressed in this book.

This book evolved from my dissertation at the Graduate Center of the City University of New York, and my gratitude goes to my advisor Rose-Carol Washton Long, for her useful comments, and to Rosalind Krauss, whose teaching enhanced my appreciation of photography. My thanks to Judy Metro, senior editor, and Jane T. Hedges, senior manuscript editor, of Yale University Press.

Finally, I would like to express my love and gratitude to my husband, Victor Tupitsyn, and to my daughter, Masha, to whom this book is dedicated. Without my husband's unfailing support and intellectual stimulation, I could not have sustained the lengthy involvement this project demanded.

Introduction

One evening in the winter of 1921, Vladimir Il'ich Lenin made
an unannounced visit to the VKhUTEMAS (Higher State Artistic and
Technical Workshops), the art school he had launched one year
earlier. The aim of the VKhUTEMAS, according to the resolution of
the Council of People's Commissars that had established the
school, was "to train artists of high quality for the benefit of the
national economy."[1] This resolution had provided a clear indi-
cation of the high expectations the new government had for
cultural activities. At the time of Lenin's visit, artist Sergei Sen'kin
was a student at the VKhUTEMAS, exploring the formal principles
of suprematism and constructivism. "We had just finished a
meeting," Sen'kin later recalled, "my duty . . . was to lock the
front door to Miasnitskaia Street. It was eleven o'clock, and I
was slightly surprised to see a car standing near our building at
such a late hour. Most likely, I thought, it was someone from the
Cheka."[2] In fact, it was Lenin, who, Sen'kin learned, had come
to the VKhUTEMAS with his wife, Nadezhda Krupskaia, to visit a
student at the school, the daughter of Bolshevik Inessa Armand.[3]

During the brief visit, Sen'kin and Lenin became involved in a heated conversation about art and politics. Sen'kin argued that "old artists cheat themselves and others when they claim that they have mastered representation; nobody has, but we are all trying to master it, for our goal is to link art with politics and we will inevitably do that."[4] To this, Lenin inquired rhetorically: "But how would you link art and politics?" And, holding up a nearby work of art, he proceeded to examine it from different angles, as if trying to find such a link.[5] But Sen'kin replied simply, "No, Vladimir Il'ich, we do not yet know how [to link art and politics] but we will figure it out. Now we are just preparing for this to happen."[6] This exchange between artist and politician reflects a larger, ongoing debate, born shortly after the Revolution and enduring until the mid-1930s, over how artistic representations might best serve the new political order.

Although the avant-garde artists who developed an abstract visual language before 1917 responded enthusiastically to the Revolution, their views on the meaning and function of art remained closely linked to the sensibility of prerevolutionary modernism. This earlier modernist position saw art that was devoid of overt subject matter or of figurative elements as autonomous and beyond the concerns of everyday life.[7] The development of this type of art was fueled by various inventions of a primarily formal and technical nature. A glance at the career trajectories of Aleksandr Rodchenko, Gustav Klutsis, and Sen'kin—artists who had abandoned abstract painting for avant-garde photography and photomontage by the mid-1920s—demonstrates the rapidity with which Soviet avant-garde artists moved from advocating the autonomy of the work of art to asserting its practical and political purposes.

When Lenin visited the VKhUTEMAS in 1921, Rodchenko, Klutsis, and Sen'kin were teaching, studying, and exhibiting at the school. Rodchenko's association with constructivism in 1920 had resulted in his reaction against painting and his production of three-dimensional constructions (fig. 1). Although these sculptural works were constructed of everyday materials and meant for three-dimensional space, they were closely linked to Rodchenko's earlier painted explorations of line and form. Such productions were quickly challenged by the next stage of constructivism, however, which evolved under the slogan From Construction to Production and called for a practical definition of a three-dimensional work. Advocates of production art, critics such as Boris Arvatov, Boris Kushner, Mikhail Tarabukin, and Osip Brik, repudiated painting for its inability to permeate everyday life and to directly influence the social environment. Instead, they proposed a "commitment to the idea of art being involved in industry and with the production of real objects

of everyday use."[8] Under the impact of such theoretical pressures, around 1921, Rodchenko moved within the VKhUTEMAS from the faculty of painting to the faculty of metalwork, where he originated programs and worked out a new methodology for teaching.[9]

Like Rodchenko, Klutsis and Sen'kin began their careers as abstract painters: they studied together at Kazimir Malevich's studio in 1919. Sen'kin began to depart from pure abstraction in 1921, when he exhibited a group of paintings that combined painterly, abstract compositions with agitational messages at the VKhUTEMAS-affiliated Cezanne Club (pl. 1). His canvases exemplified the then growing tendency to find a more effective way of linking art and politics. Klutsis graduated from the VKhUTEMAS painting department in 1921, but he continued to actively participate in the development of the VKhUTEMAS teaching system.[10] Like many of his colleagues at the VKhUTEMAS, Klutsis first became known for paintings that synthesized suprematist and constructivist compositional methods. His move

1. Aleksandr Rodchenko, *Oval Hanging Construction no.12*, c. 1920, 61 x 83.7 x 47 cm, plywood, open construction partially painted with aluminum paint and wire. The Museum of Modern Art, New York. Acquisition made possible through the extraordinary efforts of George and Zinaida Costakis, and through the Nate B. and Francis Spingold, Matthew H. and Erna Futter, and Enid A. Haupt Funds. Photograph © 1996 The Museum of Modern Art, New York.

from painting to three-dimensional constructions in 1920 (fig. 2) and then to agitational stands and kiosks in 1922 betrays his early response to productivist ideology (fig. 3). Klutsis continued to associate with the VKhUTEMAS until its closure in 1930.

Despite the presence of Rodchenko and other productivist artists and critics in the VKhUTEMAS, their influence in that school remained very limited. As Russian art historian Selim O. Khan-Magomedov points out, "Students in the faculty [of metalwork] were not always attracted by the prospect of working in industry at the end of their course of studies."[11] Khan-Magomedov concludes that by 1925 "the entire group of production-oriented faculties accounted for only thirteen per cent of the students at VKhUTEMAS."[12] Reacting to these conditions in 1923, Rodchenko, together with constructivist artists Anton Lavinskii, Varvara Stepanova, Lyubov' Popova, Georgii and Vladimir Stenberg, and Konstantin Medunetskii and the critic Brik, published a statement in *LEF*, a magazine newly founded by Vladimir Maiakovskii. This report, "The Breakdown of the VKhUTEMAS: Report on the Condition of the Higher Artistic and Technical Workshops," affirmed that the "ideological and administrative breakdown of the VKhUTEMAS [was] an accomplished fact" and complained that "the only higher education art school in the Soviet Union main-

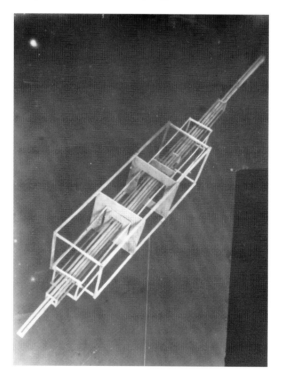

tains a miserable existence, disconnected from the ideological and practical tasks of today and from approaching proletarian culture."[13] The report specifically noted that the empty productivist departments had been replaced with departments of painting and sculpture; students were under the complete influence of easel painting. The next year, in *LEF*, Klutsis and Sen'kin published "The Workshop of the Revolution," in which they criticized the VKhUTEMAS program and its failure to "become revolutionized"; they noted that most professors

2. Gustav Klutsis, *Construction in Material*, c.1920, whereabouts unknown.

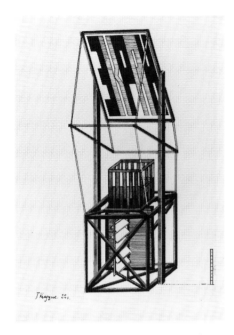

3. Gustav Klutsis, Design for a *Screen-Tribune-Kiosk for the Fifth Anniversary of the October Revolution*, 1922, 25.5 x 15.5 cm, lithograph. Private collection.

continued to teach by the old methods.[14] The true role of "the workshop of the revolution," Klutsis and Sen'kin argued, should be to prepare "productivists, whose goal is [to have] a significant sociocultural effect on a mass viewer and on artists, agitators, and propagandists who know how to respond to the practical needs of the Revolution."[15]

Shortly after Rodchenko, Klutsis, Sen'kin, and other constructivists announced their disillusionment with the state of affairs in the VKhUTEMAS, the sense of unity among the constructivists began to dissolve, and a number of confrontational factions emerged. One large group of constructivists became associated with

LEF magazine. The critical writing in *LEF* (much of it instigated or supplied by the members of the editorial board, including Brik, Nikolai Chuzhak, and Sergei Tret'iakov) concentrated on agitational and propagandistic works of art and had a direct influence on the earliest examples of Soviet avant-garde photography and photomontage. One *LEF* manifesto described the position of the *LEF* artists and critics as that of "loners-leftists" (odinochki-levye). According to this text, *LEF*'s purpose was to "unite leftist forces" and to "fight for art-building life."[16] Also, in that manifesto they referred to the role of the newspaper *Iskusstvo kommuny* (Art of the Commune) as the mouthpiece of the futurists and as the earliest source for art criticism charged with sociopolitical tendencies. Brik was a frequent writer for *Art of the Commune*, and his early criticism was largely responsible for making the first steps toward imbuing formalism with sociological tendencies.

Before Brik began to write for *Art of the Commune* in 1918, he had joined critics Viktor Shklovskii, Boris Eikhenbaum, and Lev Iakubinskii to found the first formalist literary group, Opoiaz (Obschestvo izucheniia poeticheskogo iazyka [Society to Study Poetic Language]), around 1916. Shklovskii defined the group's credo in his 1917 essay "Art as Technique." By emphasizing the autonomy of the work of art, the process of defamiliarization, and the importance of constructive

devices, Shklovskii demonstrates an affinity with the position of Rodchenko and other abstract artists of the same period.[17] Shklovskii wrote: "The purpose of art is to impart the sensation of things as they are perceived and not as they are known. The technique of art is to make objects 'unfamiliar,' to make forms challenging, to increase the difficulty and length of perception because the process of perception is an aesthetic end in itself and must be prolonged."[18] In accordance with this point of view, Shklovskii's contributions to *Art of the Commune* shortly after he wrote "Art as Technique" demonstrated his reluctance to accept the notion of a parallel between what he called "social revolution" and the "revolution of artistic forms." He also refused to consider art as "one of life's functions" and claimed that "new forms in art appear not to express new content but to replace old forms that stopped being artistic."[19] In contrast, Brik's writing for this newspaper exhibited an abrupt departure from the formalist method defended by other members of Opoiaz group. In the text "Artist-Proletarian," Brik defines art as a material object, underlines the importance of everyday life (rather than of abstract ideas), identifies with the proletariat, and claims that the talent of an "'artist-proletarian' belongs to the collective."[20] In "A Drain for Art," Brik further directs the attention of artists toward factories and plants and urges them to provide for workers "examples of new, unknown things."[21] The fact that Brik remarks on his awareness that artists were not ready for this move (since they still emphasized creation over production) confirms that in this postrevolutionary period most avant-garde artists were not prepared for a drastic stylistic change or the new function Brik envisioned for their artistic creations.

Brik's ideas, as expressed in *Art of the Commune*, had a direct influence on the formation of productivist ideology in the early 1920s and were later elaborated in his critical writings on photography. In addition, as a member of formalist circles, Brik contributed to the formation of the second period of formalism, which defended the merger of a formal method (with its emphasis on constructive devices) with content that would provide "all the richness and depth of ideological meaning."[22] This so-called formalist-sociological method, along with productivist ideology, provided the theoretical basis for most Soviet avant-garde art after Lenin's death. As a result, the productivists and formalist-sociologists undermined the prevalent idea among the avant-garde artists that abstraction was the primary mode of revolutionary creation; instead, they instigated a far more stylistically and iconographically diverse practice. Developed primarily through photography, architecture, and design, these new methodologies typified the last phase of the Soviet avant-garde from Lenin's death in 1924 to Stalin's enactment of the Consti-

tution of 1936, a historical period encompassing such key sociopolitical events as NEP (New Economic Policy), and the first and second Five-Year Plans.

Two additional discussions formulated on the pages of *LEF* and later *Novyi LEF* had a direct influence on the development of avant-garde photography. Chuzhak's article "Under the Banner of Life-Building" proposed the idea of art as a system of facts, a view that resulted in his theory of "ultra-realism." Chuzhak claimed that documentary art—or factography—was not the same as conventional realism but required the artist to pass reality "through the prism of dialectical revolt."[23] This theory of factography, along with Tret'iakov's notion of the author's new role as producer, helped to shift the attention of Soviet avant-garde photographers from creation to production.

⅄ The inauguration of the first Five-Year Plan entirely changed the sociocultural atmosphere in the Soviet Union and created promising conditions for realizing many ideas expressed by the above-mentioned critics as well as by many photographers and mass-media designers. Photographers literally left their studios and went into factories, plants, and mines in order to experience first hand what Aleksei Gan called "the human labor apparatus." The photographic record of those experiences provided an instant archive for the major mass-media publications, and the use the media made of such images provides an illuminating example of the complex relationship between modernist avant-garde artists and the organs of mass culture. At the same time, this conjunction of "high" and "low" cultures demonstrates the inadequacy of any consideration of this phase of the Soviet avant-garde within what Andreas Huyssen calls the "two track system of high vs. low, elite vs. popular."[24]

The fulfillment of the first Five-Year Plan in 1932 initiated a new period in the history of the Soviet avant-garde. The impact of conventional structural and iconographic changes on photographic images became apparent. In this final stage of the photographic avant-garde, which lasted until the completion of the second Five-Year Plan in 1937, photographers gradually abandoned their opposition to strict socialist realist canons. Art historian Benjamin Buchloh has noted that "it remains to be determined at what point, historically as well as structurally, [the change in photographic representation] takes place . . . during the 1930s."[25] Later, I will attempt to answer this key question by tracing the transformation from documentary, factographic to idealizing, mythographic practice in Soviet avant-garde photography. Formalist elements in photography were tolerated in the Soviet Union as late as the mid-1930s, suggesting a rather complex and even contradictory ending to avant-garde photographic practices in the Soviet Union.

Before proceeding, however, a few remarks are necessary regarding the conditions for research on Soviet photography. Substantial archival material is available documenting the theoretical and practical aspects of the photography of Rodchenko, Lissitzky, and Klutsis, but virtually no archival material exists for most other photographers, particularly those who did not participate in the earlier stages of the Soviet avant-garde. This is due in large part to the tendency in the late 1920s and 1930s to view photography as a nonartistic production made for mass consumption rather than for museums or archives. As a result, many vintage photographs and original photomontages were discarded immediately after they were published in the magazines. (In the captions, the word *photograph* is used to indicate that the print was made from an original negative.) Thus, such sources as *LEF*, *Novyi LEF*, *Sovetskoe foto* (Soviet Photo), *Daesh* (Let's Give), *30 Dnei* (30 Days), and *SSSR na stroike* (USSR in Construction), become essential materials for studying photography and often provide the only record of many images.

In addition, although the contributions of Rodchenko, Lissitzky, and Klutsis to photography and photomontage have been described in various catalogues and monographs, no coherent attempt has been made to connect their positions and production to the activities of the photographers who were not part of the avant-garde movement before Lenin's death.[26] The work of these other photographers, whose careers coincided with the beginning of the first Five-Year Plan, has been only briefly discussed in surveys of Soviet photography.[27] In fact, there has been a general reluctance to include photography in the history of the Soviet avant-garde.[28] This exclusion may be explained by the fact that the rise of avant-garde photography coincided with the increasing prominence of figuration in Soviet avant-garde circles. Like figurative painting, photography produced after the mid-1920s was viewed as a precursor of propagandistic socialist realism. This book attempts to change this view by showing that the Soviet photograph, as used both in photomontage and in straight photography during the late 1920s and early 1930s, continued to advance the major issues pertinent to the debates in the earlier stages of the Soviet avant-garde.[29] These issues included the role of formalism, the artist's relation to mass culture, and the role of the Bolshevik regime in the development of the arts. In this context, the function of the photographic image between 1924 and 1937 exemplifies the last "great experiment" in the search for an effective connection between art, radical politics, and the masses.

Lenin's Death and the Birth of Political Photomontage

In 1922, one year after Lenin went to the VKhUTEMAS, he became seriously ill and soon withdrew from participation in public events. By then, NEP, the project he inaugurated in 1921 to replace war communism and rescue the country from starvation after the civil war, had improved small industry and had provided peasants with access to the free market. Because NEP encouraged private enterprise and thus promoted procapitalist elements, however, its continuance stirred constant debate among various leaders of the Party. When Lenin died in 1924, the less compromising forces within the government were quick to try to curtail all NEP activities. Lenin's death also resulted in an intense struggle for the leadership of the Party.

By 1924, the Soviet art scene had experienced unique transformations. The major constructivists had publicly expressed their dissatisfaction with abstract art, and radical productivist critics had laid the theoretical foundation for the formation of a new artistic language. The main question concerned how artists could

most effectively shift from pure abstraction to a synthesis that encouraged formal innovation but preserved ideological content. In 1923, Trotsky published the article "Formal School of Poetry and Marxism," which made this hitherto narrow discussion of formalism available to much wider audiences. In 1924, an entire issue of the magazine *Pechat' i revolutsiia* (Press and Revolution) was dedicated to the debates about "formal method"; it included essays written by various literary critics, as well as one by Anatolii Lunacharskii, people's commissar of enlightenment. Formalist critic Boris Eikhenbaum, one of the contributors to *Press and Revolution,* summed up the status of formalism and confirmed the appearance of what he called "for-sotsy" (formalists-sociologists). According to Eikhenbaum, the "for-sotsy" proposed "to connect two 'methods'—formal and sociological" and to view art as "social fact and social factor."[1] In response to Trotsky's criticism that the formalists were detached from Marxism, Eikhenbaum pointed out that formalism did not "contrast" itself to Marxism but rejected "a simple transformation of socio-economic problems to the sphere of study of art."[2] He continued, "Marxism in itself does not guarantee a revolutionary position. . . . Formalism is a revolutionary movement because it frees [art] from outdated traditions and forces [and allows it] to reconsider all fundamental concepts and schemes."[3]

Because Lenin was a formidable icon for many Soviet critics and artists, their reaction to his death was immediate and involved an attempt to link his image to radical artistic manifestations. After Lenin's death, Eikhenbaum and other formalist critics published articles in *LEF* that analyzed his oratorical and written works using the formalist-sociological method. In "The Basic Stylistic Tendencies of Lenin's Speech," Eikhenbaum emphasized the formalists' new interest in what he called "practical" language, which previous formalist theory had always sought to replace with poetic language. This practical language was closely related to "agitational" needs and was directed to the masses, who "have to be convinced."[4] Eikhenbaum praised Lenin for avoiding abstractions and for introducing aspects of "the everyday, including crude words and expressions" into his writings.[5] In "Lenin as De-canonizer," Shklovskii emphasized the importance a concrete political event such as Lenin's death had in radicalizing the language used to discuss art. Specifically, Shklovskii referred to the process of *pereimenovaniia* (ousting of one word by another), an agitational gesture manifested in the renaming of many institutions, factories, and streets after Lenin's death. Shklovskii also stressed the importance of Lenin's own use of everyday language in his struggle for change: "People who attempt to understand Lenin's style must recognize above all that his style is concerned with the act of change and not with the act of establishing.

When Lenin introduces a routine fact into his writing, he does not "standardize" that routine but rather uses it to change the scale of comparison. He compares the large with the small."[6]

Among artists, Klutsis's experiments in applying formalist methodology to sociopolitical iconography were similarly connected to Lenin's image. His photomontage *The Electrification of the Entire Country,* 1920 (fig. 4), which was conceived as a poster project to introduce Lenin's electrification plan at the Eighth Congress of Soviets, constituted one of the earliest examples of the combination of an abstract composition with an overtly political message expressed through photography. Klutsis's early interest in political themes can be explained by certain details of his biography. As a young man, he became disillusioned with the monarchy after his brother was arrested and sent into exile. Later, as a member of the Latvian Rifles, he participated in the storming of the Winter Palace in St. Petersburg and the overthrow of the tsar. In 1918, Klutsis moved to Moscow and served in Lenin's personal military guard at the Kremlin. He became a member of the Communist Party in 1920. These experiences no doubt influenced Klutsis's belief that art should have a direct connection to the political goals for which he had fought. For Klutsis, it was not enough to claim, as the constructivists did, that art was for the new classless society; for him, it was essential "to construct *iconic* representations for a new mass audience."[7] To this end, Klutsis introduced photographic images into his abstract compositions and thereby created the first photomontages with specific sociopolitical messages.

Klutsis's first agit photomontages can be compared to Lissitzky's suprematist poster *Beat the Whites with the Red Wedge* of 1919–20 (pl. 2), which, like Sen'kin's composition (*Rabis*), responded to political reality by incorporating slogans into a nonobjective space in order to illustrate the principal difference between iconic and nonrepresentational forms of agitational art, particularly in terms of their effects on the viewer. Lissitzky made *Beat the Whites with the Red Wedge* while he was the head of a graphic arts and printing studio in Vitebsk. The poster was produced for the benefit of the Red Army and the slogan—inscribed across the face of the poster—refers to the civil war between the White and Red armies. Staying within the framework of constructivist theory, Lissitzky adhered to a position that abstract forms could agitate the audience to a political consciousness. Thus, although Lissitzky was responding to a specific political event, the formal way he conceived the space (a red triangle is aggressively inserted into the white circle) and the message betrayed his attempt to transcend the poster's iconographic specificity.

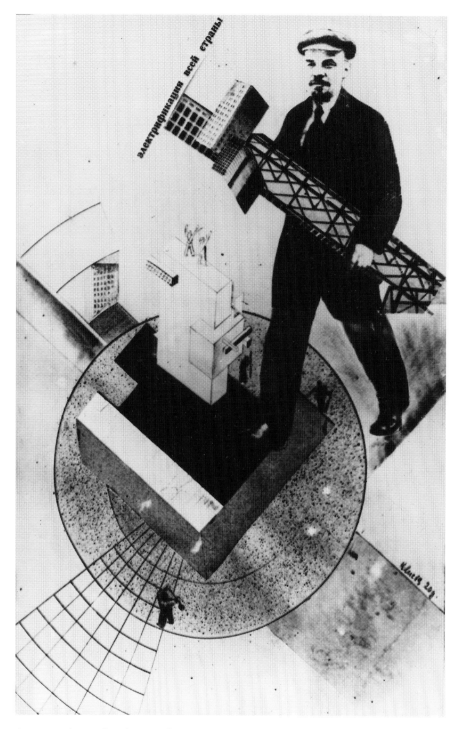

4. Gustav Klutsis, *Electrification of the Entire Country*, 1920, 17.2 x 11.5 cm, vintage gelatin silver print. Private collection.

Klutsis's belief that political consciousness could only be stirred by iconic representations resulted in his desire to expose content more explicitly. In the same year that Lissitzky made *Beat the Whites with the Red Wedge,* Klutsis produced the photomontage *The Dynamic City* (fig. 5). Here, instead of adding slogans to signify "reality" as Lissitzky did, Klutsis introduced realistic imagery by arranging four small photographs of construction workers around the central geometric shapes drawn from his first, fully abstract version of *The Dynamic City* (pl. 3). Preserving his interest in the spatial instability expressed in his abstract compositions, such as the first version of *The Dynamic City,* Klutsis sought to abolish gravity by placing the photographic images of the construction workers in various rotational positions and by adding the inscription "To look at from all sides." In writing of Lissitzky's *Prouns* (whose compositions are akin to Klutsis's photomontage *The Dynamic City* minus the workers), art historian Yve-Alain Bois described this effect as a "radical reversibility," a spacial composition that aims to overthrow "the spectator's certainty and the usual viewing position."[8]

In *The Electrification of the Entire Country,* Klutsis departed dramatically from the formal concerns of the *Proun* structure "round which we must circle, looking at it from all sides, peering down from above, investigating from below."[9] He deliberately discarded the "overall confusion" of spatial reversibility in order to introduce a more readable ideological content. Klutsis's design is dominated by a central circle overlaid by a red geometric shape and a model of constructivist architecture. Klutsis shatters the purity of

5. Gustav Klutsis, *The Dynamic City,* 1919, 28 x 22.9 cm, vintage gelatin silver print. IVAM, Generalitat Valenciano, Valencia, Spain.

abstract space by populating it with tiny figures of workers and a giant figure of Lenin who strides across the composition. The leader, who is clearly designated as the national hero, carries metal scaffolding and architectural sections, symbols of the technological modernization promised by the Bolshevik government. Here all figures are firmly grounded in the pictorial field, allowing the viewer to make an easier identification with that space and its content. As a result, unlike Lissitzky's *Beat the Whites with the Red Wedge* (or for that matter, any constructivist work), *Electrification* abandons a broad abstraction in favor of a more immediate and sociopolitically specific photographic representation.

In discussing *Beat the Whites with the Red Wedge,* French philosopher Jean-François Lyotard claims that Lissitzky's poster "turns desire back in upon itself as flesh, as an area of rhythms, contours, colors. It fails to objectify and identify the object. Plastic space becomes a space of 'anguish.'"[10] By contrast, he argues, a representational poster of the period would have provided the viewer with an "area for the investment of desire, and for the representation which is used to incite the readers of the poster to a behavior that reproduces positive experience."[11] Although the spatial and contextual legibility of *Electrification* fits the model of the representational poster that Lyotard opposes to Lissitzky's *Beat the Whites with the Red Wedge,* it would be wrong to assume, as Lyotard does, that such a work "anticipates the codes of 'socialist realism.'"[12] Rather, Klutsis's utilization of realistic imagery directly demonstrates his interest in the documentary aspects of a work of art. In this respect, his first photomontages were related to contemporaneous experiments in film, especially those of Dziga Vertov, Sergei Eisenstein, and Lev Kuleshov.[13]

Vertov's manifesto "We," written in 1919, the year the *kinoki* (kino-eye) group was founded, bears certain conceptual links to Klutsis's first photomontages. Using the notions of "dynamic geometry" and the "dynamic sketch," Vertov wrote, "Our path is from a dawdling citizen via the poetry of a machine to a perfect electric man. A new man, freed from weight and clumsiness, with the exact and light movements of a machine, will become a useful object of filming."[14] Like Klutsis, Vertov was interested in the theme of electrification, and in 1922 he asked for support to produce a film on the subject.[15] Vertov's newsreels from 1922-25, called *Kino-Pravda* (Film-Truth), endorsed a documentary basis for making art and dismissed the individual artist's vision as inferior to that of a mechanical tool. Klutsis also believed that agitational artworks depend above all on "intellectual perception," a notion that corresponds to Eisenstein's contemporaneous concept of "intellectual montage."[16] Film historian Jacques Aumont describes the latter as

"an intensification of the range of possible stimuli, primarily because it takes the spectator and his reactions into account. Intellectual montage is clearly aimed at producing meanings stripped of all ambiguity (ideologically and semantically)."[17] Like Klutsis's first agitational photomontages, Eisenstein's "intellectual montage" was based on the negation of "abstract, formal experimentation."[18] Klutsis's direct interest in the theories and films of Vertov and Eisenstein is demonstrated by his designs for the covers of the magazine *Kino-Front* in 1926. These designs were composed from stills from such films as Vertov's *One-Sixth of the World* (fig. 6) and Eisenstein's *General Line.*

As with Eikhenbaum and Shklovskii, Klutsis was prompted by Lenin's death to make his final break with abstract forms and to fully dedicate himself to the photographic image. In letters written in the late summer of 1924 to his wife, artist Valentina Kulagina, Klutsis spoke enthusiastically about photography and photomontage. He was beginning to accumulate his own documentary snapshots (later to be combined in photomontages with those borrowed from other photographers), and he mentions taking "successful photographs of the crowds."[19] In one of his letters, Klutsis specifically discusses his efforts to take photographs for use in political montages: "I began to work on the history of the VKP(b) [All-Union Communist Party (Bolshevik)] of comrade [Grigorii] Zinoviev. I will actively use photographs that I have recently collected in large numbers. On Sunday, I took a series of good shots: a parade of athletes that I came across on Red Square. Now I have to photograph workers and Red Army soldiers. Then I will be satisfied."[20] The snapshots Klutsis mentioned were used in photomontages published in the political magazines *Molodaia gvardiia* (Young Guard) and *Vestnik truda* (Herald of Labor) shortly after Lenin's death. These were designed to function as agitational representations and were distributed through mass-media publications. By producing works for magazines with large circulations, Klutsis and Sen'kin adopted the role previously assigned to anonymous

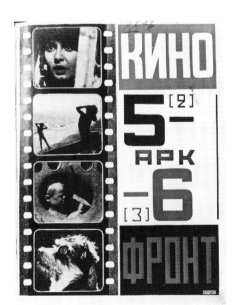

6. Gustav Klutsis, *Kino-Front,* 1926, nos. 5–6, cover, lithograph. Private collection.

designers, who, since 1917, had produced numerous photo albums dedicated to the leader of the Revolution and to other political themes.

In 1924 in the issue of *Young Guard* called "To Lenin," Klutsis and Sen'kin employed photomontage to create a vivid frame for Lenin's image. The compositional format of the pages as well as the reliance on combinations of red, black, and white derive from constructivist book designs in which typographic elements play a definitive role. Here, however, typography is combined with iconic rather than abstract imagery. In one illustration, the vertical stripes of slogans are replaced with arrows made of miniature documentary photographs, ranging from Lenin's disembodied head to mass demonstrations of workers (fig. 7). Klutsis's photomontage page called *RKP* (fig. 8) is structured around a red diamond with a constructivist agitational stand on it. Lenin speaks from atop the stand and is surrounded by four smaller figures of himself. Around the red diamond are variously shaped fragments of documentary photographs, including a ship with a sailor atop its mast, scenes of demonstrating workers, and portraits of foreign members of the Communist Party.

The magazine *Herald of Labor* was dedicated to the Sixth Congress of Unions, and its design also exemplified the successful merging between a formal constructivist design and political iconography. One striking page by Sen'kin consists of a waving worker outlined in black and filled in with multiple portraits of delegates to the Congress (fig. 9). This

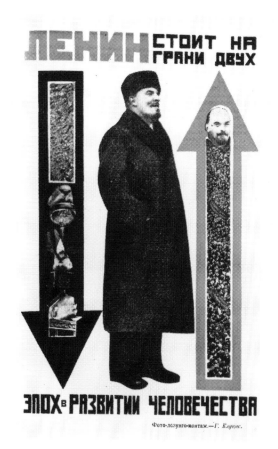

7. Gustav Klutsis, *Young Guard*, 1924, lithograph. Jane Voorhees Zimmerli Art Museum, Rutgers, the State University of New Jersey, the George Riabov Collection of Russian Art, acquired with the Frank and Katherine Martucci Art Acquisition Fund.

figure and the seven rays of slogans that stream from it overlay a full-page photograph of masses of demonstrating workers. Klutsis's most remarkable illustration in *Herald of Labor* (fig. 10) shows clasped hands which join together photographic images of collective farmers in the lower left and industrial workers in the upper right; the handshake that unites them illustrates the slogan "The Rise of Labor Productivity Will Reinforce the Union between Workers and Peasants." The bold arrows, a design element also used in *Young Guard*, are here employed to emphasize various slogans and objects of production. Applying strong formalist ele-

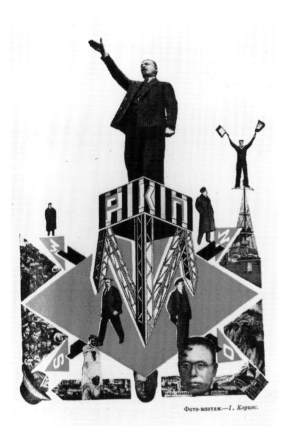

Фото-монтаж.—*I. Клуцис.*

8. Gustav Klutsis, *Young Guard*, 1924, lithograph. Jane Voorhees Zimmerli Art Museum, Rutgers, the State University of New Jersey, the George Riabov Collection of Russian Art, acquired with the Frank and Katherine Martucci Art Acquisition Fund.

ments to documentary photographs and slogans to elevate Lenin and to reflect the sociopolitical reality of the Soviet Union, Klutsis and Sen'kin's photomontages in *Young Guard* and in *Herald of Labor* explicitly combined the propagandistic state agenda with the formalist achievements of the avant-garde. They thus undertook the first steps toward realizing the formalist-sociological method.

In their photomontages for *Young Guard*, Klutsis and Sen'kin applied structural principles that are strikingly similar to the devices formalists have observed in Lenin's oratorical and written language. For example, in analyzing one of Lenin's essays, Eikhenbaum noted that "syntactic parallelism penetrates this entire work, creating repetitions, not only in large areas of speech, but also in small ones, that is, in parts of phrases; this creates breaks and harmonies in rhythm and intonation. The article is divided by paragraphs between which one finds correlations that energize the speech."[21] Lev Iakubinskii also emphasized Lenin's use of paren-

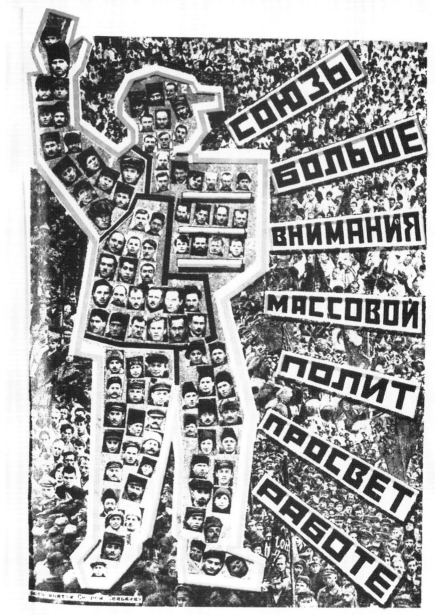

VI-ой Съезд Профсоюзов
Делегации: 1) Дальне-Восточная 2) Харьковская 3) Азербейджанская 4) Одесская 5) Уфарская

9. Sergei Sen'kin, *Herald of Labor*, 1925, no. 1, lithograph. Private collection.

theses, which, according to him, worked to break up a "continuous syntactic construction" and helped "to divert" the reader from "the main flow of a speech."[22] Klutsis and Sen'kin used a similar methodology to structure their photomontages. Lenin's figure appears on each page of the magazine in different compositional arrangements and in different scales. He is often reproduced several times on the same page, emphasizing the importance of repetition in montage. On some of the pages, Lenin is positioned in the center surrounded by photographic fragments. These "parentheses" add to the main image, while at the same time destroying a continuous composition and, in Iakubinskii's terms, diverting the viewer from the main flow of representation. All the photomontages printed in *Young Guard* rely heavily on familiar images and attempt to fill the magazine pages with as much factual material as possible. Political slogans are prominently deployed, making explicit the essential links between verbal and visual representations. One photomontage shows Lenin as an orator agitating against imperialist domination. Breaks created by the typographic slogans allow the viewer to perceive the central figure of Lenin in a much broader sociopolitical context. In general, structural elements, such as sharp diagonal compositions, severe fragmentation of bodies and objects, the interplay of scales, the graphic contrast between black and red, and the intervention of slogans, contribute to the complex structure of this new political photomontage.

Other photomontages produced by Klutsis and Sen'kin in response to Lenin's death were made for Il'ia Lin's book *Deti i Lenin* (Children and Lenin, 1924). Unlike the illustrations for *Young Guard,* which concentrated on Lenin's image as a political figure, the revolutionary leader is here presented

10. Gustav Klutsis, *Herald of Labor,* 1925, no. 1, lithograph. Private collection.

as a lovable human being surrounded by enchanted children. Except for the cover, *Children and Lenin* is printed in black and white. On the cover, a red square overlaps a black one, and both are covered with the title and with photographs of strolling Lenin and children (fig. 11). By placing representational elements over the suprematist square, this design interrupts the purity of nonobjective art. Inside, the book begins with a full-page montage showing Lenin, sitting comfortably in the center of a large, graphically radiating circle and embracing a small boy (fig. 12). Projecting from the central image are six beams, each enclosing a photograph of children. Two additional standing figures of Lenin, smaller in size and different in appearance, are placed at the bottom of the circle, as if supporting the whole structure. Other illustrations combine photographs of Lenin and groups of girls and boys with collages of children's scribbles describing Lenin's achievements and virtues (fig. 13).[23] The blocks of awkward writing superimposed on documentary photographs creates a bizarre contrast. The images are arranged in a patchy, uneven fashion, as if in a scrapbook, with portraits of children randomly interspersed with those of Lenin and freely alternating in scale and form. One image depicts a fragment of the country estate in Gorki where Lenin spent most of his time after he was shot and became sick (fig. 14). But the artists have placed the smiling leader on top of the roof, overturning the reality of Lenin's incapacity in the years just before his death.

One of the most dramatic illustrations in *Children and Lenin* shows Lenin lying in state (fig. 15). He is mourned by three children, one of whom is represented as a disembodied weeping head boldly emerging out of the dark background. The book ends with a photomontage in which three lanes of a racetrack connect two Lenin heads, one at the top of the page and the other at the bottom (fig. 16). Three children are running on the lanes, and other athletes of various ages and different sizes are scattered across the page. To compensate for the absence of narrative in these illustrations, the artists have placed excerpts from Lin's text under each image, as if to establish the meaning of the disjointed compositions. The last image, for example, is accompanied by the inscription: "Cheerful, strong, on the road of science and knowledge, running faster at the behest of Il'ich—toward communism." Here, sport functions less as a field for individual achievement than as a metaphor for the fulfillment of Communist ideals.

The photomontages executed by Klutsis and Sen'kin for *Young Guard, Herald of Labor,* and *Children and Lenin* extended Eisenstein's theory of "intellectual montage," which Klutsis had earlier explored in *Electrification.* Aumont's clarification of the three main structural characteristics of "intellectual montage" aptly describes

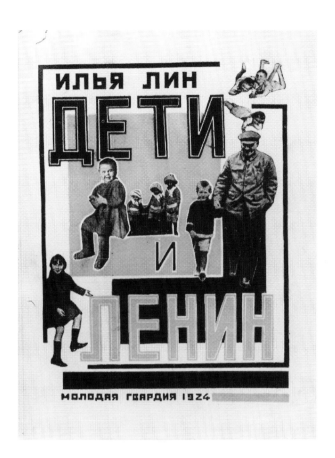

11. (above) Gustav Klutsis and Sergei Sen'kin, *Children and Lenin*, 1924, cover, lithograph. Collection of Elaine Lustig Cohen, New York.

12. Gustav Klutsis and Sergei Sen'kin, *Children and Lenin*, 1924, lithograph. Collection of Elaine Lustig Cohen, New York.

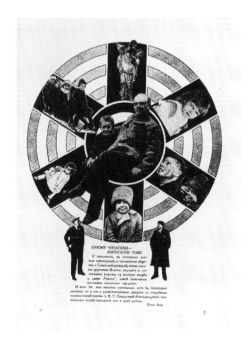

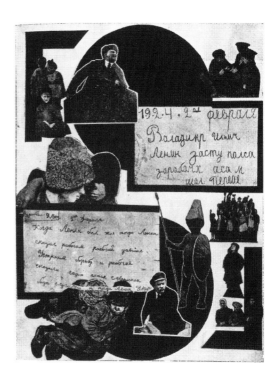

13. Gustav Klutsis and Sergei Sen'kin, *Children and Lenin,* 1924, lithograph. Collection of Elaine Lustig Cohen, New York.

14. (below) Gustav Klutsis and Sergei Sen'kin, *Children and Lenin,* 1924, lithograph. Collection of Elaine Lustig Cohen, New York.

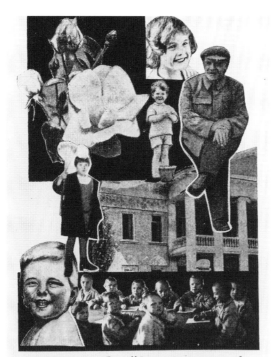

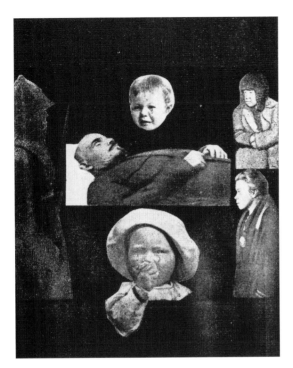

15. Gustav Klutsis and Sergei Sen'kin, *Children and Lenin*, 1924, lithograph. Collection of Elaine Lustig Cohen, New York.

the representational methodology that Klutsis and Sen'kin applied in these publications. Aumont distinguishes, first, "the conscious decision to mix together genres and styles in patchwork fashion"; second, the idea of "'circularity,' or interlocking of narratives;" and, third, "the device of 'repetition.'"[24] He continues, "The common force behind all of these 'principles' of composition seems . . . to be an anti-naturalistic or anti-linear bias already inherent in the choice of subject—and one which always appeals to both the thought of the spectator (the spectator is captivated by this patchwork effect: the circularity turns back on itself and reaffirms his sense of purpose as a spectator, while the repetition drives the point home) and the 'dialectical' structure."[25]

With such structural and contextual complexity, Klutsis and Sen'kin's books opened a new chapter in the history of sociopolitical publications. Since their contributions derived from challenging avant-garde ideas about form and design, the readers of such publications were never simply passive observers of vital social information. The artists themselves turned away from fine art to mass publications and claimed documentary photography as their primary representational tool. They thus sought to "lower the high style," commit themselves to mass culture, and work for the consumer and for a commission. As a result, their production manifested "a purely instrumentalist esthetics."[26]

Rodchenko's shift, first to photomontage and then to straight photography, occurred while he was still teaching at the VKhUTEMAS. This change was most likely instigated by both his growing distance from the school's increasingly conventional influences as well as his active friendship with the members of the editorial board of *LEF*. Nevertheless, Rodchenko's first experiments with the application of

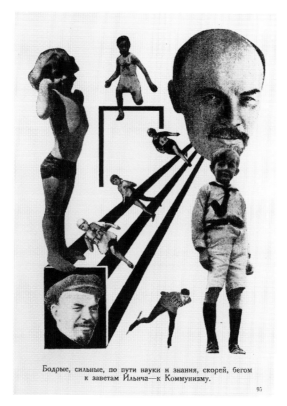

Бодрые, сильные, по пути науки и знания, скорей, бегом
к заветам Ильича—к Коммунизму.

16. Gustav Klutsis and Sergei Sen'kin, *Children and Lenin*,
1924, lithograph. Collection of Elaine Lustig Cohen, New
York.

photographic images demonstrate that he was clinging to the compositional patterns of his abstract works and that he was reluctant to mix formalist compositional methods with political iconography. His first experiments with making an artwork using a photographic image were published in the magazine *Kino-Fot* in 1922. Edited by Gan, a theorist of productivism, *Kino-Fot* was devoted to cinematography and photography. In an introduction to the first issue, Gan called cinematography "the affair of proletarian art" and distinguished Soviet from Western film practices. To illustrate this difference, he published documentary film stills from Vertov's *Kino-Pravdas* that emphasized scenes involving workers, labor, civil war, and significant everyday events (fig. 17). Surprisingly, however, along with Gan's politically charged texts and Vertov's documentary cinematographic imagery, the magazine generously displayed Rodchenko's early abstract artworks, including his spatial constructions and drawings based on an investigation of line (fig. 18). *Kino-Fot* even illustrated Vertov's manifesto "We" with a drawing by Rodchenko from his 1915 series called "Nonobjective Graphics." Along with these experiments in pure form from Rodchenko's past, *Kino-Fot* also published his first photocollages.[27] Viewed together, these two aspects of Rodchenko's oeuvre reveal his initial intention to adapt the compositional principles of his abstractions for use in these new works with figurative elements.[28] The structural affinity between the two types of work is especially visible in Rodchenko's photocollages, which appeared in the first issue of *Kino-Fot* under the title "Printed Matter for Criticism Montaged by Constructivist Rodchenko." Composed of cutouts from theater posters and daily news-

17. Dziga Vertov, Stills from *Kino-Pravda,* in *Kino-Fot,* 1922, no. 2. Soviet Photo, Moscow.

18. Aleksandr Rodchenko, Spatial Construction, in Kino-Fot, 1922, no. 2. Soviet Photo, Moscow.

19. Aleksandr Rodchenko, "Printed Matter for Criticism Montaged by Constructivist Rodchenko," in *Kino-Fot,* 1922, no. 1. Soviet Photo, Moscow.

papers, these works actually include very few photographic images (fig.19). The unsigned accompanying text distinguishes them from Western cubist and dada collages. In the latter, the article claims, printed material is used "abstractly and for the sake of aesthetic tasks only."[29] In reality, Rodchenko's experiments with printed matter cutouts are similar to those of both cubist and dada artists. In all cases, traditional materials are replaced with fragments of printed text, and in Rodchenko's works, these fragments are arranged into compositions that closely follow the patterns of his abstract works. The resulting disconnected contents of these photocollages prevent them from conveying clear messages and from over-stepping the bounds of a purely aesthetic dimension.

A few issues later, *Kino-Fot* published two more of Rodchenko's photocollages. In these, the amount of photographic imagery increased. These works, called *Psychology* and *Detective,* were used to illustrate filmmaker Lev Kuleshov's article "Montage."[30] In this short article, Kuleshov placed no emphasis on political uses of montage and praised the use of montage in American films and mass cul-ture. Similarly, in his photocollages, Rodchenko showed no interest in political or documentary subject matter but tried to render the exhilarating reality of NEP. In *Psychology* (fig. 20), Rodchenko used the image of a woman as his central de-vice; the large head of a fashionable young female observes four couples en-gaged in melodramatic love scenes. These images are squeezed together by vertical strips bearing phrases like "holy lie" or "she convinced me," clichéd statements reflecting men's stereotypical views of women's behavior in romantic relationships. *Detective* (fig. 21) is based on a similar combination of photo-graphs and texts and parodies the criminal activities stimulated by the economic opportunities provided by NEP. Although each fragment presents a criminal plot, the whole montage conveys the adventurous rather than the dangerous side of a NEP detective's life. These photocollages are structured in linear rather than circular patterns and thus lack the compositional complexities of "intellectual montage." Rodchenko avoids the repetition used to good effect in Klutsis and Sen'kin's photomontages because of his desire to construct a narrative.

Kuleshov's text and Rodchenko's imagery also stand in sharp contrast to Ver-tov's anti-Western and anti-NEP themes. In fact, Vertov's *Kino-Pravda* specifically resisted the sorts of themes that Rodchenko depicted in *Psychology* and *Detective.* "Kino-Pravda," Vertov wrote, "is shown daily in numerous workers' clubs in Mos-cow and the provinces—with great success. And if an audience of NEP-men pre-fers love stories or crime stories, that does not signify that our work is not suitable. It means that the public is not suitable."[31]

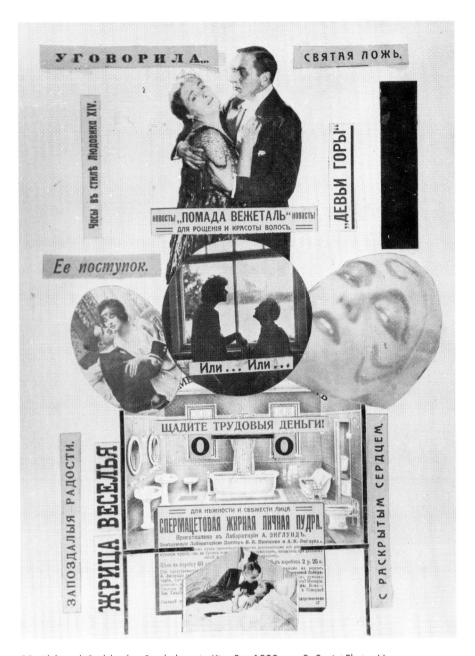

20. Aleksandr Rodchenko, *Psychology*, in *Kino-Fot*, 1922, no. 3. Soviet Photo, Moscow.

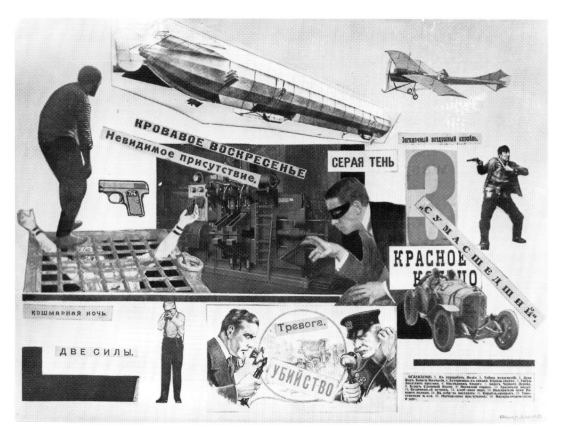

21. Aleksandr Rodchenko, *Detective*, in *Kino-Fot*, 1922, no. 3. Soviet Photo, Moscow.

Psychology and *Detective* served as the structural and thematic models for Rodchenko's major book illustrations for Maiakovskii's poem *Pro Eto* (figs. 22, 23). In these illustrations done in 1923, Rodchenko intensified the technique of unexpected juxtapositions and diverse contexts to absorb the poet's fascination with Western culture and to convey a complex, multilayered world of romantic imagination and private references. Photography critic Aleksandr Lavrentiev points out that Rodchenko's use of photography in his graphic work was spurred by Maiakovskii's 1922 visit to Berlin, where he saw many publications with photo-collage illustrations. Lavrentiev even suggests that German magazines, such as *Die Dame, Junge Welt, Moderne Illustrierte Zeitschrift,* and *Die Woche,* some of which were sold in Russia in the early 1920s, provided many of the images Rodchenko selected for *Pro Eto* illustrations.[32] Rodchenko's use of foreign magazines as the source for his photocollages suggests that he was far more concerned with photography as a new artistic means than as a vehicle to document the new Soviet life.

Rodchenko's wife, artist Varvara Stepanova, commented specifically on his conscious attempts to distinguish these photocollages from photomontages deal-

ing with political iconography.[33] In 1928 she wrote that in political photomontage, "the individual snapshots are not fragmented and have all the characteristics of a real document."[34] This observation is especially applicable to Rodchenko's illustrations for the *History of VKP(b)* (figs. 24-27), which were done in 1925-26 and published by the Communist Academy in collaboration with the Museum of the Revolution. For this portfolio, he prepared twenty-five posters laden with historical photographs, archival documents, maps, and slogans—all arrayed against red, blue, or yellow backgrounds with repetitive precision. Compared to Klutsis and Sen'kin's original and dynamic illustrations of the same theme published in early 1925 in *Herald of Labor,* Rodchenko's political photomontages appear overtly didactic and barely distinguishible from numerous contemporary examples of anonymous political propaganda. The illustrations for the *History of VKP(b)* show that Rodchenko was not ready or willing to apply the principles of high culture, as they had been developed in his early experiments with constructivism, to enrich the products of low culture, such as political publications. Instead, he attempted to reinvent his art practice by addressing the forms of popular culture and by "identifying with marginal, 'non-artistic' forms of express-

22. Aleksandr Rodchenko, *Pro Eto*, 1923, photocollage. Soviet Photo, Moscow.

23. Aleksandr Rodchenko, *Pro Eto*, 1923, photocollage. Soviet Photo, Moscow.

24. Aleksandr Rodchenko, *History of VKP (b)*, 1925-26, 30 x 21 cm, lithograph. IVAM, Generalitat Valenciano, Valencia, Spain.

25. Aleksandr Rodchenko, *History of VKP (b)*, 1925–26, 30 x 21 cm, lithograph. IVAM,
Generalitat Valenciano, Valencia, Spain.

26. Aleksandr Rodchenko, *History of VKP (b)*, 1925–26, 30 x 21 cm, lithograph. IVAM, Generalitat Valenciano, Valencia, Spain.

27. Aleksandr Rodchenko, *History of VKP (b)*, 1925–26, 30 x 21 cm, lithograph. IVAM, Generalitat Valenciano, Valencia, Spain.

ivity and display."[35] In this respect, his early applications of photographic imagery indeed continued rather than diverted from his constructivist agenda as manifested in abstract works.

In 1925, futurist poet Aleksandr Khruchenykh published *Lenin's Language: Eleven Devices of Lenin's Speech,* which featured Klutsis's construction *Radio Orator* (1922) on its cover. In this book, Khruchenykh refers to literary and visual representations of a political nature as "agits," [*agitki*], noting that "an agit must be, first of all, very popular, lucid in thought, language, and form; second, it must be very artistic and original. If it does not satisfy the second condition, then its influence will be limited only to the primitive masses, missing the highly cultivated and qualified ones, and most important, its influence will soon evaporate and will be forgotten even among the simple population."[36] Khruchenykh's ambition to link effective political art with formalist inventiveness was also Klutsis and Sen'kin's objective, as can be seen from their photomontages dedicated to Lenin. This attitude allowed them to commit themselves to an overtly political iconography without losing the opportunity to experiment. This perception of the function of political photomontage placed them in sharp opposition to the method as practiced by Rodchenko. For him, it was important to keep the rendering of strictly political imagery separate from the rest of the iconographic arsenal. As a result, in his portfolio *History of VKP(b),* Rodchenko disregarded the second condition of Khruchenykh's concept of effective "agits," that is, to be "artistic and original." He also refused to apply to them one of the main principles of constructivism, namely "invention."[37] Rodchenko's strict avoidance of political and agitational subject matter in his experimental photocollages like *Pro Eto* and of formalist methods in political photomontages placed him apart from the formalist-sociological method as defined by its theorists and practiced by Klutsis and Sen'kin. Klutsis himself said that Rodchenko's production during this period "often slipped into the methods of Western advertising-formalist montage, which had no influence on the formation of political montage."[38] With this succinct statement, Klutsis summarized the complex and controversial beginnings of Soviet photographic practice, carefully disassociating his own intentions in this field from the advertising works made by other artists during the NEP period.

Two

The Photographer
in the
Service
of the
Collective

The period of political and economic instability that began after Lenin's death culminated in Stalin's victorious emergence as party leader with his expulsion of Trotsky from the Kremlin at the end of 1927 and with his inauguration the first Five-Year Plan in 1928. With the approach of the first Five-Year Plan, the need to encourage millions of workers to take part in the Plan's grandiose economical transformations and to report news from the construction sites quickly and effectively boosted the role of the mass media. With this rapidly emerging situation, the importance of the photographic image was apparent, yet the question of what place many new magazines would give to the avant-garde photograph was an open one.

It was easy for photography to prevail over those realist paintings that leaned toward expressionistic and psychologically dramatic representations of socioplitical themes.[1] But the aspirations of one group, the Association of Artists of the Revolution (AKhR) presented a more serious threat. Initially called the AKhRR (Asso-

ciation of Artists of Revolutionary Russia—the group changed its name in 1928), this group was founded shortly before Lenin's death by artists who traveled to factories and collective farms and painted what they saw with the "'bad immediacy' of a photographic naturalism."[2] By deliberately specializing in presenting scenes that a photograph could more effectively capture, the AKhR engaged in reactionary backpeddling, not only against experimental photography, but against photography in general. In the years immediately following Lenin's death, the members of AKhR received no special recognition from the government. But in 1928, the first year of the Plan, the AKhR gained the government's official stamp of approval after the entire Politburo made a visit to one of the group's exhibitions.

Given this competetive atmosphere, avant-garde photographers were compelled to try to demonstrate that photography was a more effective tool for propagandizing the Plan's agenda. One strategy was to encourage numerous workers to participate in amateur photographic production (particularly since the productivists had failed to convince the majority of their students to work in industry). But the larger goal of advancing photography to the radical forefront of the arts and proving that it was the best tool for shaping socialist society could not have been realized without the rigorous and persuasive writings of the *LEF* critics.

Recognizing this emerging competition for the title of "true revolutionary art," *Novyi LEF* critic Osip Brik claimed that AKhR painters were merely trying "to regain lost positions and turn to a reproduction of reality in line with photography."[3] In his 1926 essay "The Photo-Still versus the Picture," Brik presented one of the earliest comments by a radical Soviet critic on photography's superiority to painting as a medium. For Brik, the "social roots of this phenomenon were clear: first of all, a great demand for someone to chronicle the new *byt* [everyday life]; second, masses of painters are out of work because no one will buy their paintings."[4] "After all," Brik continues, "Photographers reflect *byt* and events cheaper, faster, and more precisely than painters. In this lie their strength and great social significance."[5]

In this article Brik avoids criticizing painting as a technique (that would entail rejecting abstract production as well); instead he attacks painting only for the "idea of reproducing nature." To emphasize this nuance in the title, he chose the word *kartina* (picture) rather than *zhivopis'* (painting). The latter specifically implies painting as a technique, whereas the former conveys the "picturesque" qualities of painting. Relying on this nuanced play of meanings, Brik subtly expressed his disillusionment with the artificiality of realist painting. Similarly, the conventional translation of *foto-kadr* in Brik's title as simply "photograph" is inaccurate.

Undoubtedly, Brik borrowed the term *kadr* (still) from the language of cinema in order to suggest that the kind of photography he promoted had more to do with the process of filming than with that of painting.[6] In fact, in the same year, in the editorial section of the magazine, *Sovetskoe kino* (Soviet Cinema), Brik wrote: "The basis of cinematography is photography. Without photographs there is no cinema. Each filmmaker must closely follow the success and progress of photographic art. In it lies the future of cinematography. *Sovetskoe kino* is initiating a special section called *Foto v kino* [Photo in Cinema], in which *kino i foto-kadry* [cinema and photo-stills] that are interesting from a photographic point of view will be published."[7]

From this more attentive reading of the title of Brik's article, then, it is apparent that he meant for people to stop judging photography as a supplement to the fine arts and to begin to see it as an offshoot of more technical traditions. As Brik asserted, "The photographer must show that it is not life ordered according to aesthetic laws which is impressive, but also vivid, everyday life itself as it is transfixed in a technically perfect photo-still."[8] In 1928, Brik published "From Picture to Photograph," an essay in which he tried to fully separate the function of photography from that of painting. He specifically discussed photography's "absolutely new ways of recording optical facts" and emphasized the role of ideology in relation to various visual choices made by photographers. He wrote: "A photo reporter does not understand that the so-called accidental conditions of his work are ideologically necessary for presenting an object for our understanding. He does not understand that any recording of an object with old-time methods returns us to the ideology of that old period."[9]

Brik's insistence on photography's separateness from painting and on its links to cinematography was reflected in his own and other critics' theories regarding the nature of documentary practices. In his 1927 article "Fixation of Facts," Brik distinguished between past and present ways of making art: "If before," he wrote, "the artwork itself had a prime position and material was used only as a necessary raw product . . . now material has stepped to the forefront, and an artwork is only one of the possible ways to give the material concrete form."[10] Later in this article, Brik continued to connect photography and film practices, pointing to the unique ability of both mediums to record the facts of Soviet life. Like Vertov earlier, Brik criticized commercial films that had been produced during NEP for preferring "invented facts" over "real facts." Significantly, in his discussions of documentary film practices, Brik argued that one could not simply "install a camera on a street and leave."[11] Instead, he maintained, "we have to reflect reality at certain

angles."[12] This remark echoes Brik's advocacy of the formalist-sociological meth-od, with its primary goal of achieving a synthesis between socialist content and inventive form.

In 1928, one of the major defenders of overtly documentary practice, Nikolai Chuzhak, wrote in *Novyi LEF,* "Our epoch brought forward a slogan—art builds life. . . . In literature this is decoded to mean that writers should directly partici-pate in the construction taking place today (production, revolution, politics, and everyday life) and that all their searchings should be connected with concrete needs. . . . From this comes the emphasis on a document. From this comes the lit-erature of fact."[13] Among the major forms of this method Chuzhak named "news-paper and *factomontage.*" A year later, Chuzhak and other critics and writers associated with *Novyi LEF* produced a book of essays titled *Literatura fakta* (Lit-erature of Fact). Although this book was dedicated primarily to literary practices, it reflected the general disillusionment among radical artists and writers with the state of artistic production. The main goals of this new "literature of fact" were to develop what the authors called the *vne-iskustvenny suzhet* (trans-artistic plot) and to achieve "a complete concretization of literature, redirecting the center of at-tention within literature from human emotions to the organization of society."[14] As Chuzhak, the book's editor, insisted, "One should not be afraid to use 'uninterest-ing' themes as subject matter. One must only know how to 'present [this] uninter-esting [theme].'"[15] Chuzhak termed his theory of factography *ultra-realism* to dis-tinguish this new method from the types of realism employed in painting. The goal of ultra-realism was to operate with only those constructive forms that were not part of traditional aesthetics. These included common language for literary works and documentary photographs and films for visual arts.

The efforts of the critics who wrote for *Novyi LEF* to develop a totally new per-ception of photographic practice were reinforced by the opening of the *Exhibition of Ten Years of Soviet Photography* in 1928. Four hundred photographers partici-pated in this vast exhibition, which included as many as eight thousand photos. By summarizing the development of photography during the preceding decade, this exhibition confirmed the approach of a new era in photography. Like Brik, critic Leonid Volkov-Lannit believed that "photography is going to take away from easel painting the commission to provide a social record of the epoch."[16] He re-corded many examples of viewers' comments on the *Exhibition of Ten Years of Soviet Photography,* including those of one observer who asserted, "It is neces-sary to inject photography into the masses of workers and peasants now; in this time of cultural revolution, photography is destined to play a great role."[17] In con-

clusion, Volkov-Lannit wrote, "Already in this exhibition, through the husk of tra-
ditional 'artiness,' one sees the features of true Soviet photography as a represen-
tational tool of *bytostroeniia* [construction of everyday life]."[18]

In his introduction to the exhibition catalogue, critic G. Boltianskii specifically
discussed the function of photojournalism since 1917. He accorded photography
a highly important role both in documenting major political events and in develop-
ing propaganda. Among the most effective uses of photography that Boltianskii
discussed were "movable photo-vitrines" or "agitprop-vitrines," portable photo-
graphic displays that were set up on streets and in agitprop trains, agitprop ships,
and other agitprop locations. Through an application of montage techniques,
these "vitrines" combined "convincing and agitating photographs on a certain
subject matter with agitating inscriptions and slogans to present a photo-story."[19]
Like Rodchenko's series *History of VKP(b)* and many examples of overtly political
photomontage produced prior to Lenin's death, the agitprop vitrines had "all the
characteristics of a real document"; they were neither "artistic and original" nor
a hybrid of formalist "invention" with political documentation. Thus before 1928,
photojournalism or photoreportage developed separately from avant-garde
art, functioning as a tool of propaganda in competition with no other fine
arts medium.

Rodchenko participated in the *Exhibition of Ten Years of Soviet Photography*
with such renown images as his *Portrait of Mother*, 1924 (fig. 28), and several
versions of his *The Building on Miasnitskaia Street*, 1925 (fig. 29). These were
produced shortly after his first experiments with photomontage. Years later, he
wrote that in 1925–26 his work for *LEF* was concerned with the "struggle to find
photographic language capable of illustrating the Soviet subject."[20] Rodchenko
also emphasized that he searched for "the points for photographing, agitated for
representing the world by means of photography [and] for facts, reportage."[21]
He said that at the time his main goal was "to show a subject from all sides and
especially from the point of view from which it is not yet customary to view it."[22]
In other words, in retrospect, Rodchenko recalled that he was already applying
the formalist-sociological method in the photographic work he produced before
the first Five-Year Plan. In fact, however, Rodchenko did not make the transition to
this method and to factography until at least two years later. As late as 1928, he
was still reluctant to abandon his strong interest in modernist methods of photo-
graphy, which displayed no obvious concern for documentation.[23]

Brik criticized Rodchenko's photographs in 1928 precisely for their detachment
from the "social demands" of the time and for attempting to resolve painterly goals

28. Aleksandr Rodchenko, *Portrait of Mother*, 1924, photograph. Soviet Photo, Moscow.

29. Aleksandr Rodchenko, *The Building on Miasnitskaia Street,* 1925, photograph. Soviet Photo, Moscow.

through photographic language. In comments which most likely allude to Rod-chenko's two photographic series, *The Building on Miasnitskaia Street,* which includes images of buildings shot from below at sharply angled points of view, and *Pine Trees in Pushkino,* 1927 (fig. 30), in which the tops of the trees are captured from a worm's perspective, Brik wrote that "one should not depict an isolated building or tree, which may be very beautiful but which will be a paint-ing, will be aesthetic."[24] In other words, Brik felt that Rodchenko, at least in these specific photographs, continued to keep photography within the domain of "easel art." Tret'iakov also criticized Rodchenko for not being able to depart from an aesthetic ideal. "Instead of exploring the whole range of utilitarian goals confront-ing photography," Tret'iakov wrote, "Rodchenko is only interested in its aesthetic function. He reduces its activity to simply a reeducation of taste based on certain new principles—'we are seeking a new aesthetics,' 'the capacity to see the world in a new way.'"[25] Like Brik, Tret'iakov accused Rodchenko of "limiting photog-raphy's aims to those that once belonged to painting."[26] Under the influence of such vigorous critical challenges, Rodchenko began in 1928 to pay more atten-tion to the content of his photographs. As Lavrentiev confirms, "For Rodchenko, the process of experimenting in photography [at this point] became not the goal in itself but the means for displaying new socialist facts, plots, and objects."[27]

30. Aleksandr Rodchenko, *Pine Trees in Pushkino,* 1927, photograph. Soviet Photo, Moscow.

Rodchenko's new interest in "socialist facts" in 1928 resulted in a total commitment to working for mass-media periodicals. In 1928, he was commissioned to produce *Newspaper,* a series of photographs to illustrate an essay written by Leonid Saianskii for the magazine *30 Days.*[28] Rodchenko's photo-essay illustrates the activities of men and women involved in reporting for, laying out, and printing the newspaper (figs. 31, 32). The series concludes with photographs showing freshly printed newspapers (fig. 33). Significantly, Rodchenko's images emphasize the active role women played in producing mass-media publications. These include a close-up of a young messenger making a phone call to the editorial office (fig. 34) and a bird's-eye view of a woman sitting at a breakfast table reading the freshly printed paper (fig. 35). In 1929, Rodchenko worked on another photo-essay for *30 Days* called *TASS Is Speaking.*[29] In that series, he reduced the presence of people in his images (showing primarily workers' hands) and instead concentrated on close-ups of such technical aspects of mass-media production as editing, typing, and printing. In *Still Life with Leica,* 1929 (fig. 36), which followed *Newspaper* and *TASS Is Speaking,* Rodchenko reverted to staged photography to create a concise visual model for reportage. His own notebook, pen, and camera, photographed from above, overlap each other to suggest the kinship Rodchenko saw between the newspaper reporter and the photographer. In another photograph, he reiterated this point by depicting a hand proudly holding the typeset word *journalist* (fig. 37).[30]

Rodchenko outlined his new position regarding the social meaning of photography in a lecture presented at the meeting of Oktiabr' (October—Association of Artistic Labor) in 1930. In summarizing his activities during the first two years of the Plan, he asserted that the best examples of his own photography and those of his colleagues were published in popular magazines. In such periodicals, he argued, photography had great advantages over more traditional media: "Eighty to

ninety percent of any magazine is built on factual material, and neither painting nor drawing can give the sensation of the moment, the actuality of events and their documentary nature; and thus we put our trust in photography, since it shows what happened at a particular place and factually convinces us of it."[31] At the time, Rodchenko left no doubt about the legitimate content of this new, factographic production: "If we photograph a street or some event, what should we pay more attention to and what type of things should we show? There are exemplary things, such as, for instance, the paving of a street or the laying of stones on a road. But there is also impassable mud and a totally impossible road. Since we cannot contemplate both things, we must photograph either the best or the worst—but under no circumstances the middle ground! The middle ground leads nowhere, whereas the paving of the street should be photographed because it shows what one should struggle for."[32]

This documentary function

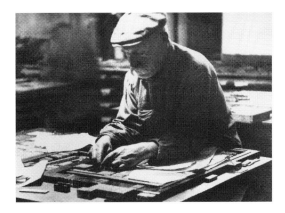

31. Aleksandr Rodchenko, *Newspaper,* 1928, photograph. Soviet Photo, Moscow.

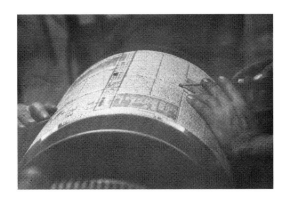

32. Aleksandr Rodchenko, *Newspaper,* 1928, photograph. Soviet Photo, Moscow.

33. Aleksandr Rodchenko, *Newspaper,* 1928, photograph. Soviet Photo, Moscow.

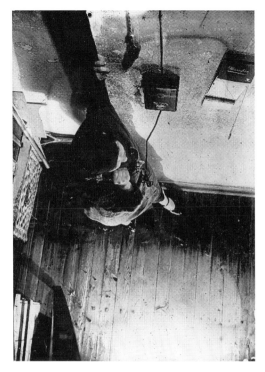

34. Aleksandr Rodchenko, *Newspaper,* 1928,
photograph. Soviet Photo, Moscow.

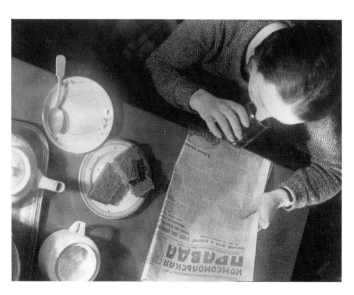

35. Aleksandr Rodchenko, *Newspaper,* 1928, photograph. Soviet Photo,
Moscow.

36. *(opposite)* Aleksandr Rodchenko, *Still Life with Leica,* 1929,
photograph. Walker, Ursitti, and McGinniss Collection, New York.

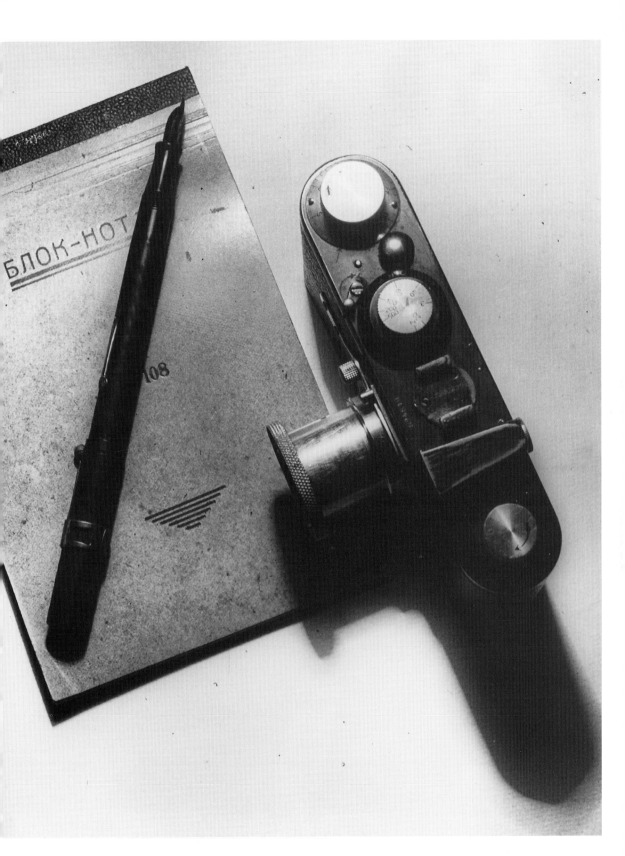

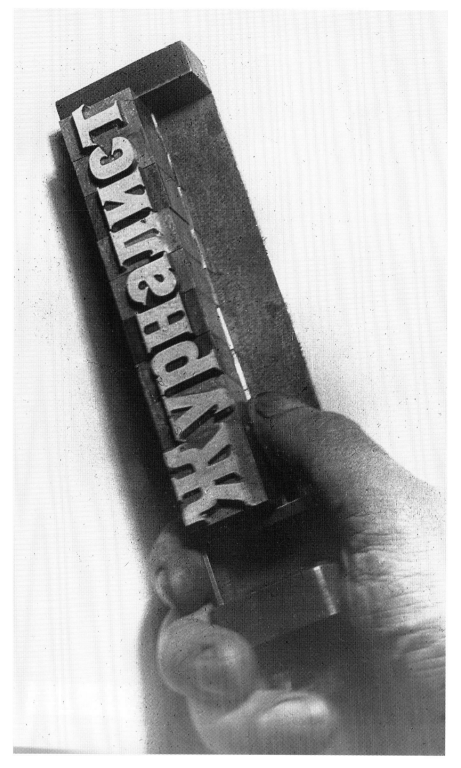

37. Aleksandr Rodchenko, *Journalist,* 1930, photograph. Soviet Photo, Moscow.

for the photographic image was evident in several new popular magazines, such as *30 Days* and *Let's Give,* which throughout the late 1920s systematically printed photographs by Rodchenko, Boris Ignatovich, Roman Karmen, Dmitrii Debabov, and Elizar Langman (fig. 38; pl. 4).[33] These photographers were directly inspired by the events and themes of the first Five-Year Plan, during which, according to Ignatovich, "the dynamism of public life became one of the most important influences on Soviet photography."[34] Ignatovich enumerated the goals of photography during this period: "How Soviet photography is different from Western photography: no entertainment, no tricks, no commerce; with the people and for the people; life in all its typical manifestations, with typical people—that is the material Soviet photography uses. Photography is the most contemporary realist art."[35]

Each page of the magazine *Let's Give* was covered with a series of photographs, generally between four and six, mostly focusing on construction sites or work at plants and factories and supplemented with concise descriptions. When commissioning the photographs, editors of *Let's Give* and similar magazines were usually quite specific about the details and subject matter of the images. Photographers were instructed to include both positive and negative views, echoing Rodchenko's call for artists to photograph "the best or the worst—but under no circumstances the middle ground."[36] This critical attitude toward "socialist facts" underscored the radical commitment to an authentic representation of the *novyi byt* (new way of life) made by Rodchenko and other avant-garde photographers.

One of the important tasks for photographers of these popular magazines was to learn to represent labor as a truly modern

38. Aleksandr Rodchenko, *Let's Give,* 1929, no. 9, cover, 30 x 23 cm, lithograph. Helix Art Center, San Diego.

and gratifying experience. Rodchenko, Ignatovich, and other photographers of the era of the Five-Year Plan were committed to producing art that was based on "the actually experienced fact of genuine participation."[37] To fulfill this ideal of making art, they traveled to various production sites and directly participated in the process of industrial restructuring. According to Lavrentiev, "When shooting the technical aspects [of production], one has to understand the meaning of technological operations and the arrangement of mechanisms, to see the structure of machines— all in order to show this convincingly in a photograph."[38] Such familiarity with the nature of the workers' labor placed the artist closer to the experience of the proletariat, thus narrowing the gap between the creator and the viewing public. Also, the artists' realization of the editors' instructions as far as subject matter was concerned led to a dismissal of the concept of the free individual expression of an "artistic personality" and converted the creator into an operator. Tret'iakov was the main spokesman for this new concept of the author. He often traveled to villages and industrial sights, spending as long as a month there, in order to produce his documentary writings, which he sometimes called "operative essays."[39] Tret'iakov emphasized "the primacy of the material over the writer's interpretation of it," saying that "the fabricated story and created novel are hateful [to us]. The once esteemed title of 'creator' sounds insulting in our age. The true man of letters in our age is the cautious 'discoverer' of new material, its nondistorting molder."[40] In general, for formalist-sociologists, the dilemma that Soviet writers—and, by extension, photographers—faced was not "how to write" but "how to be a writer."[41]

In 1934, in his famous essay, "The Author as Producer," German critic Walter Benjamin referred to the Soviet situation—and to Tret'iakov's writing in particular—as a perfect illustration of his own view of the author's new place in society. Benjamin wrote: "I should like to direct your attention to Sergei Tretiakov and to the type, defined and embodied by him, of the 'operating,' writer . . . Tretiakov distinguishes the operating from informing writer. His mission is not to report but to struggle; not to play the spectator but to intervene actively."[42] Benjamin also drew attention to the mass media as the most crucial bridge between author and public when he said, "The press is the decisive example [of this change], and therefore any consideration of the author as producer must include it."[43] The goal of this new model of the author, he argued, was "to side with the proletariat," and thus to eliminate "the conventional distinction between author and public, which is upheld by the bourgeois press."[44]

While Rodchenko and Ignatovich traveled widely to take photographs to il-

lustrate magazine articles, Klutsis often combined his own experiments in photography with a willingness to borrow documentary photographs from the archives of other photographers.[45] His major project of 1928, the first year of the Plan, was a series of postcards commemorating the *Spartakiada* (Olympic Games). According to art historian Larisa Oginskaia, Klutsis had taken pictures of a sport parade in Red Square in 1924, which were then used in the *Spartakiada* series.[46] While producing the postcards, Klutsis also examined various archives, a fact he mentioned in a May 25 letter to Kulagina: "On the second day, I visited the photographer Krasinskii to see his photographs. He has a rich archive of very good images."[47]

The *Spartakiada* series consists of nine color postcards, each dedicated to a different sport (including tennis, football, diving, riflery, and javelin throwing) (fig. 39). Varying substantially in terms of scale and viewpoint, each postcard is charged with dramatic movement and energy. As in his photomontages commemorating Lenin's death, Klutsis punctuated several postcards with portraits of the late Soviet leader. This was to suggest, as Oginskaia points out, that "every sport parade, especially the Olympic games, was to be viewed as an achievement of the Soviet state, as a manifestation of the socialist way of life."[48] In two of the postcards, Lenin's fragmented face emerges from beyond the picture frame as an affirmation of the represented activities (figs. 40, 41). In another image, Lenin is unexpectedly shown atop his own mausoleum, apparently the artist's attempt to suggest that Lenin's spirit remained alive (fig. 42). Klutsis's optimism about the postcards is reflected in a letter to Kulagina: "You can be proud that you are the first to receive the new postcards," he wrote, "They initiate a new epoch in art."[49]

The "new epoch in art" proclaimed by Klutsis may be taken as referring to the artist's new capacity to respond to social and political issues. Klutsis's postcards for *Spartakiada,* as well as the photojournalism of Rodchenko and Ignatovich, demonstrated the new prototype of the artist as an operator-producer in the direct service of the public. In Klutsis's case, such a model of authorship was most fully formulated in his photomontage posters *Let Us Fulfill the Plan of the Great Projects,* 1930, and *Male and Female Workers All to the Elections of the Soviets,* 1930, created for the celebration of the thirteenth anniversary of the October Revolution. Both posters use the same image of the outstretched hand, but each has a different slogan. Surviving preparatory photographs and photomontages for these two posters illustrate Klutsis's step-by-step formation of this seminal image. He began by photographing his own hand firmly stretched out in the foreground and nearly blocking out his blurred face (fig. 43). This early composition was followed by a

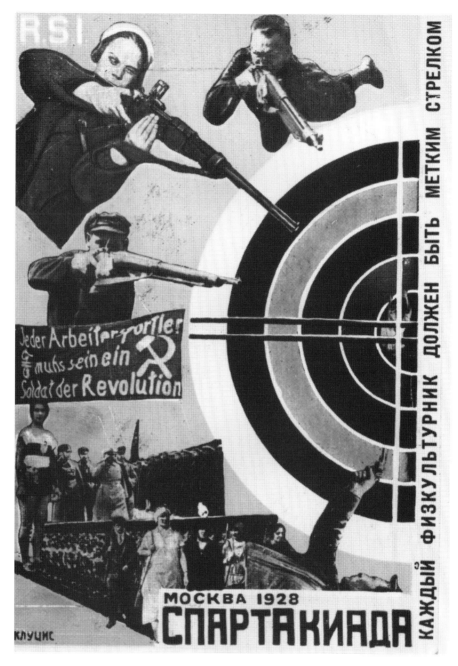

39. Gustav Klutsis, *Spartakiada*, 1928, 14.6 x 10.2 cm, lithograph. Collection of W. Michael Sheehe, New York.

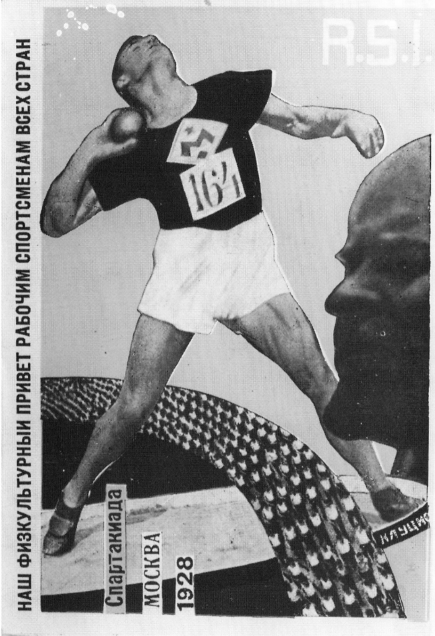

40. Gustav Klutsis, *Spartakiada,* 1928, 14.6 x 10.2 cm, lithograph. Collection of W. Michael
Sheehe, New York.

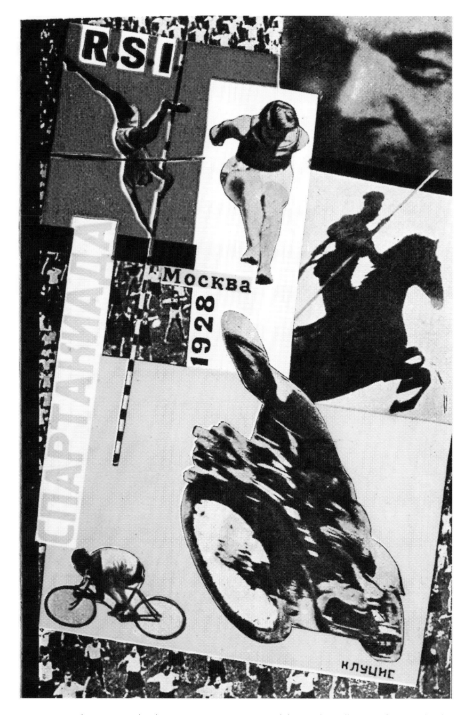

41. Gustav Klutsis, *Spartakiada*, 1928, 14.6 x 10.2 cm, lithograph. Collection of W. Michael Sheehe, New York.

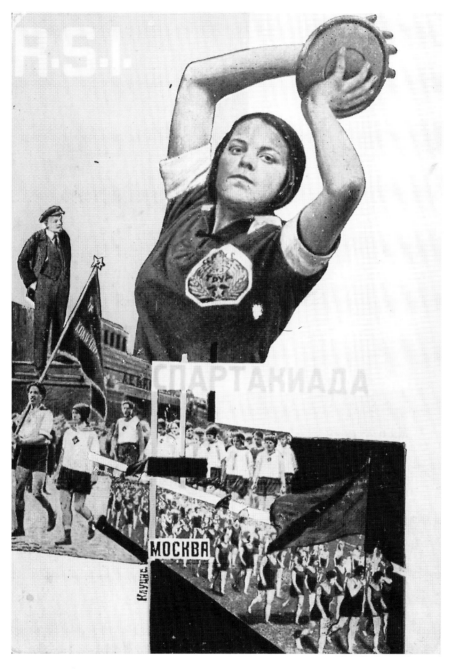

42. Gustav Klutsis, *Spartakiada,* 1928, 14.6 x 10.2 cm, lithograph. Collection of W. Michael Sheehe, New York.

photomontage in which Klutsis's hand is attached to the figure of a working man, in effect, replacing the individuality of the artist with the anonymity of the worker (fig. 44). The initial suggestion—of transforming the artist's hand (the icon of individual creation) into a representation of collective proletarian power (the icon of voting and working)—is much more explicit in the subsequent maquettes for these posters. In one of them, Klutsis has overlaid three outstretched hands on a background crowded with many groups of small figures of voting workers (pl. 5). Each hand corresponds to a portrait, two anonymous and one of Lenin. In the following maquette, Klutsis has reduced the number of hands to one and has positioned it diagonally to intersect with a crowd of workers with raised hands, the whole composition merges into the surface of the open palm (fig. 45). Lenin's portrait has been eliminated, perhaps an indication of Klutsis's inclination toward anonymous imagery. The two final versions of this photomontage printed as posters show a drastic reduction in the number of workers who are compressed together in the lower right (pl. 6). The open hand is the dominant form in both versions, and it is repeated many times, as if it belongs to the workers themselves. By using his own hand to stand for the worker's, Klutsis seems to allude to the redefined role of the artist in a socialist society: the artist's hand is a metaphor for collective rather than individual expression. To both versions of this poster Klutsis added two different slogans: "Let Us Fulfill the Plan of the Great Projects" and "Male and Female Workers All to the Election of the Soviets." These make the claim that in the period of the first Five-Year Plan the proletariat possessed a

43. Gustav Klutsis, *Untitled*, 1930, photograph. Private collection.

double force—that of producers and that of voters.

Klutsis's use of the hand image is quite different from that of a number of other modernist photographers of the early twentieth century who, according to art historian Rosalind Krauss, used "the palm of the hand as a manifestation of the natural impulse to make and leave traces."[50] Lissitzky's 1924 photomontage *The Constructor* (fig. 46), for example, is a self-portrait, showing his hand holding a compass superimposed on a shot of his head that specifically emphasizes his eye. The resulting montage seems to merge

44. Gustav Klutsis, Design for *Let Us Fulfill the Plan of the Great Projects*, 1930, 56.8 x 36 cm, photomontage. Private collection.

45. Gustav Klutsis, *Let Us Fulfill the Plan of the Great Projects,* 1930, 12 x 9 cm, vintage gelatine silver print. Private collection.

two models of the artist—the creator (hand and eye) and the constructor compass)—while maintaining the importance of the individual. Lissitzky's 1931 design for the cover of the periodical *Artists' Brigade* (pl. 7) shows a substantial change in his use of the hand image and ultimately in his perception of the artist's position in society. For this design, one hand is shown emerging from "inside" the composition, as if connected to the scene of steelworkers in the back background. Another hand, presumably representing that of the artist-producer, enters from the outside and meets the worker's hand in an ardent clasp.[51] Like Klutsis, Lissitzky depicted the hand of the artist-producer as that of an engaged creator who has decided to "side with the proletariat." The difference between *The Constructor* and the *Artists' Brigade* cover reflects the process of Lissitzky's conversion from the modernist model of the artist as isolated creator to the formalist-sociological model of the artist as engaged participant in society. This conversion was a direct result of Lissitzky's exposure to Soviet political photomontage after 1925, and to the work of Klutsis and Sen'kin in particular.

This alliance between Lissitzky, Klutsis, and Sen'kin is especially significant in the context of the International Press Exhibition (or Pressa), held in Cologne in 1928. This massive display gave Soviet artists an opportunity to demonstrate to Western viewers the sum of their achievements in applying photography to political ends. For Soviet officials such as Lunacharskii, a project that aimed at achieving propagandistic goals through photography was a radical deviation from the earlier model of "monumental propaganda." In his text "Monumental Agitation" published in 1918, Lunacharskii advocated conventional methods for producing

state propaganda. He favored permanent sculptural monuments of famous people, particularly those who participated in the events of the Revolution, and he proposed using quotations from the "great minds engraved on stone boards or cut out of bronze and installed at visible spots."[52] Shortly before the beginning of the first Five-Year Plan, Lunacharskii had also defended the paintings of AKhR artists and had spoken of the artistic advantages of their production over photography.[53] In light of these views, Lunacharskii's willingness to support the photography exhibition, which defended transient rather than monumental propaganda and boosted the importance of photography and the mass media, signified his recognition that photography could effectively convey to the West the sheer mag-

46. El Lissitzky, *The Constructor,* 1924, 10.7 x 12 cm, vintage gelatin silver print. Courtesy Houk/Friedman Gallery, New York.

nitude of the changes and achievements in the Soviet Union during the first Five-Year Plan better than any other medium.

Lissitzky was offered the opportunity to head the Pressa project, most likely because Lunacharskii knew that he had important connections in Germany that would assure a favorable Western reception for Soviet propaganda material. Klutsis and Sen'kin were associated with Pressa only as members of a large preparatory group that was assembled in Moscow to produce preliminary designs for the exhibition.[54] Given his penchant for independence, it is hard to understand why Klutsis would have accepted such a subordinate position. But this unusual circumstance may explain why it was Sen'kin who traveled to Cologne with Lissitzky for the actual installation. An angry letter from Klutsis to Kulagina (who was also a member of the preparatory group) clarifies his role: "Recently, I received from Serezha [Sen'kin] two catalogues. . . . There are some illustrations in the catalogue of the Cologne exhibition [Pressa]: a much discussed frieze with an inscription 'von Lissitzky and S. Sen'kin.' Also, there are works by Prusakov, Borisov, Plaksin, Naumov; several photographs of installation views. By the way, compositional devices are all mine, only they are better in my execution. Scums! As one might expect, neither your nor my works are there. I have not written to him [Sen'kin] and do not intend to do so."[55] Klutsis clearly felt that his participation in conceiving the initial designs for Pressa was significant and that it was underplayed in the final presentation and in the catalogue. The photographic frieze that Klutsis refers to in his letter was the key panorama of the Pressa design and constituted the main image in the accompanying catalogue (fig. 47). The frieze presents a highly dynamic photomontage composed of numerous photographs of male and female workers, grand construction sites, factories, and collective farms. These images are interspersed with marching soldiers, joyous sailors, and portraits of Lenin. The latter act as a necessary political element, unifying the forward impetus to build the new socialist order. In general, the composition of the frieze is rendered coherently, with the minimum of formalist tools. In this respect, the application of photomontage here is far less dependent on the innovative compositional methods applied by Klutsis and Sen'kin in their illustrations for books about Lenin.

In spite of his irritation with Sen'kin, Klutsis met with him a week later, and in a letter to Kulagina, he described Sen'kin's impressions of Pressa: "[Sen'kin] says that the exhibition had a very incomplete and sloppy look. A number of works, due to space limitations, were not exhibited. But their absence was unnoticed. Your hammer and sickle was repainted for a totally different purpose. Not for

47. El Lissitzky and Sergei Sen'kin, *Pressa Frieze,* catalogue, 1928.

peasants' diagrams. Your censor inscriptions on the blue rays were absent be-
cause they were lost. And on those blue [rays], they stuck dates, for no reason. . . .
But he [Sen'kin] says that the absence of such things was not noticed by anyone.
Because no one ever read anything. Perfect!"[56]

Judging from Lissitzky's early writings and exhibition designs, he had only a
modest interest in political photography or photomontage before he took over
the Pressa project in 1928. He made no propagandistic or factographic images
before 1928, and his major exhibition designs, including the room for construc-
tivist art in 1926 and the abstract cabinet in 1926–27 were based entirely on
principles of nonobjective. Moreover, in 1927, when he was asked to design the
All-Union Polygraphic Exhibition he chose to represent himself not as a politi-
cal photomontagist but as an abstract artist. In this exhibition (fig. 48), Lissitzky
displayed his seven-year-old suprematist poster *Beat the Whites with the Red
Wedge.* Significantly, Lissitzky's work hung next to Klutsis and Sen'kin's collab-
orative book cover design from 1927 *To the Memory of the Fallen Leaders,*[57]
which shows Lenin's mausoleum pierced by a zigzag line of workers (Klutsis'
design) and two hands firmly holding a triple red flag (Sen'kin's design).[58] The

pointed juxtaposition of Lissitzky's abstract design and Klutsis and Sen'kin's documentary photomontage dramatized the ongoing debate between the formalist and the formalist-sociological methods, with Lissitzky still on the side of the former.

Lissitzky's reluctance, as late as 1927, to reflect political events through factographic means places his overtly documentary designs for Pressa, (begun shortly after the All-Union Polygraphic Exhibition) at odds with his concurrent production. In this context, then, Lissitzky appears to have adopted for Pressa the methods of politically based production that had been developed earlier in the work of photographers and photomontagists like Klutsis and Sen'kin. At the very least, their concerns with political, agitational, and documentary photographic imagery seem to have influenced Lissitzky's ultimate layout of the Pressa installation, which is full of reportage material. This supposition regarding Lissitzky's preparation for Pressa may explain why Klutsis felt so close to this project and was so overtly critical of the outcome. The failure to fully acknowledge Klutsis's contribution in the documentation of Pressa and the inclusion of Sen'kin's name next to Lissitzky's on the Pressa frieze may represent Lissitzky's conflicted acknowledgment of the influence both Klutsis and Sen'kin had on his work.

But even as Lissitzky shifted toward the more politically motivated methods of his colleagues, he remained more concerned with the formal organization of the propagandistic material at Pressa than with its message. In a letter written shortly after the exhibition opened, Lissitzky emphasized his frustrations with the formal resolution of the project: "Aesthetically there is something of a poisoned satisfaction. The extreme hurry and the shortage of time violated my intentions and the necessary completion of the *form*—so it ended up being basically a theater decoration."[59] Sen'kin's comment to Klutsis that verbal elements of the exhibition had been given little significance provides further evidence that Lissitzky's primary concern was with the formal and visual coherence of the installation. Lissitzky's collaboration with Klutsis

48. All-Union Polygraphic Exhibition, 1927. Photograph, Gustav Klutsis.

and Sen'kin on the Pressa designs created a hybrid between agitational photographic imagery (content) and constructivist design (form). This union was in line with Shklovskii's pursuit in the context of a formalist-sociological method of "the development of 'hybrid' prose forms that combined journalism's respect for material with narrative or compositional techniques that could most expressively *organize* that material."[60] Unable to refuse such an ambitious project as Pressa, Lissitzky apparently developed a new methodology, as organizer of the ideas of more politically oriented artists in order to address the demands of Pressa's general documentary theme.

One year after the Pressa exhibition, Lissitzky published an essay in *Soviet Photo* that summarized his position on photography: "The language of photography is not the language of painting, and photography possesses properties not available to painting. These properties lie in the photographic material itself, and it is essential for us to develop them in order to make photography into a true art, into *fotopis'*."[61] Surprisingly, this text lacks any references to the propagandistic capacities of photography as evidenced at Pressa or to what Rodchenko termed "new socialist facts." Instead, it underlines photography's formal differences from painting while preserving painting's aesthetic function, defined by Lissitzky as *fotopis'*. This neologism stresses the importance of painterly effects in photography, particularly the contours, shadows, and textures that Lissitzky achieved in his experimental photograms. Lissitzky's emphasis on the creative or expressive aspects of photography suggests that by the end of the 1920s he was not persuaded by the notion that a strict documentary creation should supress the author's individuality. Certain of Lissitzky's gestures, such as combining his infant son's body with a spread from *Pravda* (fig. 49) or with the cover of *USSR in Construction,* both in 1930, betray the artist's efforts to resist the solely collective aspirations of factographic imagery. Only in 1931, with the *Artists' Brigade,* did Lissitzky finally adopt the factographic method and forego the model of the constructivist creator typified by *The Constructor.*

Toward the end of the first Five-Year Plan, the model of artist-producer defended by the *LEF* critics and by radical photographers was being fully realized. Many of these photographers continued to tour construction sites and mines in order to keep in close touch with the proletariat. In one of his letters, Klutsis mentions encountering a group of photographers during his own extended trip with Sen'kin across the Soviet Union. He writes, "[The trip] was quite unpleasant—dirty, uncomfortable—but most important I was able to talk to [John] Heartfield, [Arkadii] Shaikhet, and [Max] Al'pert—we ran into them in Batumi" (fig. 50).[62] Like Klutsis,

49. El Lissitzky, *I Want a Child,* 1930, 17.8 x 23.7 cm, vintage gelatin silver print. Courtesy Houk/Friedman Gallery, New York.

these photographers were collecting images for future contributions to mass-produced posters and magazines. Regarding his own snapshots of the tour, Klutsis concluded, "The photographs are quite good. There are even interesting ones. In any case, as material, all 100 percent will be used."[63]

Klutsis's 1932 poster *The Struggle for Heat and Metal* (fig. 51) was most likely conceived as a result of this trip, specifically a stop he made in Donbass, a major mining region. In another letter to Kulagina, he says, "Last night at ten o'clock, Sen'kin and I descended into a coal mine together with a shift of workers. . . . Only now do I understand all the seriousness and hardship of the coal miner's labor. . . . We received special coal miners' outfits and lanterns. Despite the fact that we did not work but only walked, we got dirty like real coal miners."[64] One of the two coal miners depicted in *The Struggle for Heat and Metal* is Klutsis

himself, wearing work overalls and a hat and carrying a miner's pick over his
shoulder. Oversized, to suggest the unsurpassable productive power associated
with coal miners, the two images of miners occupy the entire background of the
poster. A bustling industrial landscape lies at their feet, insignificant compared to
the two human giants. As with *Male and Female Workers,* Klutsis made prelimi-
nary photographs of himself for use in the photomontage (fig. 52). The resulting
image gives birth to an entirely new model of an artist's self-portrait. Instead of
emphasizing personal characteristics and distinct attributes as Lissitzky did in his
Constructor (he used his self-portrait, which was familiar from other photographs,
incorporated a compass as a symbol of his constructivist identity, and even inclu-
ded the imprint of his name), Klutsis freed his self-portrait from any references that
could identify him. As a result he surrendered his portrait to the ends of the anony-
mous imagery of the proletariat and to the aspirations of the collective rather than
of the individual.

The ardent commitment to mass-media publications and photography adopted
by Klutsis, Rodchenko, Sen'kin, and Ignatovich in the early years of the first Five-
Year Plan resulted in the nearly complete elimination from their oeuvre of unique
works of art. They viewed single-frame still photographs or photomontages not as
finished works of art produced to exist by themselves but as disposable objects
composed during the process of making agitational posters and magazines. In
this respect, they fulfilled Benjamin's dictum that "the work of art reproduced be-
comes the work of art designed for reproducibility."[65] The commitment of Soviet
photographers to the subject matter of Soviet daily life produced a new model of

50. In Batumi, 1931. From left to right: Kurtsis, Heartfield,
Bogorodskii, Elkin, Sen'kin, Al'pert, Shaikhet.

НА БОРЬБУ
ЗА ТОПЛИВО
МЕТАЛЛ
ДАДИМ в **1933** г.
84 МИЛЛ. ТОНН УГЛЯ
9 „ „ ЧУГУНА
6,2 „ „ ПРОКАТА

МЕТАЛЛУРГИЯ — ОСНОВА НАРОДНОГО ХОЗЯЙСТВА. БОЛЬШЕ-
ВИСТСКИМИ ТЕМПАМИ ДОБЬЕМСЯ ПОБЕДЫ В ВЕЛИКОЙ
БОРЬБЕ ЗА МЕТАЛЛ.

РАБОЧИЕ УГОЛЬЩИКИ! СТРАНА ЖДЕТ ОТ ВАС РЕЗКОГО
ПЕРЕЛОМА В ДОБЫЧЕ УГЛЯ!

51. (opposite) Gustav Klutsis, *The Struggle for Heat and Metal,* 1932, 141 x 100 cm, lithograph. Private collection.

52. Gustav Klutsis Wearing Coal Miner's Outfit, 1932.

the artist's function that conflicted with the modernist tendency to use elements of everyday life (as in modernist collage) while remaining within the framework of a traditional aesthetic. The contact these Soviet photographers had with reality was based on their own involvement in the recorded events and on the subjugation of their goals as individual artists to the needs and demands of the proletariat.

Three

Photo-Still

versus

Photo-Picture

The Politics of

(De)Framing

During the period of the first Five-Year Plan, critics from widely different camps were in agreement that virtually all existing art groups shared "a platform of realist genre."[1] This universal adherence to realism did not, however, reflect any general agreement regarding the medium that could best express these realist principles or the mode of realistic representation that could best serve the goals of the state. As a result, in the period of the first Five-Year Plan numerous groups of realists emerged, coexisted, and received critical coverage in the press. The majority of these practitioners were divided into two distinct camps: those who believed that innovative modernist forms must be applied to render Soviet *byt,* and those committed to reflecting everyday events in an expressly conventional manner.

Photographers and photomontagists formed a distinct faction in this pool of competing realists. In reviewing the work they produced during the first Five-Year Plan, one is inclined to conclude that they were united in their commitment to documen-

tary representation. Yet it is also strikingly apparent that these artists differed considerably when it came to composition. There were at least two principal formats: one, based on fragmentation, viewed reality as a disconnected and puzzling space; the other leaned toward whole images and saw the world as a concrete and continuous entity. These two different representational strategies correspond precisely to critic Peter Bürger's important contrast between traditional and avant-garde artists. According to Bürger, traditional artists create organic works designed to give "a living picture of the totality," while avant-garde artists make works that are "no longer created as an organic whole but put together from fragments."[2] To demonstrate this distinction, we might consider two images from the first Five-Year Plan, both of which represent street paving. Arkadii Shaikhet's *Steamroller,* 1931 (fig. 53), insists on an intelligible presentation of labor from a conventional viewpoint. On the other hand, Rodchenko's photograph of the same subject, an individual image from his series *Paving Streets: Leningradskoe Highway,* 1929 (fig. 54), disorients the viewer by eliminating the horizon and severely reducing the body of the machine. While Shaikhet seeks to grasp the totality of the paving process in one snapshot, Rodchenko reveals the operation through an unfolding series of fragments, each an "interior monologue" of the productive force. And, finally, while Shaikhet's photograph tries to seem natural, Rodchenko's images renounce shaping a whole and embrace a montage of parts.[3] Bürger points out that such montages have a different representational status: "They are no longer signs pointing to reality, they *are* reality."[4]

Among Soviet critics of this period, the major advocate of montage was Tret'iakov, who defined it as "a way of linking (comparing and contrasting) the facts [so] that they would radiate social energy and hidden truth."[5] He confirmed his commitment to experimental factography in *Novyi LEF* in 1928, linking it to utilitarian media such as "photo-information, photo-illustration and photo-posters." Tret'iakov claimed, "There is no LEF photography in general. LEF's approach to photography is above all to establish for what purpose one should take pictures and then to find the most rational points of view and ways of photographing."[6] He also noted that "it is necessary to experiment, as far as opportunity allows, in order to resolve concrete problems," since "photography is not just a stenographer, it also explains."[7] So, for instance, "when a machine is photographed, its essential detail is singled out, while its other less important parts are obscured and made lighter. . . . Specific elements can be emphasized by unusual foreshortening, by lighting, by coloring."[8] Summarizing his position, Tret'iakov stated, "The question cannot be resolved by cheap recourse to the 'primacy of content,' by as-

53. Arkadii Shaikhet, *Steamroller*, 1931, photograph. Soviet Photo, Moscow.

serting that the 'what' is more important than the 'how.' To assert the primacy of
the raw, unworked, unorganized fact is to threaten the practical, professional skill
of the photographer."[9] For Tret'iakov, formal elements contributed to the exposure
of those important fragments in each subject that serve "as prefigurations or traces
of a possible utopia."[10]

The impact Tret'iakov's views had on Rodchenko's photography is made clear
in the works Rodchenko published in *Let's Give* and other periodicals throughout
1929. Moreover, in his earlier mentioned lecture to the October Association in
1930, Rodchenko stated that his goal was "to photograph not a factory but the
work itself from the most effective point of view," and that "in order to show the

grandness of a machine, one should photograph not all of it but give a series of snapshots."[11] In this lecture, Rodchenko also revealed his debt to Brik's essay "The Photo-Still versus the Picture," when he divided press photography into two categories: *foto-kadry* (photo-stills), which he defended, and *foto-kartiny* (photo-pictures), which he criticized as "organic" representations of various everyday scenes. Rodchenko concluded that "the issue now is not to take photo-pictures but [to produce] photo-stills."[12]

In 1924, when Rodchenko moved from photocollage and photomontage to straight photography, his main problem was determining which fragment of an image should constitute the final photo-still. Rodchenko sought to frame or crop his photographs at the time he selected the shot through the camera's viewfinder and, later, when he printed the images in his darkroom. This second framing process can be clearly seen through a comparison of the two variants of Rodchenko's *Portrait of Mother,* 1924. The first, as recorded on the glass negative, shows the elderly woman in medium range, seated at a table reading a newspaper (fig. 55). The second version is more tightly framed, becoming a close-up view of the woman's face showing her hand holding glasses (fig. 28).[13] In this second *Portrait of Mother,* the cropping was designed to select the best focus for the viewer's "reading" of the image. Rodchenko believed that such moments arose, "when a

54. Aleksandr Rodchenko, *Paving Streets: Leningradskoe Highway,* 1929, photograph. Soviet Photo, Moscow.

photographer frames [an image] to obtain a sharper and more conflictual per-
ception of a subject matter. Photographic composition can be much richer than
painterly composition. It can be structured vertically, horizontally, diagonally. It
can be loaded in the center and on the edges, [it] can be symmetrical or asym-
metrical. Only with a sharp composition can one . . . deliver to the viewer the
freshness, unsteadiness and changeability of a moment that impressed the pho-
tographer."[14] In *Portrait of Mother,* as well as in other portraits from this period
(such as those of Maiakovskii), Rodchenko's framing functions as a form of "rare-
faction." Philosopher and theorist, Gilles Deleuze argues that rarefied images are
produced "either when the whole accent is placed on a single object or when the
set is emptied of certain sub-sets."[15] Although there is a clear difference between
the final, "rarefied image" of Rodchenko's mother and the more complete original
shots, in this particular case, the gap between the two is minimal and "the angle
of framing [seems] justified."[16]

By contrast, in Rodchenko's photographs after 1928, particularly in those he
published in the mass media, the images and compositional formats create dis-
connected spaces that are "beyond all narrative or . . . pragmatic justification."[17]
With regard to such disconnected spaces found in film, Deleuze employs the con-
cept of "deframing" [*decadrage*]. Although this deframing designates abnormal
points of view, Deleuze insists that they "are not the same as an oblique perspec-
tive or a paradoxical angle" and that they "refer to dimensions of the image
which transgress purely formal aspects."[18] In the Soviet context, this practice of
deframing was a formalist-sociological method that hybridized the "how" and
"what" in order "to confirm that the visual image has a legible function beyond
its visible function."[19] As in the case of framing where the image is freed from
subsets, the deframed representation is dependent on the suppression of what
Deleuze calls "the out-of-field." Unlike subsets that consist of real objects, spaces,
etc., "the out-of-field" refers to "what is neither seen nor understood, but is never-
theless perfectly present."[20] As such, it carries a great importance in the forma-
tion of the "deframed" image, which, being spatially closed, tends "to *open itself*
onto"[21] other dimensions or, in Tret'iakov's words, onto "a possible utopia."

Looking at the range of Rodchenko's and Ignatovich's photographs published
in *Let's Give* during one year, we can observe their changing attitudes toward
deframing and the suppression of "the out-of-field." Rodchenko's series *Electro-
factory* (fig. 56) includes a generous variety of photographic images and presents
the case for a more moderate employment of the deframing technique. The entire
series is printed on one magazine page. Across the top is a double image show-

55. Aleksandr Rodchenko, *Portrait of Mother*, 1924, photograph. Soviet Photo, Moscow.

ing newly manufactured lightbulbs collected for inspection on a table; the lower section of the table is obscured by a slogan announcing the future growth of production. Overlaid on this view is a fragmentary image of the machine that helped to produce these bulbs. Three other shots are laid out on the left side of the page, one beside the other with no gaps. These show female workers, or simply their disembodied hands, making the bulbs or checking on the production. On the right side of the page is a photo-still of a female worker operating a small piece of equipment. This image is separated from the images on the left by the white of the page, the word *electrofactory,* and Rodchenko's name. The final photo-still, which displays the boxes with bulbs ready to be shipped to the stores, is placed casually on the magazine page and looks uneven in relation to the image above it.

In this series, the cropped bodies of the workers, spaces, and harshly reductive views of industrial paraphernalia produce a spatial tension within each photo-still; this makes them appear overloaded and compressed. Ignatovich discusses this intentional format and gives it the name "packing"; he claims this technique produces the "maximum condensation of a photo-still."[22] In order to pack each photo-still most effectively, the photographer must take pictures from abnormal points of view (deframing). Expanding his thoughts on this practice, Ignatovich writes, "Many argue now about methods, but in reality the main issue in photography boils down to composition 50 percent of the time. Composition is not a schema; there are no instant recipes; one cannot fit live thought into prefabricated frames. Composition is a creative process. Photography has to be interpreted as an expression of life. My goal is to completely fill a photo-still, a close-up."[23]

In his own series for *Let's Give,* Ignatovich achieved this sort of composition by creating a sharp contrast between his grand themes (vast factories, huge machines, and massive timber harvesting) and the limited space into which he fit this imagery in every photo-still. Ignatovich's series *Let's Give Soviet Turbine* (fig. 57) begins with a tight shot of the plant's facade. The plant's name and the Soviet state emblem above it are uncompromisingly cropped to discourage specific signification. The other three photographs are laid out with white spacing between them (some of which is used for the title, short description, and the photographer's name) and record the interactions between workers and machines at the plant. One image catches three workers on top of a massive piece of equipment; another depicts a worker barely fitting into the upper space of the photograph. This space is cramped by the suppressed horizon and the oversized machine which extends to the edges of the photo-still. Both scenes are taken from high vantage

56. Aleksandr Rodchenko, *Electrofactory, Let's Give,* 1929, no. 12. Helix Art Center, San Diego.

points and thus operate within Rodchenko's conviction that "the most interesting points of contemporaneity are down from above, and up from below."[24]

In two other projects, *Kondostroi* and *Export Forest*, Ignatovich sought to intensify the tension between the object being represented and the space he was willing to grant to it in the photo-still. One shot from the *Kondostroi* paper factory series (fig. 58) uses a dramatically tilted perspective to provide the widest possible view of the paper-making machine. This machine is then repeated in an adjacent image but in a severely cropped format; the cramped space virtually contradicts the first view. The *Export Forest* series (fig. 59) is dominated by a vertical close-up shot of tall and tightly packed stacks of freshly sawn boards. Here the massiveness of the undertaking is conveyed not by depicting the whole production process but by specifically refusing to allow adequate space for that production in each photograph.

Ignatovich's *Red Triangle* (fig. 60) and Rodchenko's *Machinery Is Advancing in Full Gear* and *Soviet Automobile* (figs. 61, 62) all illustrate the further reduction of the already underplayed narrative aspects of reportage in *Let's Give*. To construct *Machinery Is Advancing*, Rodchenko used only two images: one is a sharply fragmented and tilted shot of the plant building; the other, a close-up of machinery overlapping another fragment of the same building. Rodchenko employs all the elements specified by Deleuze's notion of deframing: the extremely abnormal points of view result in an image so spatially closed as to appear two-dimensional. Similarly, in *Soviet Automobile*, Rodchenko has reduced industrial imagery to the core of its technical detail. The four close-ups of machine parts are identified by purely technical terms, such as "a form for manufacturing a flywheel of a motor" or "assembled crankshafts with flywheels." Every detail of the machine's surroundings is eliminated, leaving no indication of the topography of the plant. Finally, the industrial paraphernalia is separated from any human contact. In these two series, Rodchenko humanizes machines by giving them "a 'heart'" and by letting them "revolve, tremble, jolt about and throw out flashes of lightning."[25] Ignatovich's *Red Triangle*, which depicts the tires and galoshes that are a plant's ultimate product, is equally spare.

Of all of the works that Rodchenko and Ignatovich published in *Let's Give*, *Soviet Automobile* and *Red Triangle* are the strongest in their suppression of social or political content. In such representations, however, we are dealing not with an attempt to flee from social content, but rather with a struggle to manage and contain it. As Fredric Jameson has suggested, this manifestly social content is contained by being hidden "out of sight in the very form itself, by means of specific

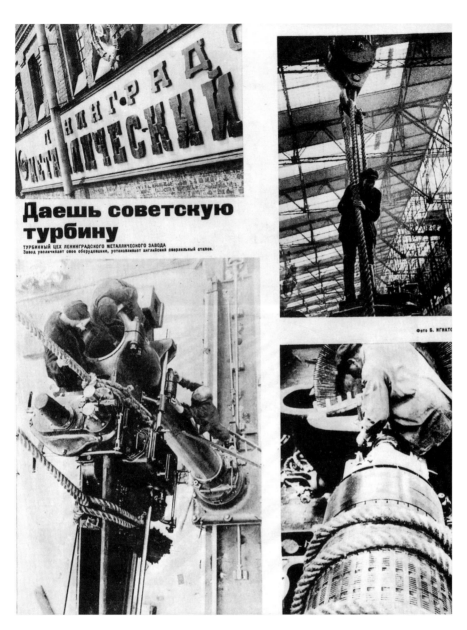

57. Boris Ignatovich, *Let's Give Soviet Turbine, Let's Give*, 1929, no. 7. Helix Art Center, San Diego.

techniques of framing and displacement which can be identified with some precision."[26] The severe reductiveness that Rodchenko and Ignatovich excised in producing these works may be also identified as "Marxist writing," to use Roland Barthes's term, in which "the closed character of the form does not derive from rhetorical amplification or from grandiloquence in delivery, but from a lexion as specialized and as functional as a technical vocabulary."[27] The extremely detailed

58. Boris Ignatovich, *Kondostroi, Let's Give,* 1929, no. 7. Helix Art Center, San Diego.

close-ups of industrial machinery direct our attention to the surfaces of these ob-
jects, not in order to accentuate their textures in a formalist manner, but to refer to
what is not shown, the "out-of-field," utopian dimensions far beyond the borders of
the fragments.

To preserve the transgressive function of the single-frame images used in the
Let's Give series, it is important to view them in this magazine format rather than

59. Boris Ignatovich, *Export Forest, Let's Give,* 1929, no. 4. Helix Art Center, San Diego.

as separate examples of Rodchenko's and Ignatovich's straight photography.[28] As presented on *Let's Give* pages, these images combine into compositions that function both similar to and differently from photomontage. Rodchenko himself connected his practices in photomontage and straight photography when he remarked that in 1924 "the work in photomontage cover[s] and illustration[s] inspired [him] to do [straight] photography. First as a supplement for photomontage

60. Boris Ignatovich, *Red Triangle, Let's Give,* 1929, no. 9. Helix Art Center, San Diego.

and then as an independent form of art"[29] Undoubtedly, Rodchenko's background in photomontage spurred him commitment to fragmentation and to compositional formats based on blending groups of nonorganic images. Photomontage, however, is based on combining documentary images from compatible but not necessarily directly connected sociopolitical contents; it thematically synthesizes factographic material drawn from various sources. By contrast, the images de-

61. Aleksandr Rodchenko, *Machinery Is Advancing in Full Gear,* 1929, *Let's Give,* 1929, no. 14. Helix Art Center, San Diego.

picted in the works shown in *Let's Give* no matter how visually disconnected they seem to be, were always factographic documentary shots taken by the photographers at the specific production sites. Using Chuzhak's terminology, then, the *Let's Give* series might be designated *factomontage.*

Two images from 1929 demonstrate the contrast between factomontage and photomontage: Rodchenko and Ignatovich's harvest sequence (fig. 63) from *Let's*

62. Aleksandr Rodchenko, *Soviet Automobile, Let's Give,* 1929, no. 14. Helix Art Center, San Diego.

Give and Klutsis's *Plan of Socialist Offensive* (fig. 64) published in the journal *30 Days*.[30] Rodchenko and Ignatovich's image consists of photo-stills showing harvesting machinery, a grainery, combine operators, and two extreme close-ups of wheat. At the center where these fragments merge, a delighted female harvester partially obscures each image. Although this factomontage is far from being a complete picture of a particular harvest, it is clearly connected to one place and one time. In Klutsis's *Plan of Socialist Offensive,* on the other hand, connections to a specific time are made primarily by means of brief texts that intrude on the image and inform the viewer about the industrial achievements of the second year of the first Five-Year Plan. Klutsis's photomontage joins photographs from a variety of events and industrial sites (only some of which may have been visited and photographed by Klutsis himself), rather than relying on reportage from a single place. Significantly, while Rodchenko and Ignatovich stress the image of a woman worker and invest within her the force that propels the industrial achievements of the Soviet Union, Klutsis relies on Lenin's portrait as a universal symbol of and inspirational source for the realization of grandiose projects. But, despite these differences, Klutsis's photomontage and Rodchenko and Ignatovich's factomontage share an important similarity in that they both depend on the method of deframing. Rodchenko and Ignatovich use abnormal points of view while taking pictures, and later when framing each image, to disrupt the narrative of harvesting. Klutsis's deframing is achieved while he is cutting and gluing the images he collected, and his approach results in a similar violation of the viewer's single-level perception of the photographic image.

Rodchenko and Ignatovich's harvest sequence brings us to the issue of the way *Let's Give* photo-stills and similar reportage series treated the worker as a subject of representation. Typically, in these images female and male workers are dominated by scenes of construction and industry, their bodies obliterated to the point where only their working hands are shown. In other instances, the workers turn from the viewer, drawing attention away from *who* is working and producing, to *what* is being made and *how* it is being made. This intentional obscuring of the individual workers was meant to suggest the presence of a vast collective responsible for the enormous levels of production. In this way, what might appear as depersonalization is also the principal indicator of a utopian context.

The reverse is true for Langman's photo-reportage. A close colleague of Rodchenko and Ignatovich, Langman employed similar photographic strategies, but in his series he specifically shifted his emphasis from machines and objects of production to individual workers. He became a professional photojournalist in the

63. Aleksandr Rodchenko and Boris Ignatovich, *Harvest Sequence, Let's Give,* 1929, no. 13.
Helix Art Center, San Diego.

early 1920s and attributed his maturity as a photographer to his meeting with Rodchenko and Ignatovich in 1929. Langman believed that "the slanting of a photo-still is needed if it can be justified, if it stresses the content." Furthermore, his reasons for some of his formalist techniques were given within the framework of Tret'iakov's notion of shock effects. Langman said that he "applied slanting to a photo-still as a form of protest against a stereotype in photography. I had to irritate the viewer with something, to kick him out of a dull standard."[31] Particularly significant in the context of the anti-aesthetic photographic discourse of the first Five-Year Plan was Langman's observation that the photographers involved in documenting the Plan were dealing with "nonphotogenic objects."[32] Langman described his 1935 snapshot of a ploughed field (fig. 65) as a typical example of a "nonphotogenic object," an image that resisted any impulse the photographer might have toward aestheticization. He wrote, "Soil was never photogenic and

64. Gustav Klutsis, *Plan of Socialist Offensive, 30 Days*, 1929, no. 12. Private collection.

65. Elizar Langman, *Ploughed Field,* 1935, photograph. Soviet Photo, Moscow.

it is very hard to photograph it. For the first time I attempted to fill up the entire photo-still with soil. It was essential to turn it into a socially meaningful photo-still, it was necessary to show that soil had been cultivated by a tractor, thus I concentrated on the display of that soil."[33] Like Rodchenko and Ignatovich, Langman insisted on revealing socialist content not directly by creating a picture that would speak from its totality, but indirectly by secluding content within the form itself. Langman's favorite "nonphotogenic" subject matters were male and female workers whose intense close-up portraits populate many of his reportage series from plants and workers' cooperatives in the 1930s (fig. 66).[34] Machinery and objects of production are not shown in these photo-stills; enlarged human faces fill up the condensed spaces (fig. 67). Interest is focused on the textures of their faces and hands (figs. 68, 69) rather than on the surfaces of industrial objects as in Rodchenko and Ignatovich's photo-stills. In some cases, Langman squeezed several workers together, forcing them to share a cramped area (fig. 70). In these group representations, Langman gives substance to the absent collective only implied in Rodchenko and Ignatovich's series from Let's Give.

Earlier I compared two types of documentary photography produced in the course of the first Five-Year Plan: Shaikhet's photo-picture Steamroller and Rodchenko's photo-still Paving Streets: Leningradskoe Highway (figs. 53, 54). In order to examine the difference between organic and nonorganic photographic representation more closely, we might consider Shaikhet and Al'pert's photo-essay A Day in the Life of a Moscow Working-Class Family.[35] An Austrian "Society of Friends of the USSR" broached the idea with the Union of Soviet Photo, which commissioned the work in 1931. From the beginning, the Soviet government had high expectations for this project, both because it was being produced for a European audience and because it communicated vital propagandistic information about workers' lives in the first fully Communist country.[36] The series was planned to demonstrate "how the family of the Red Proletarian's worker Filippov lives, works, studies, and rests" and was rapidly executed in five days under the editorial supervision of critic Leonid Mezhericher.[37] In their article "How We Photographed the Filippovs," Shaikhet and Al'pert aligned themselves with the serial method of documentary photography. But their criticism of a photo reporter who arrived "at a construction site [and] above all rapaciously jump[ed] on the most effective parts of it"[38] was a clear jab at the unconventional photojournalistic techniques employed by Rodchenko and his colleagues. Shaikhet and Al'pert further remarked that they understood series "not as a 'simple' display of a succession of workbenches or detached people at workbenches; a series has to

66. Elizar Langman, *Workers' Cooperative of Proletarian District*, 1930, 24 x 18.3 cm, vintage
gelatin silver print. Alex Lachmann Galerie, Cologne.

67. Elizar Langman, *Untitled*, 1930, 24.2 x 18 cm, vintage gelatin silver print. Alex Lachmann
Galerie, Cologne.

68. Elizar Langman, *Untitled,* 1930, 18 x 24.2 cm, vintage gelatin silver print. Alex Lachmann Galerie, Cologne.

reveal the social essence of objects and events as a whole, in their complete dialectical diversity."[39] A much more interesting approach to industrial subject matter, they argued, involved the "observation of some giant in order to periodically reflect truly well through snapshots how it began to be built, what the difficulties of construction were, how it grew . . . and finally the collective that emerged a winner in this struggle."[40]

In accordance with Shaikhet and Al'pert's desire to grasp concrete reality as an organic whole, each snapshot in this photo-essay presents a legible and complete "photo-picture." These images describe certain events in the life of this ordinary family. The series, which includes more than forty photographs, begins with an image of the Moscow area where the Filippovs live (fig. 71). The generous

view of the Moscow horizon even includes a symbol of the denounced past, a large church rising on a hill in the distance. The contrast between the Filippov's new and comfortable apartment building and their previous two-story wooden house is established by including a miniature shot of it. It is through such juxtapositions and through the inclusion of explanatory texts (such as the detailed description of the Filippov's surroundings outside and inside the building) that Shaikhet and Al'pert make their documentary case. The next photograph is a complete portrait of the family members in the apartment, each identified by name. They sit in a modestly furnished room sipping their morning tea. In the following photographs, the impulse to recognize each family member dominates all other ways of thinking about these representations. The viewer locates and identifies the Filippovs in a streetcar, in the plant where the father and son work, in the stores where the son and wife shop, and in a store where the daughter is a saleswoman (figs. 72-75). Unlike the photo-stills in *Let's Give*, the meaning of these photo-pictures is dependent on the specificity of the represented people and places. In this respect, the issue of a compositional format that is essential to the reading of *Lets' Give* photo-stills takes on a totally different meaning. Deframing is no longer

69. Elizar Langman, *Untitled*, 1930, 18 x 23.9 cm, vintage gelatin silver print. Alex Lachmann Galerie, Cologne.

70. Elizar Langman, *Untitled,* 1930, 17 x 23.5 cm, vintage gelatin silver print. Alex Lachmann Galerie, Cologne.

a vehicle for radically changing the meaning of a representation, but merely a formal device appropriated to embellish an already defined content. This explains why Shaikhet and Al'pert claimed that they were "not against unusual angles of observation and shifted positions of the camera during photographing" (figs. 76, 77).[41]

A number of photographs from *A Day* are spatially compressed and use diagonal compositions, close-ups, and high views. They comfortably coexist, however, with images that are overtly conventional in their framing and composition. Filippov's wife, for example, who, as the accompanying text suggests, chose to give up her work and take care of the home, is depicted sitting near a window, embroidering (fig. 78). The photographers have borrowed a classical compositional format from painting: an individual sits by a window through which we

see a view that carries us far beyond the room. Such recourse to traditional rep-presentational structures specifically associated with painting prompted Tret'iakov to harshly criticize the *A Day* series. Labeling it a "photo-biographical extract," he wrote that "in their photographic traditions, a carefully posed photograph of two young women with tennis rackets is no different from photographs of bourgeois celebrities at fashionable resorts."[42] Tret'iakov also pointed to some factual dis-crepancies—such as a half-empty streetcar, a rare sight in overcrowded Moscow —which he felt undercut the veracity of *A Day.*

As I pointed out in the begining of this chapter, the majority of criticism pub-lished in this period debated two distinct views of reality that are well reflected in the *Let's Give* series and the *A Day* sequence. Because most of that critical writing concerned itself with painting or literature, its analysis here would take us far beyond the subject of this book. Those debates that did deal with the na-ture of photographic images are discussed in the following chapters. So here I choose to evaluate the above-described versions of documentary photogra-phy in the broader context of the historical debate over realism as it was articulated in the writings of Bertolt Brecht, Georg Lukacs, Walter Benjamin, and Theodor W. Adorno.

Rodchenko, Ignatovich, and Langman adopted a model of reality that relied on Brecht's under-standing of how realistic representation should function. Brecht asserted that realism might discov-er "the casual complexes of society/unmasking the prevailing view of things as the view of those who are in power/writing from

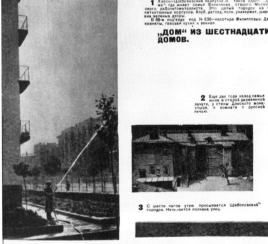

71. Arkadii Shaikhet and Max Al'pert, *A Day in the Life of a Moscow Working-Class Family,* 1931, *Proletarian Photo,* 1931, no. 4. Soviet Photo, Moscow.

72. Arkadii Shaikhet and Max Al'pert, *A Day in the Life of a Moscow Working-Class Family*, 1931, *Proletarian Photo*, 1931, no. 4. Soviet Photo, Moscow.

73. Arkadii Shaikhet and Max Al'pert, *A Day in the Life of a Moscow Working-Class Family*, 1931, *Proletarian Photo*, 1931, no. 4. Soviet Photo, Moscow.

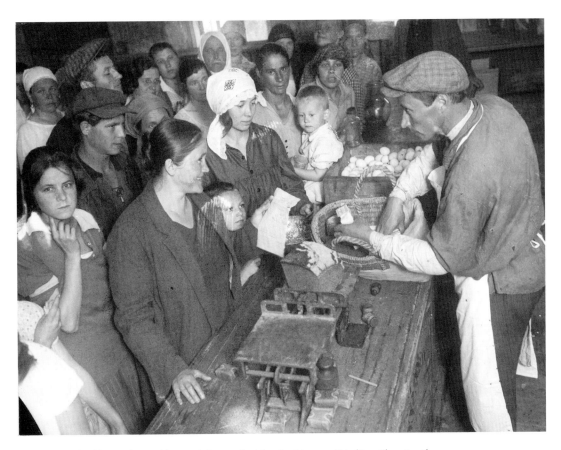

74. Arkadii Shaikhet and Max Al'pert, *A Day in the Life of a Moscow Working-Class Family*, 1931, photograph. Soviet Photo, Moscow.

the standpoint of the class which offers the broadest solutions for the pressing difficulties in which human society is caught up/emphasizing the element of development/making possible the concrete, and making possible abstraction from it."[43] For these three photographers, realistic representation was combined with experimental objectives that were directed toward the work itself, as well as toward the audience. For Brecht, the realistic work of art is composed of fragments that can be added or omitted without significantly changing the meaning.[44]

The photographs in *A Day* reflect Lukacs's theory of realism, which defends the "expression of a social whole" and looks for "knowledge of the historical process in its entirety."[45] For Lukacs, the question of one or another style of realism transcends "a formalistic category" and instead concerns issues of content. In his article "Reportage or Portrayal," Lukacs specifically criticizes the concentration on "isolated facts" or "groups of facts" at the expense of what he called "unity-in-process of the totality." His definition of bad reportage includes the criti-

75. Arkadii Shaikhet and Max Al'pert, *A Day in the Life of a Moscow Working-Class Family*, 1931, photograph. Soviet Photo, Moscow.

76. *(opposite)* Arkadii Shaikhet and Max Al'pert, *A Day in the Life of a Moscow Working-Class Family*, 1931, photograph. Soviet Photo, Moscow.

cism of the conceptualized representations. By contrast, he defends reportage that shows class relations, "disclose[s] causes and propose[s] consequences." He wrote, "In good reportage, the fact, i.e. the individual case, is depicted concretely and individually in a way that makes it really come to life."[46] In a similar fashion, Shaikhet and Al'pert treat their material as something living: for their series they chose a specific family and endeavored to provide an accurate reflection of the everyday life of each family member. For them it was significant, above all, that their photo-essay was true to life and provided a linear progression. As a result, *A Day* exemplifies the organic work of art in which "individual parts and the whole form a dialectical unity . . . the parts can be understood only through the whole, the whole only through the parts."[47]

These reportage images were produced for a broad audience, and it is important to consider the possible reception of these photographs. In the early 1920s, the shift from nonobjective to iconic representation was to a large degree fueled

by the artists' concern that nonobjective production might be inaccessible to mass audiences. Although the producers of photo-pictures and photo-stills were both equally involved in iconic representation, the contrasting models of reality they created defined two possible relationships between the image and its recipient. Brecht, who saw montage technique as the most effective form of representation for the world of labor, believed that the viewer should be confronted with "a riddle." This means that art should be both challenging and disruptive. In works such as photo-stills, then, the viewer was deprived of what Adorno calls "identitarian thinking." In Rodchenko and Ignatovich's factomontages for *Let's Give* the severely fragmented images that are dedicated to the process of labor offered the spectator a partial and perplexing picture of the work area. These photographs aggressively resist the viewer's temptation to perceive them as carriers of narrative or definite meanings; instead they produce a kind of shock. As Andreas Huyssen points out, for Benjamin and Tret'iakov, this shock was "a key to changing the mode of reception of art and to disrupting the dismal and catastrophic continuity of everyday life."[48] Both critics believed that this disruption was "a prerequisite for any revolutionary reorganization of everyday life."[49] Such a dialectical absorption of the representation of labor, and in general of the real, prevented the viewer, who was often the subject of these images, from identifying his or her reality with predictable patterns. In *Let's Give*'s photo-stills, machines, buildings, and men were "presented as a material system in perpetual interaction."[50] This created a model of contemporary life that was solely devoted to "the (communist) transitions from an order which is being undone to an order which is being constructed."[51]

By contrast, a viewer could easily find his or her own prototype within the legible space reproduced in the photographs of *A Day*. In this series, the form of one's life is already defined in representation, the naming of a worker allows the viewer to identify with the main character. These images are endlessly mimetic, conforming to a precise identification between desire and representation. In such an organic whole, Adorno notes, "to become identical, [is] to become total."[52] As such, this representation of social reality leaves no space for reflection; nothing in it can be "shocking." There is no room for doubts or for critiques of the real. There is no place for utopian thinking to enter.

Shaikhet and Al'pert placed the proletariat in a specific sociopolitical framework and designated as a hero that individual who best represented what Lukacs

77. Arkadii Shaikhet and Max Al'pert, *A Day in the Life of a Moscow Working-Class Family,* 1931, photograph. Soviet Photo, Moscow.

78. Arkadii Shaikhet and Max Al'pert, *A Day in the Life of a Moscow Working-Class Family,*
1931, *Proletarian Photo,* 1931, no. 4. Soviet Photo, Moscow.

called "the typical." Rodchenko, Ignatovich and Langman, on the other hand,
deindividualized and deframed photo production, transgressed historic specificity,
and turned the proletariat into an undivided force subsumed under the desire for
utopia. Their new model of representation was able to point out utopian aspira-
tions without resorting to nonobjective language. These two representational sys-
tems, then, corresponded to the two distinct political visions of communism that
divided the Communist Party after Lenin's death. The left position, held by Trotsky,
believed in the idea of world revolution; the faction headed by Stalin believed that
communism was a more specific project that could be realized in the Soviet Union
alone. Although by 1928, Stalin's faction had seized power and begun to imple-
ment the first Five-Year Plan, avant-garde artists like Rodchenko continued to ad-
here to the utopian aspirations embodied in world revolution.

Four

Debating the
Photographic
Image

The two diverse views of photographic representation coexisted in government-supported magazines during the first years of the first Five-Year Plan; this was primarily because the Communist Party remained reluctant to constrict representational choices. Instead, it embraced all artists who were willing to support and disseminate Stalin's program of economic reconstruction. The first signs of denunciation in the official press of the representational and theoretical strategies practiced by Rodchenko, Ignatovich, and Langman came from their colleagues, like Shaikhet and Al'pert, and occurred in the context of the photo exhibition of the October Association in 1931.

The October Association had been formed in 1928, and along with a number of other newly founded or activated groups, it reflected the artists' revitalized feeling that they could effectively influence the sociocultural direction of the country. Unlike the members of AKhR group, who hoped to return painting to the forefront of Soviet art, October united architects, mass-media designers, photographers, filmmakers, and critics who

shared a belief in art as a tool for what Chuzhak called "lifebuilding." They ad-
hered to the productivist ideology and viewed the artist not as a creator but as an
operator. The members of the October Association expressed discontent with the
tradition of nonobjective constructivism, as well as with the commercial tendency of
cultural production inspired by the private patronage of the NEP era.[1] They also
stressed the importance of cultural diversity and the danger of granting privileges
to any single artistic group. The manifesto of the October Association emphasized
the important distinction between the popular postrevolutionary slogan, Art to the
Masses, which reflected a strategy of applying constructivist ideas to utilitarian
objects, and the newer slogan, Art of the Masses, which symbolized the active
integration of amateur practitioners into professional circles.

The diversity of the October Association caused factions to develop and ulti-
mately led to its breaking up into different sections. The photography section was
formed in 1930, two years after October issued its first general declaration of
purpose, and included Rodchenko, Langman, Ignatovich, Vladimir Gruntal', B.
Zemchuzhnii, Roman Karmen, Abram Shterenberg, Ol'ga Ignatovich, Elizaveta
Ignatovich, Moriakin, and Dmitrii Debabov.[2] In addition, the heads of various
fotokruzhki (photo workshops) were accepted into the October Association (many
photojournalists of the 1930s came out of such *fotokruzhki*). The photo-stills that
Rodchenko and Ignatovich had published in periodicals and the discourse formu-
lated by productivist critics provided the theoretical base for the photography sec-
tion. But what really connected the members was their shared interest in photo-
journalism and their commitment to the themes of the first five-Year Plan. It was
considered obligatory for all responsible photojournalists to be affiliated with pro-
duction, that is, to work in the mass media and to contribute to newspapers and
magazines. In addition, every member of the October Association's photography
section had to supervise the *fotokruzhki* at the factories and collective farms.

The photography section's program, outlined in a collection of essays publish-
ed by the October Association, sought to distinguish the photographic strategies
of its members from the

aesthetics of abstract "left" photography like that of Man Ray, Moholy-Nagy, etc.
We are for a revolutionary photography aesthetically unconnected with either the tra-
ditions of autonomous painting or the nonobjectivity of "left photography." We are
for a revolutionary photography, materialist, socially grounded, and technically well
equipped, one that sets itself the aim of promulgating and agitating for a socialist way
of life and a Communist culture. . . . Through the fixation of socially directed and not
staged facts, we agitate and show struggle for socialist culture. . . . We are against
"Akhrovshchina," [AKhRism] . . . flag-waving patriotism in the form of spewing smoke-

stacks and identical workers with hammers and sickles. . . . We are against *pictur-esque* [emphasis added] photography and pathos of an old, bourgeois type.[3]

In their criticism of both Western formalist photography and the conventional realism of AKhR, the October photographers made clear that their own use of formalist devices (diagonal compositions, extreme close-ups, fragmentation, bird's-eye and worm's-eye views, and suppressed horizons) reflected a conscious ideological position. They opposed any view of reality that saw the world as a continuous, organic entity.

In the October Association's first general exhibition at Gorky Park in 1930, the photography section included the periodical *Radioslushatel'* (Radio Listener) designed by Stepanova and illustrated with reportage photography by Rodchenko, Ignatovich, and Gruntal'. Also exhibited was a group of Rodchenko's photographs that ranged from the early portraits of Maiakovskii to a more recent series taken in 1929 at the AMO automobile factory. The AMO series was executed in the reportage mode that Rodchenko had first demonstrated in *Let's Give*. They constitute the ultimate application of his technique of deframing. In one photo-still, Rodchenko employs an extreme close-up, turning the front body of a car into a flat, two-dimensional surface (fig. 79). The wholly abstract quality of the image is violated only by the specificity of the plant's engraved emblem and a diagonal line created by the junction of the two metals used to build the car. A similar spatial and iconographic abstraction is achieved in another photo-still from the AMO series. This shows a tilted table covered by columns of small parts being assembled by female hands (fig. 80). The worker's body, leaning back from her table, is deframed by Rodchenko's bold cropping of her body across the line of the shoulder. As with many of his images of workers in the *Let's Give* series, Rodchenko here confronts the viewer with a representation of labor based on anonymity. The viewer cannot identify with the worker and, as a result, is disinclined to associate the process of labor with a recognized routine.

The photography section's second exhibition opened at the House of Publishing in May 1931. A number of other photographers, including Semen Fridliand and Iakov Khalip, joined Shaikhet and Al'pert to form a group named ROPF (the Russian Society of Proletarian Photographers); they exhibited in the same space as the October photographers, but separately. This event revealed the difference between the photo-stills, as manifested in the photography of Rodchenko, Ignatovich, and Langman, and photo-pictures, as displayed in Shaikhet and Al'pert's *A Day*. This split constituted the basis for debates in the official press about the most appropriate model for Soviet photography. A declaration by ROPF members

79. Aleksandr Rodchenko, *The AMO series*, 1929, photograph. Soviet Photo, Moscow.

was published in *Proletarian Photo* in 1931, accusing the October photographers of following the path of Western photo-practitioners such as Moholy-Nagy despite the October members' own explicit affirmations to the contrary. ROPF photographers thus confined the problematics of the October photography to the context of formalist discourse as it was presented in the West. They ignored the October photographers' insistence on the notion of "how" a photograph is made as a functional, rather than an aesthetic, element. The ROPF group also failed to understand that the fundamental argument concerned a conflict between the two different visions of "social reality" and two different modes of realism.[4]

As early as 1929, critics had alleged that the October type of photography was an unfit model for the Soviet press. In a 1929 article "The Competition of the Photojournalists Unfolds," Shaikhet wrote, "Many photojournalists who submit vivid snapshots [to magazines] experience complete disappointment when the editors do not grasp their 'points of view.' Often they [the editors] simply do not understand how a photograph can be tilted or, simply said, 'fall,' or how one can publish a photograph with a close-up, for example, of the details of machines, the movements of hands, etc. . . . Above all, editors approve of photographs in which all the events are fitted into absolutely concrete and intelligible forms for the reader."[5]

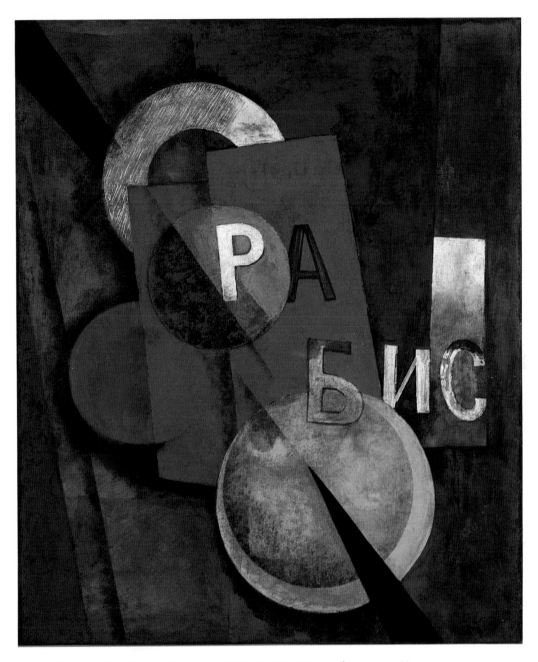

Plate 1. Sergei Sen'kin, *Composition (Rabis)*, 1920–21, 93 x 79 cm, oil on canvas. Museum Ludwig, Cologne. © Rheinisches Bildarchiv.

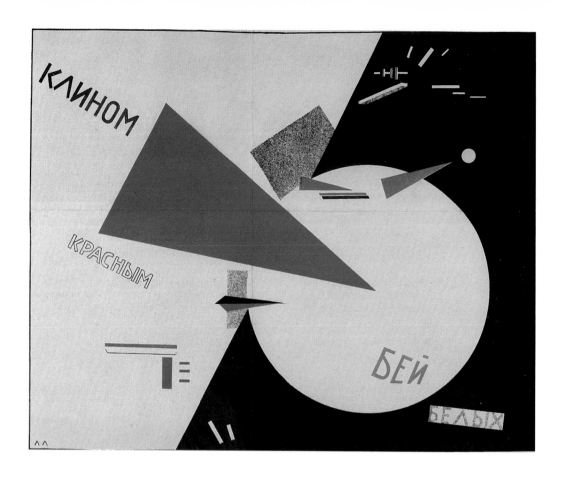

Plate 2. El Lissitzky, *Beat the Whites with the Red Wedge*, 1919–20, 49 x 69 cm, lithograph. Ars Libri Ltd., Boston.

Plate 3. Gustav Klutsis, *The Dynamic City*, 1919, 87 x 64.5 cm, oil with sand and concrete on wood. Art. Co. Ltd.(The George Costakis Collection).

Plate 4. Aleksandr Rodchenko, *Let's Give*, 1929, no 6, cover, 30 x 23 cm, lithograph. Helix Art Center, San Diego.

Plate 5. Gustav Klutsis, *Let Us Fulfill the Plan of the Great Projects*, 1930, 18.2 x 10.7 cm, photomontage. Private collection .

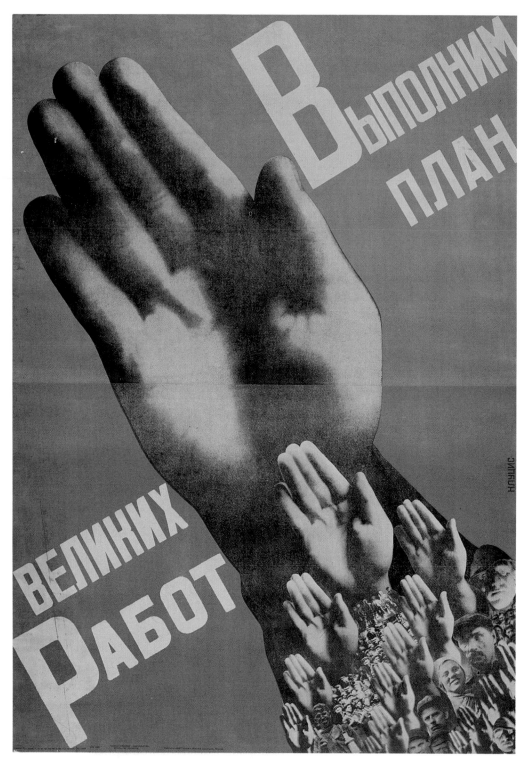

Plate 6. Gustav Klutsis, *Let Us Fulfill the Plan of the Great Projects*, 1930, 118.7 x 84.4 cm, gravure. The Museum of Modern Art, New York. Purchase fund, Jan Tschichold Collection. Photograph © 1995 The Museum of Modern Art, New York.

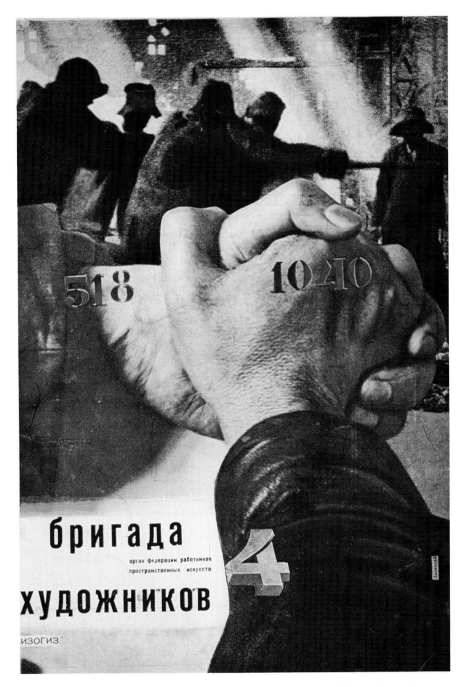

Plate 7. El Lissitzky, *Artists' Brigade*, 1931, no. 4, cover, 31.5 x 21.2, lithograph. Productive Arts, Brooklyn Heights, Ohio.

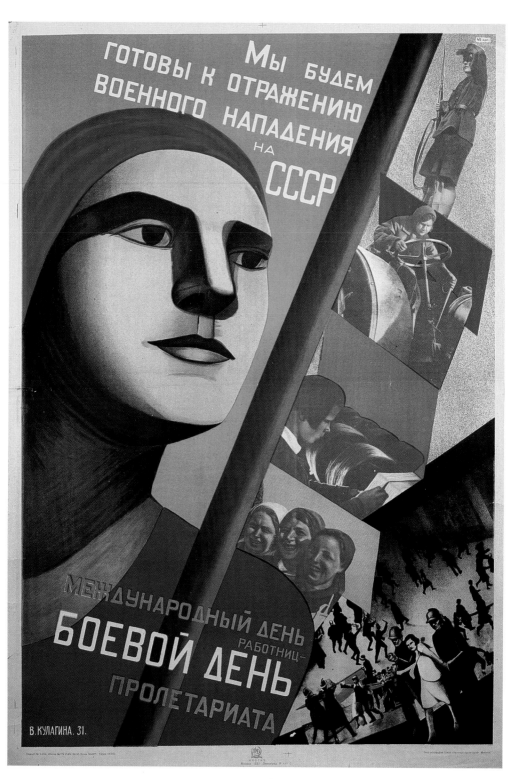

Plate 8. Valentina Kulagina, *International Working Women's Day Is the Fighting Day of the Proletariat*, 1931, 94 x 69.3, lithograph. Private collection.

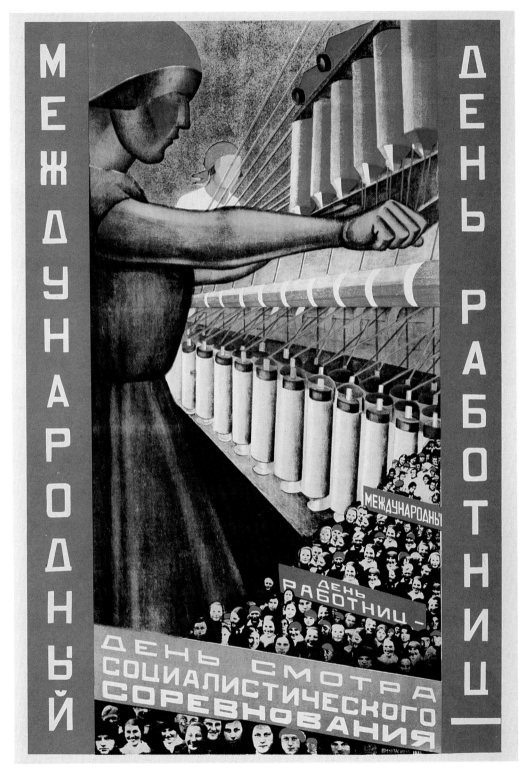

Plate 9. Valentina Kulagina, *International Working Women's Day*, 1930, 108.9 x 72.1 cm, lithograph. Private collection.

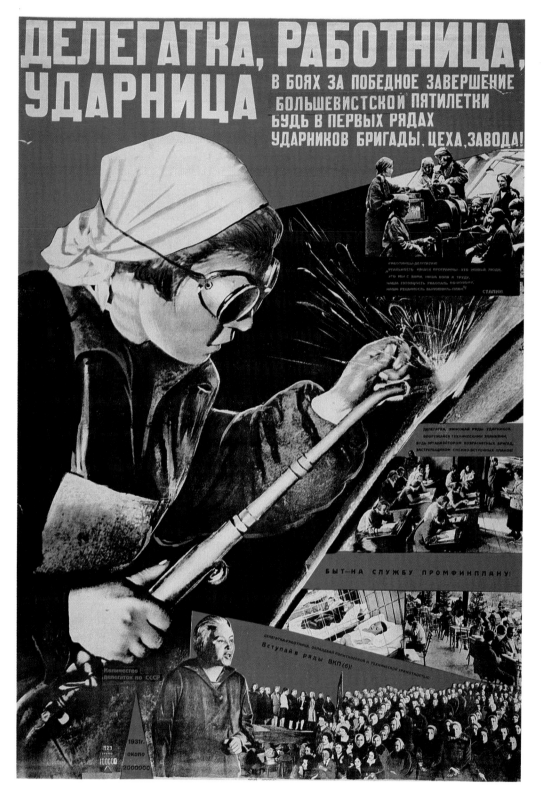

Plate 10. Natalia Pinus, *Female Delegate, Worker, Shock-Worker*, 1931, 104 x 75 cm, lithograph. Private collection.

Plate 11. Gustav Klutsis, *In the Storm of the
Third Year of the Five-Year Plan,* 1930, 86.4 x
61.6, lithograph. Private collection.

Plate 12. El Lissitzky, *Russian Exhibition in
Zurich,* 1929, 126.4 x 90.5 cm, lithograph.
Courtesy Houk/Friedman Gallery, New York.

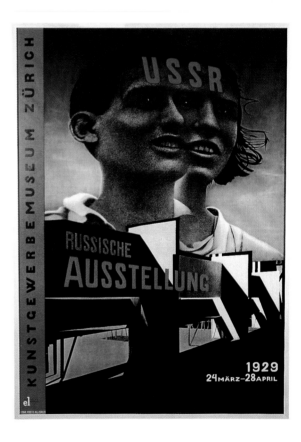

Plate 13. Gustav Klutsis, *We Shall Repay the Coal Debt to the Country*, 1930, 10.2 x 7.6 cm, vintage gelatin silver print with color. Private collection.

Plate 14. Gustav Klutsis, *We Shall Repay the Coal Debt to the Country*, 1930, 16.5 x 11.5 cm, vintage gelatin silver print with color. Private collection.

Plate 15. Gustav Klutsis, *We Shall Provide Millions of Qualified Workers,* 1931, 140 x 110 cm, lithograph. Private collection.

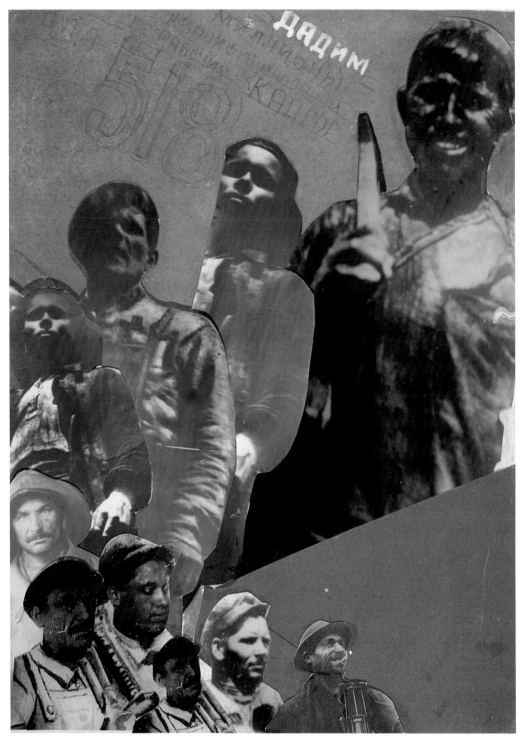

Plate 16. Gustav Klutsis, *We Shall Provide Millions of Qualified Workers*, 1931, 21.5 x 13 cm, photomontage. Private collection.

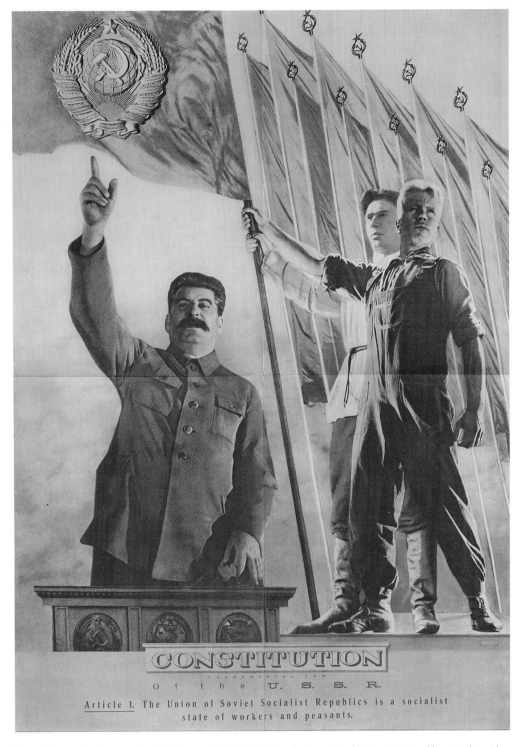

Plate 17. *USSR in Construction*, 1937, nos. 9–12, El Lissitzky designer. Productive Arts, Brooklyn Heights, Ohio.

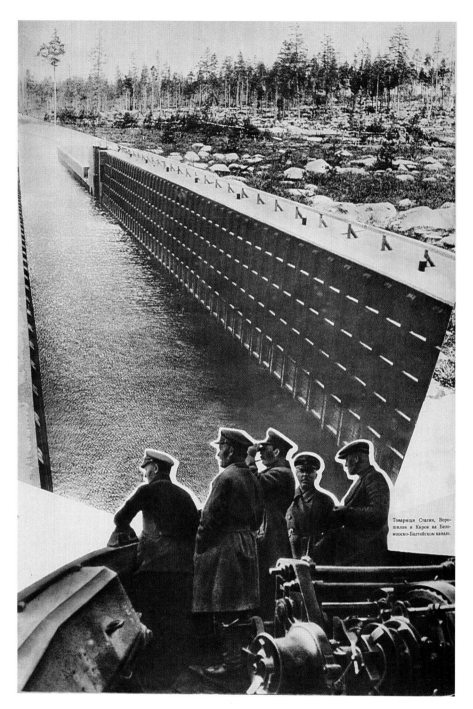

Товарищи Сталин, Воро-
шилов и Киров на Бело-
морско-Балтийском канале.

Plate 18. *USSR in Construction,* 1933, no. 12, Aleksandr Rodchenko designer and photographer.
Productive Arts, Brooklyn Heights, Ohio.

Plate 19. *USSR in Construction*, 1933, no. 12, Aleksandr Rodchenko designer and photographer. Productive Arts, Brooklyn Heights, Ohio.

Plate 20. *USSR in Construction*, 1935, no. 12, Aleksandr Rodchenko and Varvara Stepanova designers. Productive Arts, Brooklyn Heights, Ohio.

Plate 21. *USSR in Construction,*
1936, no. 8, Aleksandr Rodchenko
and Varvara Stepanova designers.
Productive Arts, Brooklyn Heights,
Ohio.

Plate 22. Gustav Klutsis, *The
Feasibility of Our Program Is Real
People, It's You and Me,* 1931,
34.3 x 20.3 cm, pencil on paper.
Private collection.

Plate 23. Sergei Sen'kin, *Let's Strengthen the Industrial Might of the Soviet Union*, 1932, 100 x 70 cm. Private collection.

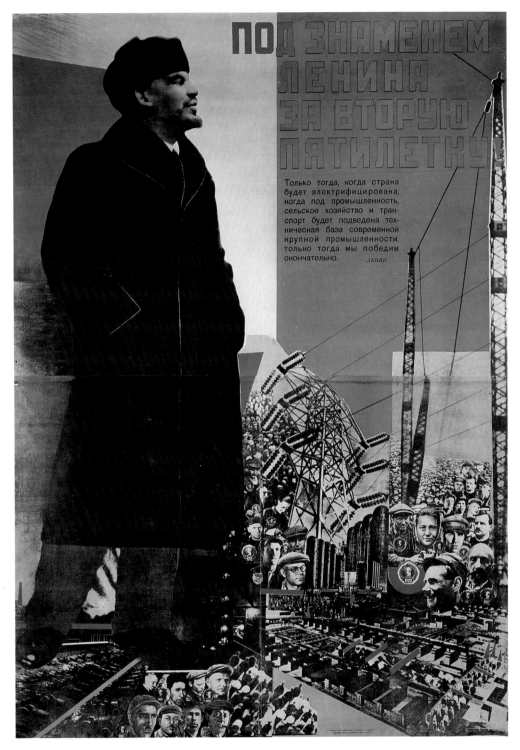

Plate 24. Sergei Sen'kin, *Under the Banner of Lenin for the Second Five-Year Plan,* 1932, 140 x 99 cm, lithograph. Private collection.

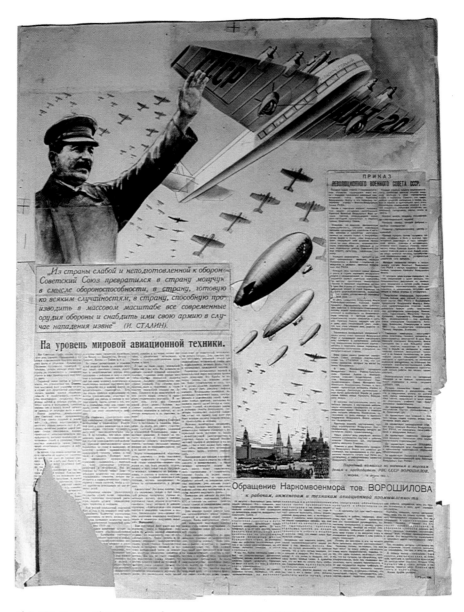

Plate 25. Gustav Klutsis, Design for *Pravda,* August 18, 1933, 65 x 48.2 cm, photomontage.
Private collection.

By the early 1930s, this position had acquired clear official support. In 1931, the Central Committee of Proletarian Cinematographers and Photographers stated that they preferred the photographic methods employed in *A Day* as a model for the "proletarianization" of Soviet photography. The Central Committee's plenum declared that the images from *A Day* presented a "bright realist documentary representation of the class truth of our reality [plus] the ability to expose the class essence of the events."[6] What followed was a widespread tendency in the Soviet press to glorify and heroize the proletariat. Workers were not shown as an undifferentiated class whose personal deeds were subsumed under a united desire for a utopian society (as is the case in the photographs of Rodchenko, Ignatovich, and Langman), but as a class of heroes whose achievements were "determined by objective forces at work in society."[7] It was felt that showing and naming a superproductive or exemplary worker in the press would provide others with an inspiration for competition. Similarly, Soviet leaders believed that designating the fulfillment of a specific amount of production would redirect the worker's desire, moving it from abstract or utopian thinking about socialist labor in general toward the realization of specific projects of the Plan.

80. Aleksandr Rodchenko, *The AMO series*, 1929, photograph. Soviet Photo, Moscow.

The opening of the 1931 exhibition at the House of Publishing triggered heated discussions in the press about this issue. Critics such as Mezhericher, the editor of *A Day*, became major voices in the debate over the proper role of photography. In "Soviet Reportage Today," Mezhericher adhered to an already familiar critical line. He claimed that the photographs exhibited by October members were not press photography but aestheticized production and that Rodchenko had negated the importance of content and had thus undermined photojournalism at its core. Mezhericher continued: "Rodchenko is a skillful and stubborn 'left' artist; along with a dose of the positive (the elimination of impressionist-type canons in painting and the finding of a truly photographic language), there is in his work a dose of the negative (penetration of the new Moholy-Nagian canons, formalism from the 'left' instead of formalism from the 'right,' negation of 'content,' and thus a negation of the essential nature of photo-journalism)."[8]

As a typical example of the weaknesses of this Moholy-Nagian photography, Mezhericher cited Langman's *Lacemaker,* 1930 (fig. 81), calling it the "apogee of formalism." Langman's photograph shows a close-up of a female hand working on a piece of lace. The lace stretches over the entire image, with the lacemaker's face seen through the fabric. This creates a sharp discontinuity between foreground and background. Although Mezhericher acknowledges the technical mastery of Langman's photograph, he labels it "a typical aesthetic snapshot, an example of a senseless adoration of a fragment of reality plucked from its surroundings without reason. . . . The author is too preoccupied with a contrast between the *faktura* of the hand and the fabric and with creating an interesting effect with a face seen through the woven fabric. . . . Here, a formalist task is resolved using the scene of a factory production; it could just as easily be achieved with the material of a petty bourgeois environment. The idea is lost in the pursuit of form."[9]

A number of other photographs exhibited at the House of Publishing also met with harsh criticism from the press. Langman's *Gymnastics on Radio,* 1930 (fig. 82), in particular, was accused of having a confusing composition. It features two young men exercising in front of a radio. Their bodies, positioned parallel to one another, only partially fit the boundaries of the photo-still. The gymnasts stretch from the upper right and reach toward the close-up radio in the lower left-hand corner. Each gymnast has one arm twisted upward; these are abruptly cropped by the photograph's frame. The foremost gymnast's other hand is pointed to the lower right; this increases the sense of diagonal movement already established by the sloping floor. As a result of these complex spatial relationships and the

81. Elizar Langman, *Lacemaker,* 1930, 24 x 18 cm, photograph. Soviet Photo, Moscow.

way the photo-still is "packed," the image seems to have several viewpoints and
no clearly legible structure.

The photo-still *Gymnastics on Radio* is just one image from a series document-
ing a commune of young people from the Dinamo plant. Other photographs from
this series demonstrate Langman's tendency to use extreme close-ups to draw the
viewer's attention to seemingly insignificant details. His photograph *Young Com-
mune "Dinamo"*, 1930 (fig. 83), for example, presents three young men sitting at
a table drinking tea. In the immediate foreground, a third male is pouring tea,
and the close-up view of the kettle he holds virtually obscures his already greatly
fragmented image. Langman's commitment to capturing the fleeting facts of Soviet
byt tended to contradict the officially endorsed principles of descriptive photogra-
phy. As a result, *Proletarian Photo* observed, "When Langman comes to the com-
mune of young people at the *Dinamo* plant, he is confronting an exceptionally
serious subject: the new youth is being molded to fit the new conditions. . . . One
cannot grasp such a theme all at once. One should visit the commune not once,
not twice, but more, and talk a lot with the guys. But Langman's eye and his cam-

era button act fast. And, as a result, one of the most thrilling problems of our new social construction is blocked by a kettle."[10]

Similarly, Ignatovich's *New Moscow,* 1930 (fig. 84), was denounced in *Proletarian Photo* for concentrating on indistinct fragments of reality. In this image, a cathedral tower, the symbol of old values, is pushed to the background, while fragments of political banners, which mark the new revolutionary aspirations, crowd the foreground. The messages on the banners are broken up into syllables and thus prevent the viewer from easily deciphering the nature of "new Moscow." Instead, the image functions in a Brechtian way, giving the viewer "a riddle" that is supposed to provide a challenge, awakening a new political consciousness. Ignatovich's *Old Leningrad—New Leningrad,* taken in 1930, is a view from an airplane that juxtaposes the city's prerevolutionary St. Isaac's Cathedral and a contemporary industrial plant (fig. 85). Fridliand dismissed the image as "a caricature of a Soviet plant" and complained that it offered "nothing new, nothing old—all the same partyless treatment of Soviet reality—all the same formalism that removes one from the profound dialectic disclosure of the social essence of

82. Elizar Langman, *Gymnastics on Radio,* 1930, 24 x 18 cm, vintage gelatin silver print. Alex Lachmann Gallerie, Cologne.

the phenomena into the realm of a fruitless abstraction of the 'original' and 'unusual.'"[11]

And, finally, the critics regarded Rodchenko's *Pioneer with a Horn,* 1930 (fig. 86), as a distorted image of a Soviet pioneer. Fridliand wrote: "The snapshot *Pioneer* most clearly manifests the leftist, narrow formalist tendencies of October's creative principles, which provide counterrevolutionary distortions of Soviet reality. A pioneer is sacrificed to satisfy 'creativity from the left,' which echoes the production of the right 'hunters for beauty

83. Elizar Langman, *Young Commune "Dinamo,"* 1930, 15.8 x 23. 7 cm, vintage gelatin silver print. Alex Lachmann Galerie, Cologne.

in general.'"[12] The young bugler in Rodchenko's photograph is seen from a worm's-eye view; the image is so severely deframed that only his head, with a distinct view of the chin, and a tiny fragment of a horn, remain in the photo-still. The pioneer's head is positioned diagonally and tilted upward toward the sky. Rodchenko used this upward gaze in a number of other photographs of pioneers produced around this period (figs. 87, 88); in some, the viewer is positioned directly below the subject. This pose was criticized by photographer and critic Ivan Bokhonov, who said of Rodchenko's photograph *Pioneer Girl,* 1930 (fig. 89), also included in the second October exhibition, "The Pioneer girl has no right to look upward. That has no ideological content. Pioneer girls and Komsomol girls should look forward."[13] For Soviet ideologues, even such subtle directional signals figured in the conflict between photo-stills and photo-pictures. "Forward"—that is, the horizontal or diachronic—fit into the domain of the observable future. This ideology found its reali-

85. Boris Ignatovich, *Old Leningrad. New Leningrad, Proletarian Photo,* 1931, no. 2. Productive Arts, Brooklyn Heights, Ohio.

zation in photo-pictures, which confined the image to already determined and visible reality. By contrast, "upward"—that is, the vertical or synchronic—was synonymous with the unknown, the unseen, and the unpredictable. These conditions were made manifest in photo-stills, particularly by means of deframing which directed the image upward, into the out-of-field.

A comparison, made in *Soviet Photo* between Rodchenko's *Pioneer with a Horn* and Shaikhet's *Red Army Skiers,* 1928 (fig. 90), illustrated the schism between these two models of representation and demonstrated the congruence between the views of the government and the representational choices of the ROPF. In discussing these two images, the press criticized Rodchenko for selecting an "unsuccessful" moment, one that did not reveal the essence of a pioneer organization. As such, the critics argued, the image might cause the viewer to believe that "pioneers just blow horns." On the other hand, Shaikhet's photograph, a high view of a group of soldiers skiing through a snowy forest, was praised for having a strong sense of narrative, which would allow the viewer to mentally

84. *(opposite)* Boris Ignatovich, *New Moscow,* 1930, photograph. Soviet Photo, Moscow.

86. *(opposite)* Aleksandr Rodchenko, *Pioneer with a Horn,* 1930, photograph. Soviet Photo, Moscow.

87. Aleksandr Rodchenko, *Pioneer,* 1928, photograph. Soviet Photo, Moscow.

88. (below) Aleksandr Rodchenko, *Pioneer,* 1930, photograph. Soviet Photo, Moscow.

89. Aleksandr Rodchenko, *Pioneer Girl,* 1930, photograph. Soviet Photo, Moscow.

continue the story. *Soviet Photo* went so far as to suggest their own version of the story: "The Red soldiers are in a hurry to reach the village where they will conduct meetings, talk about collectivization, help to set up cultural activities, and generally strengthen ties between the proletarian city and the poor village. Not only will this trip result in one more initiative for the socialist reconstruction of the village, it will

also offer a splendid opportunity to practice skiing, a skill that significantly reinforces the defense potential of our army."[14] This comment clearly suggests that, even in nonserial photography, the official press demanded representations that could form a continuous plot, if only in the viewer's mind.

Mezhericher praised the ROPF photographers, saying that their work could "be imagined as pictures on the walls of a club, a panel on a square or in a park, a postcard or a shield over the demonstration column."[15] He attacked the October photographers for the excessive fragmentation of their images. His argument against Langman's *Lacemaker* as a "fragment of reality plucked from its surroundings" is typical of the larger Marxist crusade against fragmentation. Like all critics, photographers, and painters who adhered to the Lukacsian model of realism, Mezhericher believed that he was realizing Marx's project of emancipation, the most fundamental characteristic of which was "to make the world whole, to connect the disconnected . . . to overcome old contradictions."[16] In this sense, frag-

90. Arkadii Shaikhet, *Red Army Skiers,* 1928, 34.5 x 43.8 cm, vintage gelatin silver print. Alex Lachmann Galerie, Cologne.

mentation was not considered a purely artistic device; it was a state of reality caused by the "nonorganic" phenomena of capitalism. From Marx's utopian standpoint, the course of reality is characterized by its movement from fragmentation toward unity. Such a paradigm of dialectical change was, in Marx's opinion, identifiable with progress, for, as Hegel had said, "The truth is the whole." By trying to organize the world into homogeneous "photo-pictures," the ROPF photographers were fulfilling Marx's holistic drive to overcome fragmentation and alienation. In ROPF's oeuvre, the process of "reunifying a fragmented world" was primarily achieved by means of the photograph's iconic functions. By contrast, October's single-frame photographs and factomontages were based on indexical representations in which "the network of cuts and lines of jutting edges and unmediated transitions from fragment to fragment are as important, if not more so, as the actual iconic representation contained within the fragment itself."[17] As a result, October's photography pointed to the life beyond the frame and thus aimed at a more universal model of "reunification."

The events surrounding the October Association's exhibition at Gorky Park in 1930 also summed up the major achievements in photomontage and marked a turning point in its development (fig. 91). Klutsis's article "Photomontage as a New Kind of Agitational Art," published in a collection of essays by the October Association, outlined the importance of photomontage in the development of the Soviet mass media and argued that in its impact on the audience photomontage is comparable only with film, which "combines a mass of photo-stills into a complete artwork."[18] Klutsis linked the emergence of photomontage with the bankruptcy of nonobjective art and with the constructivists' search for utilitarian applications of their formal methods. He claimed that he was the first Soviet artist to use photomontage in his *Dynamic City* and then in the illustrations for *Young Guard* which he produced with Sen'kin. And, although he acknowledged that Lissitzky and Rodchenko were also among the early practitioners of photomontage, Klutsis emphasized that they were inclined toward formalist-advertising tendencies and thus had no influence on the evolution of agit-political photomontage.

In a description of one of the October Association's meetings before their first exhibition at Gorky Park, Kulagina made clear the difficulties that Klutsis faced as an uncompromising defender of a specific mode of photomontage. She wrote, "Yesterday the exhibition committee met to select the works for the polygraphic section. Klutsis, Novitsky, Ginsburg, Kurella, and less significant people like Telingater were there. . . . Gustav was in the minority—the only photomontagist out of

91. Exhibition of October Association, Gorky Park, Moscow, 1931. Photograph, Gustav Klutsis.

seven members of the committee—and when they rejected his cover, a good one, he announced that he was leaving the committee because of its structure. This created a scandal, and everyone started arguing. Gustav told Telingater that he had not done a single work on his own. Everything is like somebody else's."[19]

For Klutsis, Solomon Telingater, a close friend of Lissitzky's, was an example of an artist whose work merely imitated formalist-advertising photomontage. Telingater's preference for playful designs and imagery revealed itself in his choice of verbal messages, which were often eclectic and playful. In his two-part bookmark, *The Word Is Given to Kirsanov,* 1930 (fig. 92), constructivist typography is mixed with photographs to produce a cartoonish portrait of Kirsanov. Telingater's use of photomontage was far different from that of the artists Klutsis celebrated in his article: Vasilii Elkin, Faik Tagirov, Kulagina, Nikolai Spirov, and Natalia Pinus. Those artists used photomontage to convey political and economic messages. Klutsis stressed that his work (and that of his colleagues) was connected to "thousands of nameless workers and collective farmers who depict urgent political themes with the photomontage method."[20]

To illustrate his article on photomontage, Klutsis included photomontage posters by Sen'kin, Elkin, Kulagina, and Pinus (fig. 93), along with his own works.[21] Sen'kin's poster *Who Is Saying That There Is No Lenin, Lenin's Light Is Burning Everywhere* is akin to the illustrations he and Klutsis had made earlier in memory of Lenin. In the poster, the leader is shown repetitively and in different scales, juxtaposed next to his mausoleum (the sign of his immortality). Elkin's poster is dedi-

92. Solomon Telingater, *The Word Is Given to Kirsanov,* 1930, lithograph. Private collection.

cated to Max Geltz's book *From White Cross to Red Banner,* which stressed the vital role of the worker in the revolutionary process. Kulagina's photomontage *We Are Building,* 1929, and Pinus's *Female Collective Farmer–Build Collective Farms,* also included in Klutsis's article, illustrate how photomontage could reflect the roles of women during industrialization and collectivization. Both images portray female workers as anonymous but powerful heroines, responsible for continuous socioeconomic transformations. Judging from remarks Kulagina made in her diary just a few months before the October Association Exhibition at Gorky Park, she considered women's themes in the mass media to be of vital importance. She wrote, "Today I began a poster concerning the construction and collectivization of a village. Nobody has yet been able to create a persuasive poster on this theme; usually [such posters] are limited to showing a woman on a tractor or a woman with a cow (as if she is dragged to a *kolkhoz*)."[22] Kulagina's major posters from this period elevate women's role in the prerevolutionary days, as well as in the postrevolutionary period. Her *International Working Women's Day Is the Fighting Day of the Proletariat,* 1931 (pl. 8), juxtaposes scenes of women participating in demonstrations against the tsar with a series of photographic images showing emancipated, exuberant, and daring women building socialism. These photo fragments documenting women's everyday lives are contrasted to a hand-drawn rendering of a bold female worker. She is placed against a red banner whose pole stretches diagonally across the frame dividing her from the photo fragments. In *International Working Women's Day,* 1930 (pl. 9), a giant female factory worker operates a hefty textile machine. In the foreground, and much smaller in size, packed-together masses of women workers commemorate the holiday. They are mindful that their present position was made possible by the Bolshevik's liberation of women. Pinus's *Female Dele-*

gate, *Worker, Shock-Worker*, 1931 (pl. 10), similarly presents women as active citizens making decisions about political and economic reforms. Here, a female metallurgist rules the space; next to her, other females, much smaller in scale, appear as students, agitators, workers, and mothers.[23]

In "Photomontage as a New Kind of Agitational Art," Klutsis also claimed that

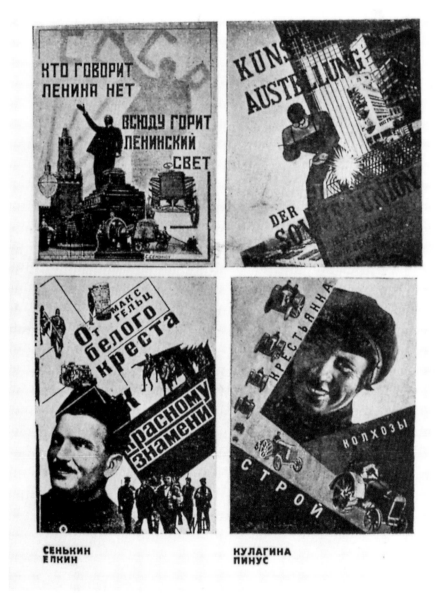

93. Clockwise from upper left, posters by Sergei Sen'kin, Valentina Kulagina, Vasilii Elkin, and Natalia Pinus, reproduced in *Izofront*, 1931. Productive Arts, Brooklyn Heights, Ohio.

Soviet agitational photomontage had an influence on "Communist publications in Germany."[24] To emphasize this point, he juxtaposed his poster *In the Storm of the Third Year of the Five-Year Plan,* 1930 (pl. 11), with John Heartfield's *The Dead Parliament* of the same year. He also placed Lissitzky's *The Constructor* (fig. 46) next to Jan Tschichold's photomontage *Laster der Menschheit*—a woman's portrait combined with constructivist form and typography. Since Klutsis was seeking to distance himself from the formalist-advertising tendencies typified by Lissitzky, this last comparison was probably meant to link Lissitzky to more formalist German constructivist traditions. But the fact was that in 1930 Lissitzky was largely preoccupied with bold architectural and exhibition designs. His use of photography was largely confined to its application to these activities.[25] Lissitzky's famous poster for the Russian Exhibition in Zurich in 1929 (pl. 12) had used photomontage to create a dramatic double-headed image of male and female youths who share an eye and have "USSR" written across their foreheads. In the foreground of this poster are a number of empty exhibition stands, which serve to make the public wonder about the content of the exhibition. In his 1930 designs for the International Hygiene Exhibition in Dresden (fig. 94), on the other hand, printed messages and photographic images cover virtually every square inch of the walls, stands, and ceiling. As with his Pressa installation, the architectural scale of Lissitzky's Dresden project emphasized the great didactic potential of photomontage, taking it beyond the framework of magazines and posters and endowing it with greater power to influence the viewer.

Klutsis rounded out the illustrations to his photomontage article with his own *Dynamic City, Sport* from 1922 and with illustrations from *Young Guard* and *Pitiash* from 1926. These images were presented as the first Soviet photomontages and as prototypes for the posters Klutsis produced in response to the Five-Year Plan. During the Plan, he concentrated (as did the straight photographers), on representations of workers and labor, themes he had begun to develop as early as 1924. In the 1924 photomontage *Male and Female Workers Sign Up for the Party of Il'ich* (fig. 95), he created a vigorous picture of the Soviet workforce and emphasized its political meaning by including slogans urging workers to join the Bolshevik Communist Party. To further inspire the viewer, a portrait of Lenin, then the people's favorite leader, was added in the upper right, effortlessly overseeing the photomontage's busy field of action. A monumental figure of a worker, placed diagonally in the upper left, tops the entire composition. His disproportionately large left hand works a lathe, while his right hand is shown idle. But Klutsis transgresses reality here, adding a third, disembodied hand that helps the worker op-

erate the lathe. Another robust worker is seated in the lower right, his work tool is overlaid by multiple images leaving his hand pointing in a disjointed gesture, toward the lower left. There, a firmly installed female head boldly confronts the viewer. Combining elaborate formal play of verticals, horizontals, and diagonals with political and workforce iconography, Klutsis transformed the didactic information into a puzzling space, forcing the viewer to accept a multifaceted conception of his subject matter.

By 1930, when Klutsis produced his major series of posters, *Struggle for the First Five-Year Plan,* he was firmly committed to using nonorganic, fragmentary images. In *Let Us Fulfill*

94. El Lissitzky, *International Hygiene Exhibition in Dresden,* 1930. Deutsches Hygiene-Museum, Dresden.

the Plan of the Great Projects, Klutsis eliminated the surplus details characteristic of *Male and Female Workers Sign Up for the Party of Il'ich* and summarized the idea of work in the iconic image of a hand. An arm (actually Klutsis's) stretches from the lower right to the upper left and confronts the viewer with an open palm, pushing the whole image toward the viewer. The two-dimensionality of this poster is further advanced by slogans written in white on both sides of the hand. Crowds of workers, all packed into the lower right of the composition, are similarly dominated by repetitive rows of smaller versions of the main hand image. As in *Let's Give's* photo-stills, this poster design is based on a severe reduction of the narrative mechanisms. For example, Klutsis has removed any view of the construction sites that inspire the slogans. This more abstract treatment of industrial subject matter places Klutsis's image on the level of a codified metaphor, transgressing the immediate meaning of its message.

Two more landmark posters from the series *Struggle for the First Five-Year Plan* were published with Klutsis's photomontage article. In two posters from 1930, *We Shall Repay the Coal Debt to the Country* (fig. 96) and *In the Storm of the Third Year of the Five-Year Plan,* Klutsis worked out a representational model of a work-

95. Gustav Klutsis, *Male and Female Workers Sign Up for
the Party of Il'ich,* 1924, photomontage. Private collection.

er. For *In the Storm of the
Third Year,* he grouped
several steelworkers close
together in profile in a
tight space on the left
side.[26] Their arms join
together to point toward
the site of production
which, however, the art-
ist has cropped from the
composition. In the lower
left, Klutsis placed a large
gloved hand holding a
heavy tool. In the lower
right, there is a small frag-
ment of an industrial land-
scape, heavy with smoke;
this contributes an ele-
ment of concreteness to
the otherwise loosely
rendered and spatially

vague imagery.[27] The poster's red background pushes the workers to the fore-
ground, whereas the fragment of a slogan pasted over the closest figure pulls
them back. Overall, this representation turns the workers into symbols of a pro-
ductive process rather than actual producers.

For *We Shall Repay the Coal Debt to the Country,* commemorating the thir-
teenth anniversary of the October Revolution, Klutsis showed coal miners as the
main force behind the building of a socialist society. Several preliminary designs
for this poster, executed over black-and-white photographs, demonstrate how
Klutsis made decisions about space and color.[28] In one design (pl. 13), Klutsis
colored the middle coal miner's outfit red and the two lateral figures blue and
retained all the parts of all the bodies; as a result, the figures appear tangible
and the space realistic. In another design, which became the prototype for the
final poster, the left and right coal miners were cropped and the color was elim-

96. *(opposite)* Gustav Klutsis, *We Shall Repay the Coal Debt to the Country,* 1930, 101.6 x
71.2 cm, lithograph. Private collection.

inated from all three costumes (pl. 14). In the final poster, the viewer encounters
coal miners as mighty images emerging from the vibrant red background and
marching down a staircase. Their bodies, together with other details, are distinctly
flattened, depriving the image of concreteness and endowing it with universality.

In the press coverage of the exhibition in Gorky Park, Klutsis and Sen'kin's
posters were praised as examples "that convince the viewer of the great poten-
tial of photomontage."[29] Soon after, however, Klutsis's posters were criticized for
their abstract and fragmentary nature. In 1931, the Central Committee of the
Communist Party publicly expressed its dissatisfaction with the activities of many
artistic organizations, including IZOGIZ, which was primarily responsible for the
commission of photomontage posters.[30] In response, the Communist Academy's
Institute of Literature, Art, and Linguistics organized a debate on the topic of the
political effectiveness of posters in general and of photomontage posters in par-
ticular. Klutsis, Sen'kin, Elkin, and Tagirov actively participated in these discus-
sions. Klutsis gave a lecture, "Photomontage as a Tool for Agitation and Propa-
ganda," based on his article. In this revised text, he continued to insist on the
distinction between photomontage's advertising and its political tendencies, but
intensified his argument against abstract art saying that "photomontage appeared
as the proletariat's counterattack against nonobjective art."[31] This polemical state-
ment, together with Klutsis's description of photomontage as a universal political
method used for mass propaganda by professionals and amateurs alike, clearly
shifted the mission of photomontage from the realm of the merely artistic to the
domain of overtly political. Klutsis's lecture is particularly notable for its affinity
with the views later expressed by Walter Benjamin in his 1936 essay "The Work
of Art in the Age of Mechanical Reproduction."[32] Like Benjamin, Klutsis under-
lined the primary importance of the photographic method in its ability to "use
photomechanical properties of a camera to create representation." "In this,"
Klutsis continued, "lies the principal difference between photomontage and oth-
er forms of art in which manual techniques are used to create representational
forms. . . . The industry of machines, which consistently replaces manual labor
with mechanization, penetrates the techniques of representational arts."[33] Both
Benjamin and Klutsis viewed photography as the first truly revolutionary means
of reproduction, aligning its dominant position with the rise of socialism and iden-
tifying the way it insistently gives ideological meaning to artistic production.

A number of photomontage practitioners, including Sen'kin and Elkin, re-
sponded directly to Klutsis's lecture. Sen'kin agreed with Klutsis's desire to politi-
cize photomontage and with his assertion that "we must fight for photomontage as

political art, which has nothing to do with dadaist mysticism and advertising."[34] Other speakers underscored Heartfield's importance and wanted to invite him to teach and exhibit in the Soviet Union.[35] In response, Klutsis claimed that "political photomontage as an ideological weapon of the attacking class made a decisive influence on the Communist press in Germany and, particularly, on Heartfield. He turned from a formalist, dadaist, and mystic to a prominent political artist-photomontagist."[36]

Critic N. Bekker's response to Klutsis's lecture was particularly important because he specifically challenged Klutsis's posters depicting the first Five-Year Plan. Bekker accused Klutsis of "deindividualizing a worker," claiming that a poster artist must differentiate between various types of workers because "there is no unified face of the proletariat." Bekker noted that Klutsis's posters do not designate "that we have old workers who used to be social-revolutionaries, Mensheviks; that we have workers who just recently came from a village. That is why the working class should not have one face, we must differentiate it."[37] Bekker specifically attacked *Male and Female Workers All to the Election of the Soviets* for showing only the process of voting and complained that "it looks as if we only vote but do not work."[38] This last remark echoed the earlier complaint that Rodchenko's *Pioneer with a Horn* made it seem as though "pioneers just blow horns." Bekker opposed the nonorganic qualities in photographic representation and objected to concrete narratives and actions being replaced with utopian symbols and connotations.

The particular use of slogans in Klutsis's posters and his adherence to what Bekker designated the "deindividualizing a worker" should be viewed in the context of the writing on language and ideologies published at the time by critics Mikhail Bakhtin and Vladimir Voloshinov. In his 1929 study *Marxism and the Philosophy of Language,* Voloshinov pointed out that "signs can arise only on *interindividual territory.* It is territory that cannot be called 'natural' in the direct sense of the word: signs do not arise between any two members of the species *Homo sapiens.* It is essential that the two individuals be *organized socially,* that they compose a group (a social unit); only then can the medium of signs take shape between them. The individual consciousness not only cannot be used to explain anything, but, on the contrary, is itself in need of explanation from the vantage point of the social, ideological medium."[39]

Whether directly or not, the views expressed in *Marxism and the Philosophy of Language* undoubtedly had an impact on the practitioners of such a key "ideological medium" as photomontage. In his major posters of 1929–31, Klutsis constructed what Voloshinov calls "interindividual territory" by grouping workers and

other individuals in close connection with each other and by fragmenting "natural" aspects of each composition, including bodies and other descriptive elements. The most striking example of this is Klutsis's poster *Speed Up the Tempo of Industrialization,* designed in 1930 for the sixteenth Party Congress (fig. 97). Here, two faces, one male and one female, loom over a smoky industrial landscape and gaze out at the viewer with smiles of contentment. The woman's face is placed behind the man's and partially merges into it, giving the impression of an androgynous or "interindividual" image.[40] For the same Party Congress, Klutsis worked out another model of "interindividuality," based not on the images of anonymous men and women, but on the recognizable portraits of Lenin and Stalin. In 1930 in *Under the Banner of Lenin for Socialist Construction* (fig. 98), Klutsis for the first time explores the relationship between Stalin and Lenin as political leaders competing for the dominant position in postrevolutionary Soviet society. In this composition, Stalin's head is largely obscured by that of Lenin, Klutsis's favorite leader.

The difference between the slogans used in the final versions of these two posters and those Klutsis used in the preliminary designs attests to Voloshinov's argument that in Marxism the word is "an essential ingredient accompanying all ideological creativity."[41] Apparently, the long meetings of the IZOGIZ were often dominated by arguments over the precise choice of verbal messages.[42] The replacement of "The Plan for Socialist Attack" by "Under the Banner of Lenin for Socialist Construction" and the substitution of "We Will Build Our Own World" for "Speed Up the Tempo

97. Gustav Klutsis, Design for *Speed Up the Tempo of Industrialization,* 1930, 26.5 x 17.9 cm, vintage gelatin silver print. Private collection.

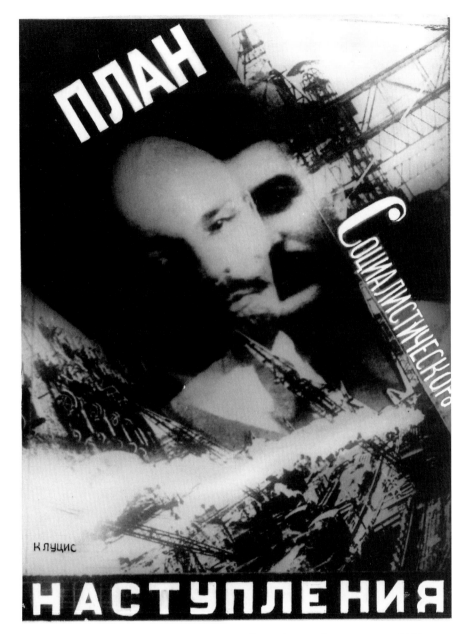

98. Gustav Klutsis, Design for *Under the Banner of Lenin for Socialist Construction*, 1930,
97 x 71 cm, vintage gelatin silver print. Private collection.

of Industrialization" in Klutsis's posters demonstrates the increasing governmental
control over language and the shift from daring revolutionary slogans to predeter-
mined and repetitive bureaucratic postulates.[43]

As with straight photography, the more active involvement of political institu-

tions in official debates about the uses of photomontage began to influence the artists' choice of themes and compositions. Klutsis's initial response to this pressure can be detected in *We Shall Provide Millions of Qualified Workers* (pl. 15), one of his last posters fully dedicated to the representation of anonymous workers. In contrast to his major works of 1930, this 1931 poster employs a vastly expanded space. A long line of male and female miners recede into a deep background populated by a carefully rendered landscape of factory buildings. Klutsis has discarded his interest in the "deindividualization" of a worker and presents the diverse faces of the proletariat. The composition lacks many of Klutsis's familiar photomontage techniques—including fragmentation, overt diagonals, exaggerated and disembodied details, and flattened spaces—though these are still present in a preliminary photomontage for the poster (pl. 16). As a result, the nonorganic and fragmentary nature of *We Shall Repay Coal Debt to the Country* or *In the Storm of the Third Year* is replaced by "a living picture of totality." The spectator's experience of the process of construction is replaced by a coherent visualization of a more "finished project." Thus, in Klutsis's work, the entire conflict between nonorganic and totalizing imagery was eventually played out.

As a result of the government's need to promote and document the progress of Stalin's ambitious projects, experimental photographic reportage flourished during the period of the first Five-Year Plan. This revitalized the mass media and created many opportunities for experiments and the broad expansion of avant-garde ideas. The status attained by photography and photomontage between 1928 and 1932 was comparable only with that of painting and graphic arts in the brief period immediately following the Revolution. At both times, artists had special opportunities to conduct extensive experiments thanks to the government's desire to use their skills in promoting its sociopolitical message and to temporarily disregard the formal methods employed in such work. When the first Five-Year Plan was completed in 1932, one year ahead of schedule, the government's attention to cultural affairs intensified and the nature of the mass-media photographic image began to change. These new circumstances brought about entirely new photographic practices and initiated the next and final phase in the history of the photographic avant-garde in the Soviet Union.

The Restructuring
of a
Photographer

Although visibly fragmented in the years between Lenin's death and the end of the first Five-Year Plan, the Soviet cultural world began to acquire an artificial sense of unity by the beginning of the second Five-Year Plan in 1933. A year earlier, in 1932, the Central Committee of the Communist Party had issued its Decree on the Reconstruction of Literary and Artistic Organizations, which had dissolved many art groups and institutions and had begun to advocate the principles of socialist realism. These developments drastically reduced the possible affiliations for artists and forced many diverse practitioners on to a common ground. In 1936, a year before the completion of the second Five-Year Plan, a special committee was authorized to take charge of all cultural affairs. This brought to a final halt any deviations from the agenda of socialist realism. Thus, the period between 1932 and 1936 constituted the final stage of the Soviet photographic avant-garde, a phase that has remained the least studied and the most controversial.

According to art historian Benjamin Buchloh, "By 1931 the goals of facto-
graphy [in the Soviet Union] had clearly been abandoned."[1] I would argue that
it was not until 1932 that factography (as well as the use of fragmentary photo-
graphic imagery in the work of Rodchenko, Lissitzky, Klutsis, and others) began
to be replaced by Stalinist or mythographic imagery and more organic composi-
tions. Although this insistence on a more precise chronology may seem insignifi-
cant, in fact, it is critical to any understanding of the nature of this formal transi-
tion, making clear that it was in no way abrupt and was motivated by a complex
series of cultural and political events.

The main preoccupation of artists such as Klutsis, Lissitzky, and Rodchenko, in
the last years of their careers (Klutsis was shot in 1938, Lissitzky died in 1941,
and Rodchenko was gradually pushed to the background of Soviet cultural activi-
ties) was their work for IZOGIZ. In 1932, Lissitzky was hired by IZOGIZ as a de-
signer for the magazine *SSSR na stroike* (USSR in Construction). Rodchenko also
signed on with IZOGIZ as its Moscow photo correspondent. And Klutsis, follow-
ing his participation in the exhibition *Posters at the Service of the Five-Year Plan*,
went to work for the IZOGIZ poster department.

The ambitious goal of the IZOGIZ magazine *USSR in Construction* was to pro-
vide propaganda that would reach well beyond the borders of the Soviet Union.[2]
Having successfully completed the first Five-Year Plan, Stalin wanted to provide the
West with a positive view of Soviet life and to counteract possible misrepresenta-
tions propagated by his enemies. In the introduction to the first issue, the editorial
board, which included such highly respected people as the socialist realist writer
Maxim Gorky, remarked that "in order to deprive our enemies inside and outside
the Soviet Union of the opportunity to distort and discredit the testimony of words
and numbers, we decided to turn to *svetopis'* (writing by light) to the work of the
sun—to photography."[3] The editorial board of *USSR in Construction* sought the ac-
tive involvement of key mass-media designers like Lissitzky and Rodchenko and
of such writers as Tret'iakov and Eduard Tisse. The journal developed a thematic
focus starting with the third issue, and shortly thereafter single photographs with
short inscriptions were replaced by long photo-essays. In describing *USSR in Con-
struction*, Mezhericher, who in 1934 defined the magazine as one that "made
the Soviet Union justly proud," commented on these compositional changes:

> [*USSR in Construction*] was founded to popularlize industrialization by means of photo-
> graphy. But along with the growth and development of the magazine, the task of popu-
> larization has grown into that of an ecstatic artistic reflection of socialist reality. Friends
> of the magazine who have watched over it since 1930 have seen how, over time, the

form and function of a photographic snapshot itself have changed. At first [the magazine], which attempted to be simply a documentary, inspired just criticism. . . . Then in an attempt to be more expressive and to reflect the grand scales and tense tempo of construction, the snapshot began to grow and acquire a compositional force.[4]

Mezhericher observed that *USSR in Construction* offered a new type of photographic representation, which he called "monumental artistic photography."[5] This phrase accurately describes the new style in photography in the early 1930s that was born of the shift from factographic to mythographic representation.

The images in *USSR in Construction* consisted of photographs of industrial sites, collective farms, and other areas of vast production. Unlike *Let's Give, 30 Days,* and other popular magazines of the late 1920s, in which documentary photo-stills were generally printed in the form they were submitted by the photographers, in *USSR in Construction* the photographs were regarded as raw material to be manipulated and connected by a chief designer such as Lissitzky or Rodchenko. By combining the works of many diverse photographers in one issue, on one page, or sometimes even in a single photomontage, the magazine downplayed individual authorship and succeeded in erasing the differences between the methods defended by various practitioners of photography before 1932. By foregrounding a unified artistic spirit, the magazine fulfilled the government's desire to use previously antagonistic photographers to demonstrate the ideology of totality.

Lissitzky, who continued to work on *USSR in Construction* "even when his illness made [him] lie in bed,"[6] was instrumental in shaping the magazine's graphic image.[7] He later wrote: "I devoted myself fully to the magazine. The word *design* does not convey the full creative substance of our work. I dare say that the work on the 'character' of certain magazine issues, such as 'Cheluskintsy' or 'Constitution of the USSR' and others, was no less intense than on a painting. The public resonance was no less wide."[8] Lissitzky's description of Dziga Vertov's film *Three Songs of Lenin* (1934) echoes his own representational strategy for *USSR in Construction*. Lissitzky wrote, "With the strength of a deep love for our days, actions, class, party, leaders, and masses, many separate, very simple moments and facts have been collected. And with great artistic feeling [they have been] woven into an affecting sonata. Here, everything—poetry, plastic form, musical theme, human voice, time, and space—has been brought into harmony."[9] According to Vertov's own 1936 account of this film, he had "succeeded . . . in making [the film] accessible, comprehensible to millions of spectators. But it was not done . . . at the cost of rejecting processes used in the past. What matters above all is the unity of form and content. It is not permissible to trouble the audience with some trick or

process that does not flow naturally from the content and that is not demanded by circumstances."[10]

Like Vertov, Lissitzky believed that in producing designs for *USSR in Construction* he did not betray the methods of representation that he had practiced earlier. In fact, in his autobiographical notes, he makes no distinction between the importance of his early avant-garde work and his late work for propagandistic publications. In this later production, Lissitzky began to use straight photography and photomontage, less as a means to pinpoint discontinuities of visual language than to promote an ideology of unity. By creating what he called "synthetic compositions," Lissitzky sought to "give an idea about what Soviet power and the Communist Party created for twenty years."[11] By this time, Lissitzky had withdrawn from fieldwork (partially because of his bad health), but he used the work of other photographers to construct photomontage layouts. Once again, however, the technique of photomontage was shifted from its avant-garde function of fragmenting and deframing to the new purposes of synthesizing and totalizing.

The structural and iconographic changes occurring at the time in mass-media representations entailed a broader shift in the status of the author-as-producer. This situation is detectable from Lissitzky's use of the image of a hand in several issues. In the issue dedicated to the Soviet Arctic, one page shows a photograph of a hand writing a telegram to "the heroes of the Arctic" (fig. 99). The telegram is signed "Maxim Gorky." In this case, the function of the author's hand is quite different from that of the modernist engineer represented in Lissitzky's early self-portrait, *The Constructor* (fig. 46). This hand is also unlike that of the Benjaminian author-as-producer who sides with the proletariat, as in Lissitzky's cover design for the periodical *Artists' Brigade* (fig. 7). Instead, Gorky's hand stands for a new model of the instructive author, one who sides with the proletariat not by participating in production activities but by affirming the deeds of the proletariat from a distance.[12] In another montage produced for *USSR in Construction* , Lissitzky shows Stalin standing atop Lenin's mausoleum and waving to the masses (fig. 100).[13] This time, the hand of the instructive author is replaced by the hand of a leader, who presents himself as the ultimate author of the social system.[14]

Lissitzky considered the design of the 1937 "constitutional" issue of *USSR in Construction,* which was dedicated to Stalin's constitution of 1936, of great importance (pl. 17). In this issue, every aspect of the subject matter conveys the spirit of unification, which refers mainly to the new union of the Soviet socialist republics.[15] Using a great variety of ready-made photographs, Lissitzky created each double-page spread of this issue as if it were a theatrical stage, with por-

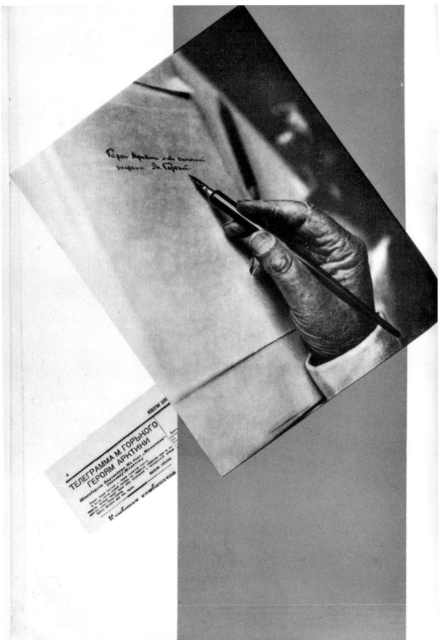

99. *USSR in Construction*, 1933, no. 9, El Lissitzky designer. Productive Arts, Brooklyn Heights, Ohio.

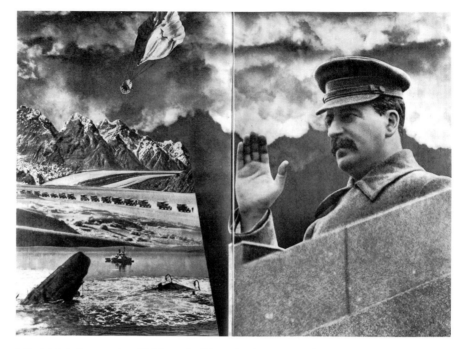

100. *USSR in Construction,* 1934, no. 2, El Lissitzky designer. Productive Arts, Brooklyn Heights, Ohio.

traits of Stalin, his *apparatchiks,* colossal workers, heroic navigators, exuberant athletes, happy mothers, and children set amid the grandiose imagery of industry, modern cities, lavish agriculture, and newly erected monuments (figs. 101-104). This stage, however, is not for Brechtian theater, which "requires the viewer to constantly ask himself or herself questions, to doubt the assurance of his or her apprehension of the real."[16] Rather, these compositions return us to the version of the theater as "an opiate, seducing its public" by presenting it with a single and nonconflictual model of reality.

Lissitzky extended these compositional choices in his design of the main pavilion of the All-Union Agricultural Exhibition (VSKhV) that opened in Moscow in August 1939 (fig. 105). Although he was first assigned the job of chief artist for the VSKhV in 1934, in 1937 Lissitzky signed a contract to design only the main pavilion.[17] In his notes for the project, he refers to the photomontages in the "constitutional" issue of *USSR in Construction* as possible prototypes for the mural paintings and a painted frieze he planned for the walls of the pavilion. He writes, "At the front of the hall, to the right and left, are two [exhibition] stands that address the subject of land. . . . One stand has a painting in the middle that is

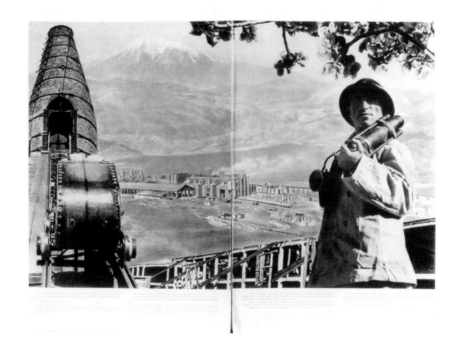

101. *USSR in Construction,* 1937, nos. 9–12, El Lissitzky designer. Productive Arts, Brooklyn Heights, Ohio.

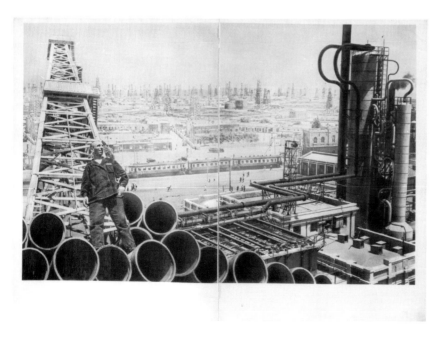

102. *USSR in Construction,* 1937, nos. 9–12, El Lissitzky designer. Productive Arts, Brooklyn Heights, Ohio.

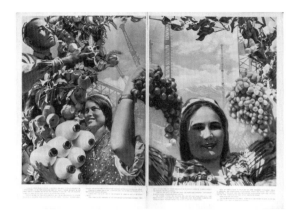

103. *USSR in Construction,* 1937, nos. 9–12, El Lissitzky designer. Productive Arts, Brooklyn Heights, Ohio.

based on my montage in the anniversary [constitutional] issue of *USSR in Construction,* with only the addition of a banner with Stalin's portrait."[18] The frieze depicting the peoples of the Soviet Union and the fruits of their labor was planned to cover the whole central hall. Lissitzky's decision to execute this frieze in painting reflects the conflicted status of photography at this time. In his notes, Lissitzky first stipulates that his frieze should be painted. But this suggestion is then crossed out, apparently indicating a reluctance on his part to relinquish photomontage as the main technique in his exhibition designs.[19] This substitution of photomontage by painting in exhibition designs as well as the color reproductions of socialist realist paintings that began to appear in photographic magazines such as *USSR in Construction,* marked the return of the cult of painting and the end of photography's primacy among Soviet visual representations.[20] But even more significant are the notes in which Lissitzky describes the main pavilion of the All-Union Agricultural Exhibition, for here we find further illustration of his advancing from factographic practice to "synthetic compositions" that endorsed Stalin's vision of reality.[21] Lissitzky writes, "Taking into consideration the special political significance of the main pavilion, I aimed to avoid small didactic forms [this type of photomontage had formed the base for the Pressa designs] and instead [tried] to find something that would resonate with the achievements of our epoch of

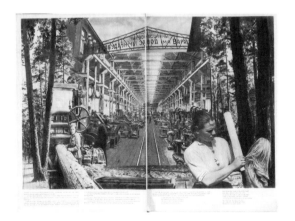

104. *USSR in Construction,* 1937, nos. 9–12, El Lissitzky designer. Productive Arts, Brooklyn Heights, Ohio.

socialist construction, a clear, comprehensible to all, monumental form."[22] Although in this late period of his career Lissitzky still spoke about the importance of form and "formal search," at this point he tended to "endow form with the substance of form."[23]

It is difficult to explain the continuous change in Lissitzky's work. How does one move from the minimalist designer of the *Abstract Cabinet* in 1926-27, to the photomontage exhibition designer of Pressa in 1928, to the socialist realist designer of the All-Union Agricultural Exhibition pavilions of 1939?[24] Perhaps we find a partial answer to his "numerous identities" in a statement Lissitzky made shortly before his death in 1941: "Our generation accepted the task of working for a commission, but the experience has shown that a serious work of art can be created only if one gives oneself a task (an internal social commission)."[25] In this view, the apparent stylistic discontinuity in Lissitzky's career can be explained by his persistent commitment to what he called an "internal social commission." In other words, Lissitzky's dedication to the development of form had less to do with invention or formalism per se than with his desire to use existing forms to achieve their fullest social application. To fulfill this notion of an "internal social commission," Lissitzky committed himself to many forms of expression, accepting contracts for exhibition planning, for designing magazines and photo albums, and for making posters. As far as his employer, the Soviet government, was concerned, Lissitzky was a political asset. In 1928 he was appointed to design Pressa because the government believed that

105. El Lissitzky, *Design for the All-Union Agricultural Exhibition*, 1935–38, tracing paper, graphite and color pencil. Tret'iakov Gallery, Moscow.

his fame in the West would ensure the positive reception of Soviet propaganda material. A decade later, the Soviet cultural establishment continued to entrust Lissitzky with ambitious projects, such as *USSR in Construction* or the All-Union Agricultural Exhibition, with the conviction that as long as the pro-Communist international community knew that such artists as Lissitzky were safe and employed it would not believe "the rumors" about Stalin's ferocious purges.[26]

In an essay published in 1936, Rodchenko sought to explain his own transformation from a radical leader of the October group to IZOGIZ's official photo correspondent. He wrote, "After the attacks on my [photograph] *Pioneer,* the October Association expelled me in an attempt to disassociate itself from formalism. The leadership passed to Boris Ignatovich who failed in every possible sense, and the group fell apart. To cure myself of easel painting, aesthetics, and abstraction, I plunged into photo-reportage—photographing sports events was the most difficult."[27] At the time, the Soviet cultural establishment was desperate for skilled mass-media designers and was willing to overlook Rodchenko's close association with formalism in order to enlist him as a photo correspondent. His price for this new commission was a swift reconciliation with photographers who, just a short time before, had been openly antagonistic toward him. Rodchenko's effort to create an amiable atmosphere during the collaboration between the photographers participating in the magazine's design is reflected in Lavrentiev's description of various meetings. "In Rodchenko's studio," he writes, "there was an active center for creative photography in action. Here, the photographic excursions of Petrusov, Khalip, Prekhner, Ignatovich, and other Soviet photographers were planned. Here, their works for the magazine were accepted."[28] Like Lissitzky, Rodchenko designed his issues of *USSR in Construction* using primarily photographs supplied by the many participating photographers. The issue dedicated to the construction of the White Sea Canal (no. 12, 1933) is an exception in that it includes only Rodchenko's own photographs.

Regarding Rodchenko's journey to the White Sea Canal construction site, Lavrentiev writes, "In 1933, A. M. Rodchenko returned from a creatively successful trip to the White Sea Canal where he took more than three thousand shots with a Leica."[29] Lavrentiev's tendency to present Rodchenko's photographing of the White Sea Canal as primarily an aesthetic undertaking conflicts with Rodchenko's own perception of this project. "Gigantic will brought the outcasts from the past here to the canal. And this will was able to inspire enthusiasm in the people that I did not see in Moscow. . . . I was lost and amazed. I was taken by this enthusiasm. I forgot about all my creative upsets. I was simply photographing. I did not

think about formalism. I was shocked by the sensitivity and wisdom that had been brought to bear in reeducating people."[30] Rodchenko's spirited description of life at the canal site matched the remarks of prisoners themselves that were published in the same issue of *USSR in Construction*. They praised the Soviet system for transforming them from senseless criminals into productive workers. Their morality tales, recounting the changes in their character and lifestyles, were illustrated by juxtaposing photographs of drunks and prostitutes with the images of constructors and caretakers.[31] The presence of political leaders on the first and last pages of the magazine prevented the reader from missing the ideological implications of the construction project and its representation. At the beginning of the magazine is a portrait of Stalin for whom the canal was named. He presides over the vast waters of the White Sea (fig. 106). At the end, Stalin reappears in the company of Sergei Kirov, Kliment Voroshilov, and other *apparatchiks,* who, by means of photomontage, are placed on a shipping lock (pl. 18). Stalin holds binoculars and looks forward to a future beyond the photo-still's frame.

Unlike Lissitzky, who rejected modernist photographic practice in the "consti-tutional" issue of *USSR in Construction,* Rodchenko only partially abandoned the methodology of formalist photography in the White Sea Canal issue. Lavrentiev notes that in the photograph depicting barges entering a shipping lock (fig. 107), Rodchenko used "two prints made from one negative" and that he "only slightly departed from symmetry by adding several figures of the builders near one of the ranges."[32] In a number of other images in this issue, Rodchenko remained loyal to the spirit of experimentation and retained his familiar formalist devices, such as fragmentation, close-ups, (pl. 19) sharp diagonals, and slanting compositions (fig. 108). Some photographs are virtually deserted and focus on the canal's locks as simply a subject of photographic experimentation, without any reference to a specific place and time (fig. 109). Rodchenko's depiction of life at the canal con-struction site seems at first to represent a nonconflictual reality, in which all energy is trained on the fight against nature. At first glance, there are no signs of forced labor. On closer inspection, however, one notices the omnipresent guards main-taining strict control over the canal's construction (fig. 110).

Given IZOGIZ's zealous censors, it is unlikely that Rodchenko was completely free to sort the three thousand photographs from his trip to the canal exactly as he wished. As a result, the White Sea Canal issue shows only fragments of the reality of life at the canal site. Fragmentation, in this case, was not a deliberate attempt to fracture a too-conventional comprehensive picture of reality, as with the October photography. Nor was the concept of unified reality that was promoted achieved

БЕЛОМОРСКО - БАЛТИЙСКИЙ КАНАЛ

ИМЕНИ ТОВ. СТАЛИНА

БЕЛОМОРСТРОЙ РОЖДЕН ПО ВОЛЕ ПАРТИИ, ПО ИНИЦИАТИВЕ
ЕЕ ВОЖДЯ, ВОЖДЯ ВСЕХ ТРУДЯЩИХСЯ – ТОВАРИЩА СТАЛИНА

106. *USSR in Construction,* 1933, no. 12, Aleksandr
Rodchenko designer and photographer. Productive Arts,
Brooklyn Heights, Ohio.

by including all possible factographic details, as with ROPF's production. Rather, both positions were replaced by an officially endorsed method of fragmenting the facts, providing only a partial view of reality and omitting unwanted photographic images.

Rodchenko and Stepanova collaborated to design a number of issues of *USSR in Construction.*[33] In the issue dedicated to the "brave Soviet parachutists," the two artists introduce a circular design as the basis for their page layout. This allows them to freely accommodate a variety of scenes from the parachutists' everyday activities as well as various political messages. On one page, a portrait of Stalin is surrounded by half a circle, which in turn is superimposed over a triangle-shaped image of clouds with numerous parachutes floating down (pl. 20). Stalin looks up and romantically observes the scene. In another collaborative issue dedicated to the Soviet timber industry (pl. 21), Rodchenko and Stepanova also use a circular format, combining descriptive scenes with the close-ups of piles of lumber. As in Rodchenko's earlier series on the same subject, here the viewer's attention is more often drawn to the textures of the wooden boards than to the activities surrounding their production. But, unlike those earlier fractured images, here the repeated addition of the circles helps the viewer grasp the meaning of the design. These circles carefully record the symbols of Soviet power, such as official buildings, the Soviet flag, a train displaying the state emblem (fig. 111). In Rodchenko's work for *USSR in Construction,* the often strained combination of conventional photomontage and inventive structural principles testifies to the

ongoing struggle over representation in Soviet photography, a dispute over whether Soviet life should be depicted as a series of disconnected spontaneous facts or as a carefully controlled and heroic unity.

Rodchenko's career as a photographer culminated in his participation in the 1935 *Exhibition of Works by the Masters of Soviet Photo Art* (fig. 112) and in the widely publicized discussions on the status of photographic practice that ensued. This exhibition, which was held in Moscow at Vsekokhudozhnik on Kuznetskii most, was the last one to include avant-garde photography and to downplay portraits of political leaders. Each participant was asked to submit twenty photographs, which were then judged by a committee of critics, photographers, and filmmakers, including Mezhericher, Arkadii Shterenberg, Fridliand, Rodchenko, and Eisenstein. All together four hundred photographs were selected. Previously, avant-garde photographers had tended to manifest their stylistic and ideological diversity by breaking into groups, but this exhibition (like *USSR in Construction*) was notable for its spirit of unification. Former members of the October Association, such as Rodchenko and Langman, were exhibited alongside ROPF's mem-

107. *USSR in Construction*, 1933, no. 12, Aleksandr Rodchenko designer and photographer. Productive Arts, Brooklyn Heights, Ohio.

108. *USSR in Construction,* 1933, no. 12, Aleksandr Rodchenko designer and photographer.
Productive Arts, Brooklyn Heights, Ohio.

109. (above) *USSR in Construction,* 1933, no. 12, Aleksandr Rodchenko designer and photographer. Productive Arts, Brooklyn Heights, Ohio.

110. *USSR in Construction,* 1933, no. 12, Aleksandr Rodchenko designer and photographer. Productive Arts, Brooklyn Heights, Ohio.

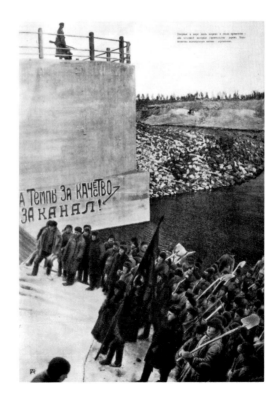

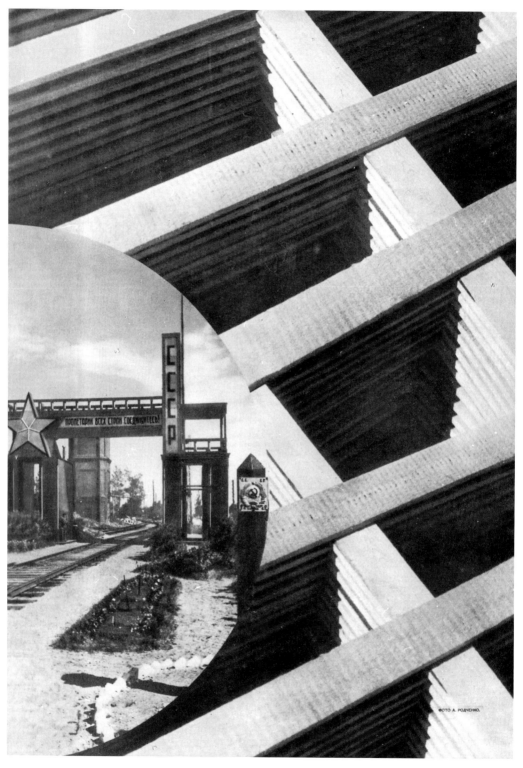

111. *USSR in Construction*, 1936, no. 8, Aleksandr Rodchenko and Varvara Stepanova designers. Productive Arts, Brooklyn Heights, Ohio.

bers, including Fridliand, Shaikhet, and Al'pert. The unsigned introduction to the catalogue (most likely written by its editors Mezhericher, G. Boltianskii, and M. Grinberg) criticized factography for its "documentary impartiality and mechanical, indifferent, and 'chronicle-like' fixation of facts." Virtually ignoring the major photographic debates of the 1920s, which concerned photography's separation from the principles of easel painting, the catalogue defended the type of photography that possessed the qualities of painting and encouraged new photo-reportage based on "expressive, artistic form." Finally, it called for a merger between the old pictorial school and the new tendencies in photography in order to have "a Soviet photographic art that is unified, growing, and rich with perspectives."[34]

Despite this provocative slant toward pictorialism and synthetic expressiveness, the exhibition displayed a number of overtly formalist images. Among these were Langman's visually complex *Skating Rink*, 1935 (fig. 113), his severely tilted snapshot of a collective farm field, 1935 (fig. 114), and his portrait titled *Comrade Ordzhonikidze at the Inauguration of Kramatorskii Plant*, 1934 (fig. 115). The last is especially surprising since it uses a radical composition to portray a bureaucrat. Sergo Ordzhonikidze, the People's Commissar of Heavy Industry, is viewed from below, apparently giving a public speech. But only the microphone before him betrays this fact; no rapt audience members are shown. Above him hang the typical Party banners, but their slogans are so obscured and fragmented that the ideological meaning can be only partially deciphered.

The inclusion in this exhibition of Langman's images as well as Rodchenko's *Pioneer Girl* (which had been widely criticized for its formalism in 1931) provided a clear demonstration of the Party's desire to subdue adversary moods, at least among those photographers who they needed to direct the new project of socialist

realism. Rodchenko himself was surprised by this inconsistency and attempted to explain why he felt he had been attacked in the press in 1931: "It was advantageous to involve me provocatively in the 'debate' in order to obtain material for scolding the left formalists. . . . But does the party want this, and should we have

112. *Exhibition of Works by the Masters of Soviet Photo Art*, 1935. Photograph, Aleksandr Rodchenko. Alex Lachmann Galerie, Cologne.

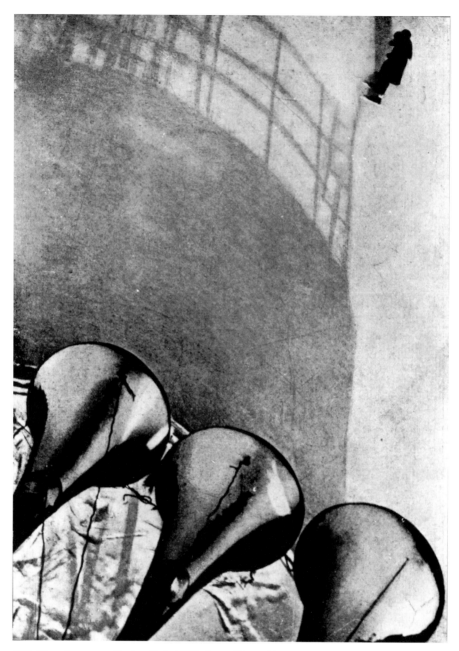

113. Elizar Langman, *Skating Rink*, 1935. Soviet Photo, Moscow.

such relationships between critics, magazine staff, and photographers?"[35] At least two conclusions can be drawn from Rodchenko's speculation and the presence of formalist photography in the exhibition of 1935. First, the general public and most artists (including Rodchenko) believed that the cultural conflicts of the period were

114. (above) Elizar Langman, *Collective Farm Field,* 1935. Soviet Photo, Moscow.

115. Elizar Langman, *Comrade Ordzhonikidze at the Inauguration of Kramatorskii Plant,* 1934, photograph. Soviet Photo, Moscow.

ЛАНГМАН Е. М. ◆ т. Орджоникидзе на пуске *Краматорск.* з-за

generated by various artistic factions rather than by Party policies. Second, the surprising willingness of the Party to tolerate formalist works as late as 1935 indicated that the struggle—hitherto on the level of aesthetics—had now shifted to a political project whose aim was to simulate, at any cost, an atmosphere of creative unanimity. Hence, what was exhibited in 1935 was less important than the status of the artist in relation to the Party's political interests.[36]

Rodchenko's *A Jump into Water,* 1934 (fig. 116), and *Make Way for Women,* 1934 (fig. 117), both included in the 1935 exhibition, demonstrate how he had begun to depart from his characteristic formal devices. In *A Jump into Water,* one of the three images with this title, the curled body of a swimmer is caught high in the arc of a dive. Although the diver occupies the upper right of the photograph, Rodchenko has refrained from actually placing him in the corner. Clouds cover the bottom of the photograph. A less known version of this image reveals that Rodchenko was contemplating a different composition (fig. 118). In this version, Rodchenko kept only enough of the clouds to fill up the lower left corner, and he placed the diver diagonally opposite the clouds, in the upper right corner. Through this formal device, Rodchenko established a distinct upward direction, completely ignoring the reality of the body descending downward, toward the swimming pool. As in his earlier photographs, in this version of *A Jump into Water,* Rodchenko turned a concrete event into a picture of utopian aspiration. His *Make Way for Women* records a line of young females in tank tops and shirts walking between two rows of similarly dressed men. The composition is notable among Rodchenko's photographs because it depicts the sporting event from a conventional point of view. But, even more, it records Rodchenko's response to the criticism that his images of pioneers always looked upward. Here, the female athletes stride boldly forward.

Ignatovich, who refused to participate in the exhibition because he disagreed with the selection of the participants, strongly criticized the artificial atmosphere of unanimity. In *Soviet Photo,* he asked, "How did it happen that our rich, multi-layered Soviet photo-reportage, which only recently had gone through the period of hot creative debates and fights, suddenly lost face at this exhibition and appeared in form and content as anemic and insipid." Ignatovich complained that the committee was crippled by its clear favoritism toward the "so-called artists," which prevented it from providing "a proper display of the left wing of Soviet photo-reportage."[37] He also noted that there were many old photographs and

116. Aleksandr Rodchenko, *A Jump into Water,* 1934, photograph. Soviet Photo, Moscow.

117. Aleksandr Rodchenko, *Make Way for Women,* 1934, photograph. Soviet Photo, Moscow.

few recent ones in the exhibition and that the participants were mainly distinguished older photographers rather than young beginners. Ignatovich attacked Rodchenko specifically: "Even old 'lef' Rodchenko gave up and exhibited his tastelessly painted *Rumba* and a sweet winter landscape" (fig. 119).[38] Ignatovich's open criticism of such officially sanctioned events as the *Exhibition of Works by the Masters of Soviet Photo Art* attests to the fact that in 1935 it was still possible both to exhibit formalist photography and to express overtly controversial opinions about it in public.

Ignatovich's own production from this period was still based on a serial approach he had developed in the late 1920s for his reportage *Let's Give.* In his late series, such as *Photo-Essay about the Shoe Factory "Parizhskaia Kommuna,"* 1934, and *Searchlight Plant "Frezer,"* 1935, he introduced substantial changes in his compositional devices, however. The shoe factory series begins with a discernible image of the plant's headquarters, showing both its buildings and industrial paraphernalia (fig. 120). Inside the shops, men and women are captured sitting close to each other, operating sewing machines to turn piles of leather into shoes (fig. 121). Unlike Ignatovich's earlier recordings of labor in which the working process and the workers were substantially concealed for the sake of creating a puzzling space for the viewer, here the photographer offers a mundane picture of shoe production with a meticulous documentation of the producer

and the produced. The *Searchlight Plant "Frezer"* series further advances this tendency toward clearer and more readable compositions. Here, every formalist technique (such as close-ups or diagonals) is eliminated and strictly conventional angles are employed. In well-designated spaces, workers complete projects in close communication with each other, establishing a sharp contrast with the earlier alienating and fragmented depictions of Soviet workplaces (fig. 122). Ignatovich's two series set a precedent for all future Soviet reportage.

118. Aleksandr Rodchenko, *A Jump into Water*, 1934, photograph. Soviet Photo, Moscow.

119. Aleksandr Rodchenko, *Rumba,* 1935, photograph.
Soviet Photo, Moscow.

120. Boris Ignatovich, *Photo-Essay about the Shoe Factory "Parizhskaia Kommuna,"* 1934, photograph. Soviet Photo, Moscow.

121. Boris Ignatovich, *Photo-Essay about the Shoe Factory "Parizhskaia Kommuna,"* 1934, photograph. Soviet Photo, Moscow.

Following the 1935 exhibition, a public discussion, "About Formalism and Naturalism in Photo Art," was held. This discussion is significant as the last public event in the history of Soviet avant-garde photography in which the content was not entirely submerged under ideologically charged rhetoric. The official press noted that "each [photographer] described his own creative searchings and mistakes and then, with sincerity and honesty, admitted the failings of his colleagues and criticized their mistakes."[39] Langman, Khalip, Fridliand, Al'pert, and Rodchenko participated in the discussion. Rodchenko played the role of the mentor compelled to criticize the "mistakes" of Shaikhet, Fridliand, Al'pert, Langman, and his former friend Ignatovich. Other participants charged Rodchenko with formalism. As a result of this debate, Rodchenko wrote his last important text, "The Restructuring of an Artist."

As the title of the discussion suggests, formalism and naturalism were the major topics, with specific attention given to the question of "surpassing the elements of formalism and naturalism in photography [and to] the struggle for socialist realism."[40] Rodchenko was praised for his departure from the "narrow formalist principles of work" and commended for his photographs of the White Sea Canal construction, which, according to the critic Sergei Morozov, demonstrated that he "voted for realism." However, in Morozov's opinion, Rodchenko was still defending factography and "displayed a sarcastic attitude toward photographic material organized in advance (as if 'staged')." In spite of this criticism, however,

122. Boris Ignatovich, *Searchlight Plant "Frezer,"* 1935, photograph. Soviet Photo, Moscow.

Morozov attempted to justify various formalist methods still found in Rodchenko's and Langman's photography. For example, he supported Langman's close-up and tilted representation of the plowed earth, from the series Langman made during a trip to Kazakhstan, by asserting that "the land is a very socially meaningful object" and "this snapshot, unlike many similar ones, shows an exemplary treatment of the land."[41] Photographs from Langman's series *Kazakhstan* (fig. 123) were also praised in *Soviet Photo*: "Comrade Langman's Kazakhstan photographs . . . prove that he is successfully traversing the paths of socialist realism. [And, although he still uses] his familiar formal methods, such as exaggerated *fakturness* [attention to surface] and distorted compositional proportions . . . his use of these devices is not unjustified." In other words, *Soviet Photo* suggested that formalist methods might be applied as long as the photographer remained "against fetishism of methods, against submission of content and subject matter to them."[42] Mezhericher's analysis of Rodchenko's photograph *Jump on a Horse*, 1936 (fig. 124), similarly illustrates how this critic redefined formalist methods.

> I cannot say that [Rodchenko] is fully freed from the formalist remnants. Among the works that were hung here during the first days of the discussion, there are two in which we see Rodchenko's sharp and characteristic methods of composing a still; but at the same time, we cannot really classify these works as formalist. One of them shows a jump over the barrier. If we look closely at the photograph, we can see that it is significantly tilted; but this is not a trick but a technique brought about by a need to strengthen and to underline the elasticity of the horse's movement over the obstacle. . . . The technique can and must be sharp, but in each case it must be subordinate to the content and raise its impact.[43]

Morozov, Mezhericher, and the editors of *Soviet Photo* all recognized that, in Rodchenko and Langman's late photographs, formalist techniques did not yield the same results in 1935 as they had in the late 1920s and early 1930s. Earlier, both photographers had striven for a sort of "zero degree" or "neutral mode" of photography in order to disintegrate bourgeois consciousness.[44] Now, the reductive elements of the formalist method had become mere ornaments for the embellishment of the new socialist realist content.

The second half of the discussion was dedicated to analyzing the naturalist method, which was defined as "a preoccupation with the biological side of the phenomenon at the expense of its social content."[45] According to Morozov, "Naturalism and formalism often interweave in photography," and hence, "naturalist characteristics may be found in the work of Shaikhet and Al'pert as well as in that of Rodchenko and Ignatovich. The most widespread sign of naturalism is

Е. Лангман Ударница хлопка тов. Асылбаева из Пахта-Арала

123. *(left and below)* Elizar Langman,
Kazakhstan, Soviet Photo, 1935, no.
10. Productive Arts, Brooklyn Heights,
Ohio.

Е. Лангман Один из лучших ударников тов. Имамбаев в гостях у знатного человека
Караганды тов. Кузиштабаева

the reduction of the whole meaning in a snapshot to details." As an example, he refers to a third version of *A Jump into Water* (fig. 125), which was shown at the 1935 exhibition. Morozov mentions that this photograph was criticized for "having in the foreground the striking detail of legs covered by extensive hair and with bent toes." Rodchenko responded ironically that his swimmer was not "a ballerina and thus his legs are not shaved." This led to Morozov's retort: "In the depictions of swimmers or instructors of Soviet sport the reader wants to see a beautiful trained body. In Rodchenko's photograph, the character is killed by biological detail."[46] Such objections to detail were understandable since specificity stood in direct confrontation with the official goal, namely, to concentrate on the representation of the total, idealized image of Soviet man. If one does not retouch the hairy legs of a swimmer, then in every official portrait of Stalin one must also leave unconcealed his chicken-pox scars. Naturalistic representations were also dangerous for the viewer because they might initiate "undesirable" emotions, particularly erotic ones.

In the discussion "About Formalism and Naturalism in Photo Art," the notion of the "photo-picture" was given precedence over that of the "photo-still." The socialist realist version of the photo-picture had little to do with the way it had been defined by ROPF members in 1931, however. In fact, ROPF's understanding of the implementation of photography in the context of the all-inclusive narrative was criticized in this discussion. The former formalist critic Il'ia Sosfenov wrote, "Our photo art is faced with the task of stressing the content. 'Left' montage inside the photo-still and 'right' series, to different degrees, both turned out to be unable to express the huge spectrum of new ideas brought forward by the epoch of the second Five-Year Plan."[47] In place of these two approaches to photography, the ideologues of socialist realism proposed what may be called the "staged photo picture," a deliberately artificial style that was equally hostile to the ROPF motto, That's How It Is in Real Life, and to the October photographers' commitment to sacrifice all-inclusive content to the protocol of fragmentary reality.

124. Aleksandr Rodchenko, *Jump on a Horse*, 1936, photograph. Soviet Photo, Moscow.

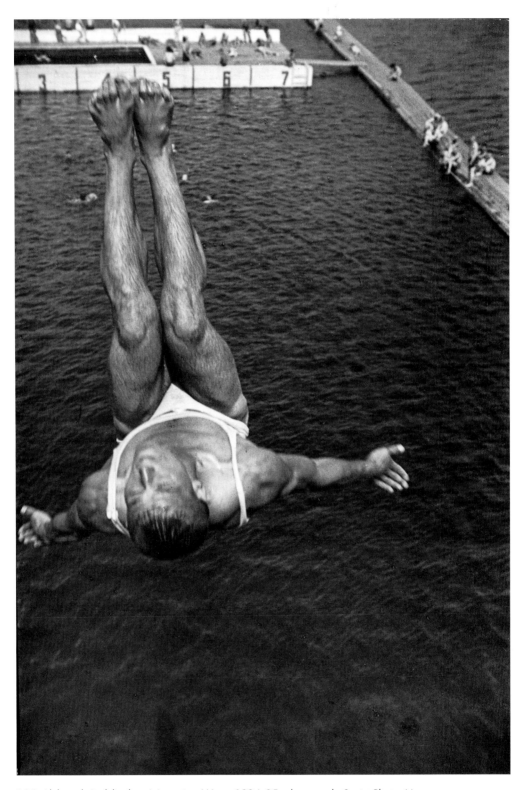

125. Aleksandr Rodchenko, *A Jump into Water,* 1934–35, photograph. Soviet Photo, Moscow.

This new model of the socialist realist "photo-picture" was overtly convention-al and excessively romantic and accounted for the majority of the photographs published in *Soviet Photo* as illustrations of the discussion. Among these were many portraits of political leaders, a genre that was beginning to receive the greatest acclaim and encouragement. For example, Ignatovich's 1936 photo-graphs of *Comrade Stalin with Pioneer Girl Mamlakat* (fig. 126) and *Comrade Stalin with Maria Demchenko at the Meeting of Komsomol* were described as "the best works by Ignatovich of the last year or two."[48] Rodchenko professed that, for him, the photograph he made of the *Meeting at the Canal with the Participation of Comrades Kaganovich and Iagoda* in 1935 was "exceptional-ly significant." He noted, "The picture is simple, spontaneous; the composition employs a new format, which I am trying out for the first time."[49] This emphasis on simplicity coincided with the beginning of an official promotion of the twin concepts of *narodnost'* (for the people) and *partiinost'* (for the party), which would become the main requirements for all socialist realist works.

Rodchenko's *Meeting at the Canal* and the series of photographs he made during the various parades in 1936–38 were hardly "spontaneous." For the latter assignment he was given restricted access to record an official parade that in-cluded sport scenes, dances, a display of the achievements of the Republics, mili-tary might, and portraits of prominent political heroes (fig. 127). The minimalist photo-stills of the October period, with their images of people caught off guard, are here replaced by photo-pictures of romanticized dancers and virtuoso athletes. These new Soviet heroes are not simply "found" jumping into water, blowing into a trumpet, or exercising in the morning, but are recorded performing, after days of rehearsal, on the stage of Red Square. This new photo-reportage was based on maximum expressiveness, overt theatricality, and careful staging and result-ed from strictly defined commissions with specific political aims. Statements by Mezhericher and Fridliand reflect this final twist in the nature of photo-reportage. Mezhericher asks: "Is photo-reportage art or not? Newspaper pages have changed. A demand for a beautiful artistic snapshot that is pleasant to the eye has grown above all." Fridliand responds, "Readers are not satisfied by the dry protocol-like photograph that reflects the craftsman-like indifference of a photog-rapher. Readers demand that they be shown the face of their wonderful country with the maximum expressiveness."[50] At this point, most critics and photographers simply adopted a stance of "confidence in the possibility of deducing political and ideological positions from the purely formal properties of a work of art."[51] In the 1930s, this "criterion," which Jameson and others attribute to Lukacs, was rapidly

126. Boris Ignatovich, *Comrade Stalin with Pioneer Girl Mamlakat, Soviet Photo,* 1936, no. 1, cover. Soviet Photo, Moscow.

becoming a vital weapon against anyone who continued to diverge from conventional methods of representation.

The first step in Klutsis's shift from factographic to mythographic imagery was made in his photomontage *The Feasibility of Our Program Is Real People, It's You and Me,* 1931 (fig. 128). In this montage, Stalin is inserted into the ranks of

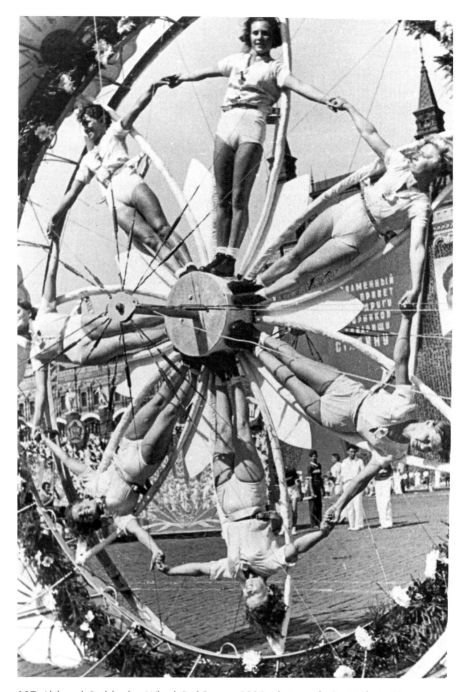

127. Aleksandr Rodchenko, *Wheel, Red Square,* 1938, photograph. Soviet Photo, Moscow.

marching coal miners. This jarring montage displaces collective anonymity on both the visual and the verbal level: hitherto anonymous workers are now joined by a concrete image of the political leader, and the Five-Year Plan's anonymous slogans are replaced by a simple statement signed by Stalin. In this case, however, both linguistic and compositional structures remain democratic, since there is no distinction of scale between the leader and the workers, and Stalin implicitly acknowledges that his role in the construction of socialism equals, rather than surpasses, that of the masses (pl. 22).[52] This poster marks the first step toward the state's total usurpation of the proletariat's historical position as the author of socialist reconstruction. This, in turn, displaced Klutsis's own authorial model, which was based on submission to the ideals of the proletariat and on the suppression of individual codes and gestures.

In his discussion of the function of the author, Roland Barthes writes that "it is language which speaks, not the author; to write is, through a prerequisite impersonality . . . to reach that point where only language acts, 'performs,' and not me.'"[53] Klutsis's entire photomontage production, until Stalin's image takes a frontal position in *The Feasibility of Our Program,* sought to suppress his own role as author in favor of the working-class viewer to whom his production was addressed. The anonymous workers and slogans that fill his posters convey the "impersonality" of that production; the method itself, photomontage, performs the agitational function. With the return of the personal pronoun "me" to the poster's slogans, Klutsis resurrects the author, not as the individual creator but as the state's authorial "ego," personified by Stalin. In his next two posters, *Victory of Socialism in Our Country Is Guaranteed,* 1932, and *At the End of the Five-Year Plan Collectivization of the* USSR *Must Be Basically Over,* 1932 (fig. 129), Klutsis further expanded the role of the myth in constructing his image of state power. Stalin's image now dominates both workers and collective farmers. The anonymous slogans in these posters, which once emphasized social facts and immediate issues, have been replaced by general propaganda statements authorized by Stalin.

Klutsis's posters *The Feasibility of Our Program* and *Victory of Socialism* became highly popular and were widely displayed on the streets of Moscow (fig. 130), used for educational purposes (fig. 131), and employed as illustrations for politically charged articles about posters.[54] These posters were also central images at the exhibition *Posters at the Service of the Five-Year Plan* held at the Tret'iakov Gallery in 1932 (fig. 132). For the catalogue's author, P. S. Kaufman the exhibition demonstrated "a difficult path from a passive illustrative poster or

128. Gustav Klutsis, *The Feasibility of Our Program Is Real People, It's You and Me*, 1931, 28.5 x 20.3 cm, photomontage. Private collection.

a bourgeois advertising one to an expressive one that is clear and intelligible to the masses" and was "organized in response to a resolution of the Central Committee of the Communist Party regarding poster production."[55] Nikolai Dolgorukov, Elkin, Klutsis, Sen'kin, and two women, Pinus and Kulagina, participated in the show, each presenting from two to seventeen posters, the largest number being contributed by Klutsis. The exhibition was organized thematically, with only one section dedicated to advertising posters that were made for export. Regarding posters made for domestic usage, the catalogue noted that the "poster's main new quality is an attempt to combine its usual service of notification and information with politically instructive mass work. Thus a mere informative poster has turned into a tool of political agitation."[56] Another section of the exhibition was called "discussional" and included posters in which, as the catalogue pointed out, "the alien influences, formalist tricks, advertising approaches, inability to choose the right images, and political illiteracy are clearly expressed."[57]

As with Klutsis's work, the posters exhibited by Sen'kin and Kulagina at the Tret'iakov Gallery demonstrated significant compositional and iconographic changes. Unlike Sen'kin's typical poster for the first Five-Year Plan, *Let's Strengthen the Industrial Might of the Soviet Union*, 1932 (pl. 23), in which a worker fully dominates the space, in *Under the Banner of Lenin for the Second Five-Year Plan*, 1932 (pl. 24), a gigantic figure of Lenin is positioned atop tiny figures of workers, as if suggesting their diminishing role in socialist construction. In comparison to Sen'kin's earlier dynamic representations of Lenin, the leader appears to be static and pompous in this poster. The slogans take the form of longer statements printed in a more ordered format. Kulagina's *Female Shock Workers Enter the Rows of VKP(b)*, 1932 (fig. 133), features a female worker, rather than a leader, as the central image.[58] But, even in this case, the artist depicts the woman holding an issue of *Pravda* in order to point out the growing link between the Central Committee of the Communist Party and mass-media production. In her diary, Kulagina noted the impact of this political change on the production of posters: "As of the 21 [of August], none of the posters have yet been put into production; [they] have been sent to TsK [Central Committee of Communist Party]. And of course, two of mine have been rejected. Try to work here! There are so many difficulties, whereas [posters] pass through IZOGIZ. . . . I am sure that if my first posters had been sent to TsK, they would have been banned."[59]

This new policy of sending poster designs to the Central Committee for approval was a result of the Party's distrust of IZOGIZ activities, and its decision to

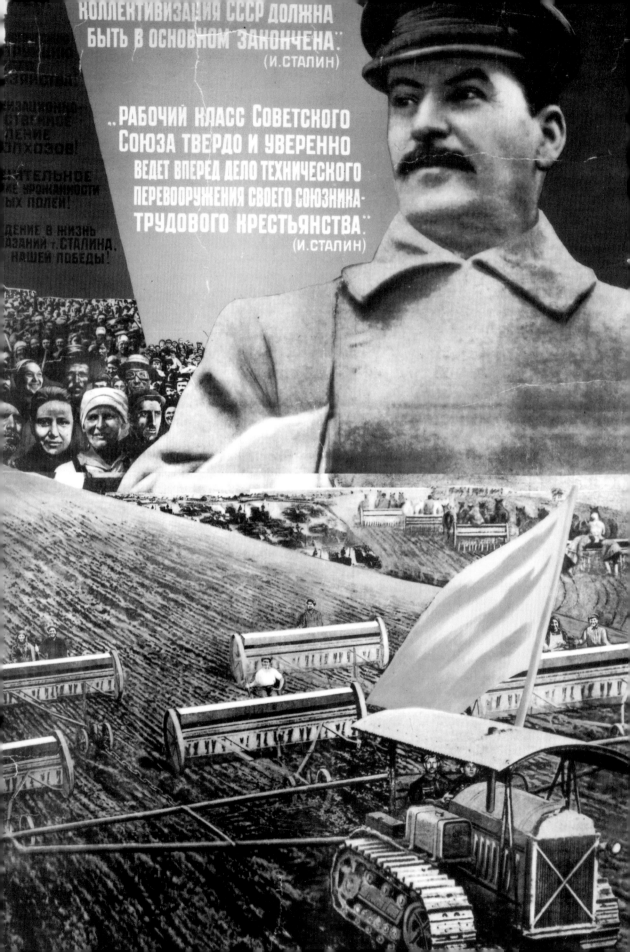

129. (opposite) Gustav Klutsis, *At the End of the Five-Year Plan Collectivization of the USSR Must Be Basically Over*, 1932, lithograph. Private collection.

130. Gustav Klutsis's Posters Displayed on the Streets of Moscow, 1932. Photograph, Gustav Klutsis.

131. Gustav Klutsis's Posters Used for Educational Purposes, 1932. Photograph, Gustav Klutsis.

132. A View of the Exhibition *Posters at the Service of the Five-Year Plan*, Tret'iakov Gallery, Moscow, 1932. Photograph, Gustav Klutsis.

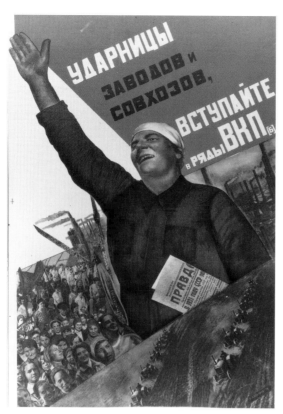

133. Valentina Kulagina, *Female Shock Workers Enter the Rows of VKP (b)*, 1932, 89.6 x 59.7 cm, lithograph. Private collection.

"purge the apparatus of IZOGIZ" and to "investigate the production of ideologically harmful posters and paintings."[60]

Although Kulagina was able to give primacy to a female worker in this poster, this image is distinctly different from her earlier representations of women. The genuine involvement of women in everyday activities as shown in her earlier posters is here replaced by a sense of artificial happiness and a glorification of Stalin's political course. Similarly, Pinus's poster *Women on Collective Farms Are a Substantial Power*, 1933 (fig. 134), produced in collaboration with Klutsis, illustrates the process of the subordination of women's desires, which had hitherto been invested in labor, to Stalin's authority. The poster shows two female collective farmers, one on a tractor and another using a scythe, under Stalin's patriarchal gaze. There is no ambivalence here: Stalin is offered as the ultimate referent for their effort and accomplishment.

Kulagina's description of a discussion between Klutsis and an IZOGIZ editor on the subject of the poster *Youth to the Planes*, 1934 (fig. 135), suggests that by that time female images were indeed treated as secondary and as ineffective in the creation of mythographic scenarios: "Today Rabinovich talked to Gustav about his poster *Youth to the Planes*. [Rabinovich] commented, 'Haven't you gotten too excited about showing women in the foreground? In the background, you show courageous and efficient [male] youths; but in the foreground, slightly sugary women with smiles.' Gustav replied: 'I wanted to show that the female pilot

preserves her womankind despite severe schooling . . .' But I wonder whether this is the goal of a poster."[61]

Many of Klutsis's late montages record what may be described as the struggle for "political authorship." As an artist responsible for mass-produced posters with political messages, Klutsis's livelihood depended on the consequences of Stalin's megalomaniac aspirations, which were specifically dependent on reshaping the story of his role in the Revolution. Stalin had at least two objectives in recharting the course of Bolshevik history: the first was to displace the idea that Lenin was the sole "author" of the Revolution and instead to propagate a dual Stalin/Lenin authorship; the second was to eliminate any individual or document that would contradict his own account of these events. In the last photomontages Klutsis made before he himself fell victim to political falsification, we can see the struggle to make these images adjust to the Soviet mythological apparatus.

Klutsis had first explored the relationship between Stalin's and Lenin's images in 1930 in the poster *Under the Banner of Lenin for Socialist Construction* (fig. 98). In this composition, the artist attempted to convey the sense of ambiguity associated with Stalin's role in revolutionary events, by allowing Lenin's head to cover part of Stalin's head. This depiction changes abruptly, however, and in his 1933 montages for the first color issues of *Pravda*, Klutsis was clearly struggling over the positioning of the two leaders. Klutsis no longer placed Stalin's image

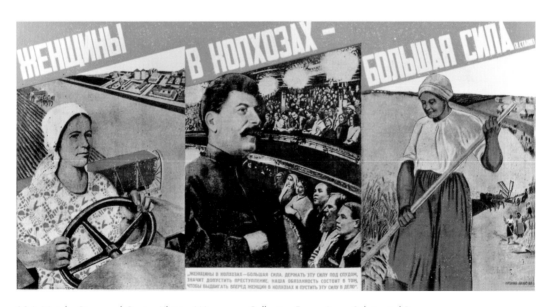

134. Natalia Pinus and Gustav Klutsis, *Women on Collective Farms Are a Substantial Power*, 1933, lithograph. Private collection.

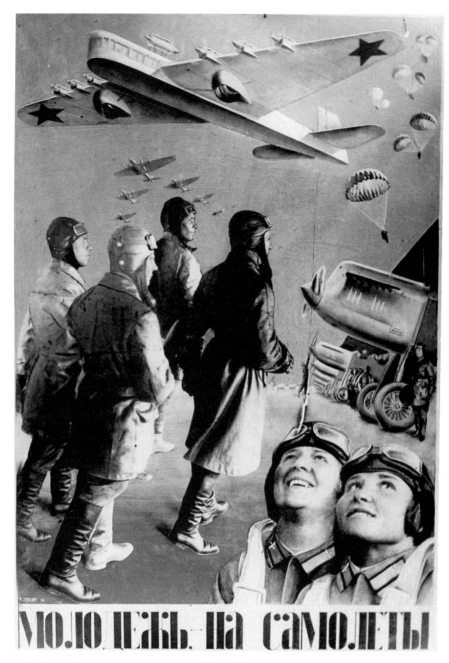

135. Gustav Klutsis, *Youth to the Planes*, 1934, 17.2 x 11.5 cm, vintage gelatin silver print. Private collection.

behind that of Lenin; in only one montage are the two political figures in the same row. The rest depict Stalin well to the front. For example, in the August 18, 1933, issue of *Pravda* (pl. 25), Stalin appears alone against a background of blue sky filled with rows of airplanes and dirigibles. Saluting the air force of the Soviet Union, he stands at the height of the biggest plane, named after Maxim Gorky. There are no signs of Lenin or the masses. If Stalin's feet were not covered by the text of the accompanying article, the picture of the Kremlin, small and distant in relation to the leader, could be seen spread at his feet.[62] Klutsis wrote to Kulagina about this *Pravda* design, "As I see it, I have finished the front page for *Pravda* of August 18. Now it is the most busy time: this and that have to be changed. But it seems that it will go ahead. We will print it in two colors, to the fear of enemies. . . . Everything has to be done at a crazy pace."[63]

Another *Pravda* montage, dating from November 7, 1933 (fig. 136), the sixteenth anniversary of the Revolution, served to illustrate a front-page article called "The Masses Create History." Lenin returns in this composition but appears only in the background. His portrait is formal and dull in contrast to the fervent image of Stalin in the central position, completely free from the shadow of his predecessor. In this holiday montage, Stalin adopts a Napoleonic pose with his face turned away from Lenin, gazing out over a "utopian" visual field crowded with Soviet aircraft, factories, mechanized harvesters, and determined, energetic faces. Although the masses appear in this montage, their presence seems superfluous. The inference that Stalin is the sole creator of history is inescapable.

Significantly, Klutsis not only turned to drawing to produce the *Pravda* photomontages, but he even retained the hybrid of drawing and photomontage in the final publication. For example, in the August 18 *Pravda* montage, some of the planes are drawings rather than collages from photographs, and in the November 7 *Pravda* montage, Klutsis has drawn the whole industrial landscape. This return to more conventional artistic methods reflected a widespread dissatisfaction among influential Soviet artists with photomontage. In 1932, Kulagina noted, "There is a reaction against photomontage at all fronts."[64] And Aleksandr Deineka, a prominent artist who also actively contributed to such magazines as *Let's Give,* said of Klutsis's designs for *Pravda,* "Pravda is afraid of drawing."[65]

The *Pravda* photomontages implicitly document the ongoing struggle on the political stage. But other works from the period demonstrate much more explicitly the purges inspired by Stalin's inexhaustible desire for absolute power. A number of Klutsis's surviving posters, photographs of posters from the 1920s, and original montages are self-censored. An image from *Herald of Labor* dating from 1925

shows Grigorii Zinoviev's slogan Marx Plus Lenin Equals Bolshevism, The Ideology of the Third International, but the slogan was crossed out, probably around 1936, when Zinoviev was on trial. A final example of this sort of self-censorship is a large 1935 montage by Klutsis in which a lively and powerful bust-length photograph of Stalin is placed before a sculpture of Lenin (fig. 137). In the original

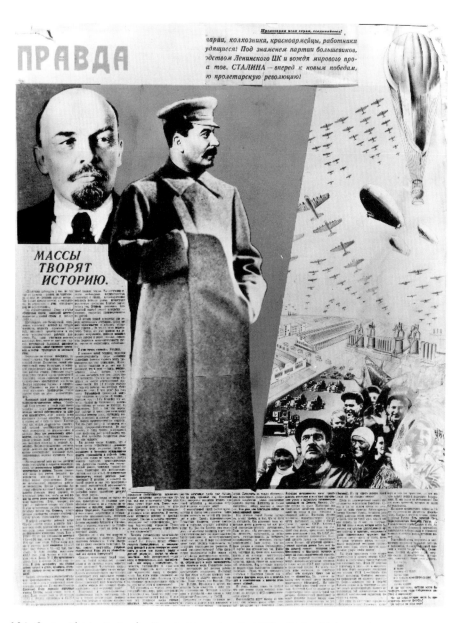

136. Gustav Klutsis, Design for *Pravda*, November 7, 1933, 67.4 x 50.2 cm, photomontage. Private collection.

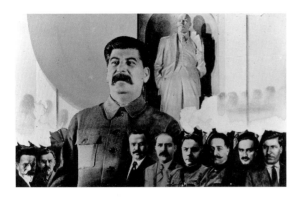

137. Gustav Klutsis, *Politburo*, 1935, 40 x 58 cm, photomontage. Private collection.

version, Stalin's figure was flanked by two rows of apparatchiks but, as the remnants of the torn-off photographic portraits suggest, Klutsis eliminated some of them, perhaps in fear of being accused of supporting the "people's enemies." A preliminary sketch (fig. 138) for this photomontage, depicts two rows of empty heads that surround a recognizable portrait of Stalin. This drawing dramatically demonstrates that by 1935 Stalin's image was the only one guaranteed to survive. The empty ovals, reserved for the heads of the tyrant's servants, were subject to perpetual replacement. At this point, Klutsis's role as a photomontage artist was fully controlled by the government, and his compositional choices began to equal life-and-death decisions.

Klutsis's last official commission involved traveling to Paris in 1937 as one of the designers of the Soviet pavilion at the Paris World's Fair. As with the Pressa exhibition, Lissitzky was chosen to lead a brigade of artists who would design the interior of the Soviet pavilion. After the numerous exhibits had been prepared, the Soviet government sent to Paris "powerful trains, made by Soviet workers at the local plants, with sculptures and paintings by masters of art, wonderful books by writers and scientists, crafts by Soviet female folk artists, a map of the Soviet Union made from precious stones, etc."[66] The whole pavilion consisted of six halls, each of which was devoted to demonstrating Soviet achievements in a particular field of culture (painting, music, theater, film) or production (collective farms and science). According to the commissar of the Soviet pavilion, N. Mezhlauk, "The entire pavilion of the USSR, as well as its separate halls, must be perceived by the viewers as a harmonious whole."[67]

Despite the rather conventional arrangement of the pavilion, Klutsis expressed excitement about it in his letters to Kulagina:

Our pavilion is wonderful from far, close-up, and inside. Remarkable sculptures by [Vera] Mukhina. All this should have been bigger in size. . . . The interest in our pavilion is exceptional. It is full of people all the time. It looks really good in its lightness, clearness, and new ideas. Unknown hands, probably French male and female workers, bring unusually bright roses and cover the bust of Il'ich [Lenin] and the sculp-

ture of comrade Stalin. There are angry [visitors] as well. Primarily these are White officers, emigrants. My panel turned out wonderfully. Installed here it brings the whole ensemble to life and gives meaning to an abstract obelisk and other surrounding pieces.[68]

The panel Klutsis mentions in this letter was his large photomontage frieze; titled *Working People of the USSR Are Voting for Stalin's Constitution,* 1936-1937 (fig. 139), this work depicts an immense hall filled with numerous multinational workers and peasants, all voting for Stalin's Constitution. Stalin stands victoriously at the podium, presenting his speech. Behind him Politburo members are lined up in front of a sculptural bust of Lenin. Compared with the Pressa frieze (fig. 47), which vividly revealed fragments of the Soviet Union's multisided reality, this photomontage attempted to convey a single political event using an overtly conventional composition. The characters of this photomontage appear staged and motionless, as if attesting to the departure of spontaneity from Soviet photographic representation. And significantly, here, it is the leader, not the worker, who is being celebrated.

In an attempt to describe photography's importance to this event, *Soviet Photo* noted, "As large as the number of exhibition items is, without the help of photography, it appeared to be impossible to represent our achievements fully. As a result, in each hall of the Soviet pavilion, one could find large-scale photomontages, single photographs, and thematic photo albums."[69] Many photomontages and photo panels were made by little-known artists from prints provided by Soiuzfoto (Union Photo) that had often been taken by major photographers like Georgii Petrusov, Anatolii Skurikhin, Shaikhet, Dmitrii Debabov, Iakov Khalip, and Langman. This division of the artistic process attests to the fact that, although a substantial portion of the pavilion's

138. Gustav Klutsis, *Untitled,* 1935, 17.6 x 13.4 cm, color pencil drawing on photo paper. Private collection.

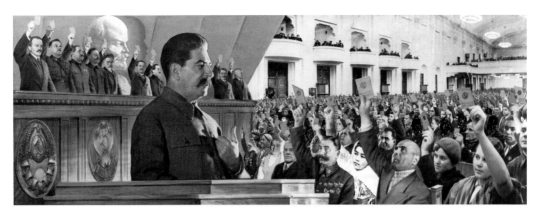

139. Gustav Klutsis, *Working People of the USSR Are Voting for Stalin's Constitution*, 1936–1937, 11.7 x 34.1 cm, vintage gelatin silver print. Private collection.

design was based on photography, it was deployed not as an avant-garde language of expression (as in the case of earlier exhibition designs by Lissitzky and others) but merely as a technical tool enabling designers to represent Soviet achievements on a full scale. In other words, to create a powerful visual effect, individual photographs were commissioned from the nation's leading photographers, but to ensure greater control over the content, the actual execution of the photomontages was assigned to lesser-known but more reliable artists. In addition to the World's Fair pavilion, the Soviets organized a large exhibition of the "distinguished works by Soviet masters of photo art."[70] This parallel exhibition made clear that the Soviets were not only downplaying the importance and independence of documentary photography but also pushing for the return of photography to the realm of fine art.

The period of the second Five-Year Plan constituted an ambigious space in the transition between two distinct cultural eras during which the representational strategies of the photographic avant-garde were infected by the virus of overtly politicized iconography and initial forays into socialist realism did not escape the application of avant-garde methods. The *First All-Union Exhibition of Photo Art* organized at the State Pushkin Museum in Moscow in 1937 provided a closing chapter to the history of Soviet innovative photography. The location of this exhibition once again pointed toward photography's unification with painting. In the Soviet press, the exhibition was characterized as socialist realism "displaying the deployment at full strength of all the possibilities given to a photographer."[71] Rodchenko was the exhibition's chief designer, and among the other participants were Shaikhet, Langman, Ignatovich, Fridliand, and Al'pert. In an attempt to be

historical, the exhibition included around 1,500 objects concerned with the October Revolution (whose twentieth anniversary it commemorated) and the civil war, as well as numerous portraits of Lenin, Stalin, prominent Politburo members, and distinguished workers. Photographs of industrial sites and collective farms, landscapes and still lifes were also included. Apart from his photograph *Field Flowers*, 1937 (fig. 140), Rodchenko's own exhibit was generally praised. Because of the play of light and shadow around the face of a girl sitting at a table with a bouquet of flowers, *Field Flowers* was predictably denounced as an attempt "to satisfy formalist ideas."[72] The criticism of Langman's fragmenting depiction of a female tea collector from above and from the side was similarly repetitive. What was new in the criticism of this show, however, was the insistence that photography be evaluated in purely painterly terms and that its documentary value should be downplayed. The critic Morozov, for example, while discussing a photograph of a mother with a child, concluded that although the image depicts a real woman, "in its wholeness as an artistically rendered image, it grows beyond a document and approaches the significance of a painting."[73] Morozov's comment documents the vital moment when painting fully reasserted its superiority over the photographic image and photography was mainly called upon to multiply "the effects of reality or . . . the fantasies of realism."[74]

By the end of the second Five-Year Plan, the totalitarian terror had begun to affect the cultural community. Around that time, Mezhericher, Klutsis, and Tret'-iakov were arrested, to name only those who fit the official title "the enemies of Soviet photography."[75] Disturbed by these events, Rodchenko wrote in 1938, "These are strange times. Everyone is whispering. Everyone is afraid. It is nerve-wracking that everyone has friends who have been arrested. I do not know for what reason and where they are."[76] This veil of terror coincided with the "transcendental illusion" attained in mass-media representations. Jean-Francois Lyotard argues for a connection between the two when he writes, "The price to pay for such an illusion is terror. . . . We have paid a high enough price for the nostalgia of the whole and the one, for the reconciliation of the concept and the sensible, of the transparent and communicable experience."[77] The ultimate union of all Soviet republics, celebrated in the constitutional issue of *USSR in Construction*, unleashed the terror of a government now confident of its total power. But to assume that the totalizing images that populated mass-media representations in the late 1930s solely served the government's interests is to fully disregard the place of the public

140. Aleksandr Rodchenko, *Field Flowers*, 1937, photograph. Soviet Photo, Moscow.

in the process of transforming factography into mythography. When Rodchenko speculated about whether it was the party or the cultural community that undermined avant-garde manifestations such as formalism, he completely ignored the role of the public and their interests as far as representation is concerned. This was a mistake. As Lyotard reminds us, "When power assumes the name of a party, realism and its neoclassical complement triumph over the experimental avant-garde by slandering and banning it—that is provided the 'correct' images, the 'correct' narratives, the 'correct' forms which the party requests, selects, and propagates can find a public to desire them as the appropriate remedy for the anxiety and depression that public experiences."[78]

In the end, just as Stalin succeeded with his campaign of purges because thousands of informers from the public were willing to cooperate with him, the avant-garde succumbed to socialist realism because the masses, for whom dismal living conditions and harsh labor were a daily reality, were no longer captivated by the ambivalence of the fractured images of the avant-garde. Instead, the public found comfort in the "therapeutic" socialist realist representations that successfully neutralized the pain of their reality by overtly heroizing their life and work.

Notes

INTRODUCTION

1. Izvestiia VTsIK, 25 December 1920.
2. Cheka is the abbreviation for the Extraordinary Commission to Combat Counterrevolution, Sabotage, and Speculation. In these recollections, Sen'kin also noted that "many black-market dealers lived in our building, and quite often someone from the Cheka came to visit them; we were happy about such visits for different reasons, one of which had to do with the freeing of living spaces where we would place students." Sergei Sen'kin, "Lenin v kommune VKhUTEMASA," *Vospominaniia o V.I. Lenine* (Moscow: Molodaia Gvardiia, 1955), 205.
3. Armand, a close comrade of Lenin, had died in 1920, and it is likely that he took care of her daughter. Sen'kin's explanation of why Lenin came to the VKhUTEMAS contradicts the official explanation that the visit was to familiarize him with the activities of the school.
4. Sen'kin, "Lenin v kommune VKhUTEMASA," 205.
5. According to Sen'kin, Lenin was talking about a project for a book design that was hanging on the wall next to a diagram showing how to decorate an agitprop train. Sergei Sen'kin, "Avtobiografiia" (1954), unpublished manuscript, Sen'kin Family Archive, Moscow.
6. Sen'kin, "Lenin v kommune VKhUTEMASA," 205.

7. The views on art held by Rodchenko and other artists at the time of the Revolution can be drawn from their statements published for *X Gosudarstvennaia vystavka. Bespredmetnoe tvorchestvo i suprematism.* See *Sovetskoe Iskusstvo za 15 Let: Materialy i Dokumentatsiia,* ed. I. Matsa (Moscow: OGIZ-IZOGIZ, 1933).

8. Christina Lodder, *Russian Constructivism* (New Haven: Yale University Press, 1983), 103.

9. For a comprehensive survey of Rodchenko's early work, see Selim O. Khan-Magomedov, *Rodchenko: The Complete Work* (Cambridge: MIT Press, 1987).

10. While studying painting, Klutsis also participated in various propagandistic projects, including the photomontage panel *Storm: Attack on Counterrevolution* created for the Fifth Congress of Soviets in Moscow in 1918.

11. Khan-Magomedov, *Rodchenko: The Complete Work,* 172.

12. Ibid.

13. Brik, Rodchenko et al., *LEF,* no. 4 (1923): 27.

14. Sergei Sen'kin and Gustav Klutsis, "Masterskaia Revolutsii," *LEF* 1, no. 5 (1924): 155–59.

15. Ibid., 155.

16. Brik, Tret'iakov, et al., "Programma. Za chto boretcia *LEF*?" *LEF,* no. 1 (1923): 6, 7.

17. This connection between literary and artistic formalism can be partially explained by M. M. Bakhtin and P. N. Medvedev's remark that "Russian [literary] formalism was tightly interlaced with the artistic program . . . of Russian futurism." They also point out that "the formalists did not engage in polemics with other . . . movements in literature as much as with other artistic programs." See M. M. Bakhtin and P. N. Medvedev, *The Formal Method in Literary Scholarship: A Critical Introduction to Sociological Poetics,* trans. Albert J. Wehrle (Cambridge: Harvard University Press, 1978), 64.

18. Victor Shklovskii, "Art as Technique," in *Russian Formalist Criticism: Four Essays,* trans. and with an introduction by Lee T. Lemon and Marion J. Reis (Lincoln: University of Nebraska Press, 1965), 12.

19. Victor Shklovskii, "Ob iskusstve i revolutsii," *Iskusstvo kommuny,* 1919, no. 2: 2.

20. Osip Brik, "Khudozhnik-proletarii," *Iskusstvo kommuny,* 1918, no. 2: 1.

21. Osip Brik, "Drenazh iskusstvu," *Iskusstvo kommuny,* 1918, no. 1: 1.

22. Bakhtin and Medvedev, *Formal Method in Literary Scholarship,* 65.

23. Nikolai Chuzhak, "Pod znakom zhiznestroeniia," *LEF,* no. 1 (1923): 17.

24. Andreas Huyssen, *After the Great Divide: Modernism, Mass Culture, Postmodernism* (Bloomington: Indiana University Press, 1986), 14.

25. See Benjamin H. D. Buchloh, "From Faktura to Factography," *October,* no. 30 (Fall 1984): 14.

26. For Rodchenko, see Hubertus Gassner, "Analytical Sequences" in David Elliot, ed., *Alexander Rodchenko* (Oxford: Oxford Museum of Modern Art, 1979), Hubertus Gassner, *Rodchenko Fotografien* (Munich: Schirmer/Mosel Verlag, 1982), and Aleksandr Lavrentiev, *Rakursy Rodchenko* (Moscow: Iskusstvo, 1992). For Klutsis, see the pioneering studies of his work and photographic practices: Larisa Oginskaia, *Gustav Klutsis* (Moscow: Sovetskii Khudozhnik, 1981) and *Gustav Klucis: Retrospektive* (Kassel: Museum Fridericianum, 1991).

27. The survey books about Russian photography were, as a rule, not written by art historians. Among these surveys are Grigorii Chudakov, *Pioneers of Soviet Photography* (London: Thames and Hudson, 1983), and three volumes of *Antologiia Sovetskoi Fotografii* (Moscow: Planeta, 1986–87).

28. The first attempt to include a section on photography (beyond Rodchenko) in an exhibition of the Soviet avant-garde was *The Great Utopia,* an exhibit at the Guggenheim Museum in New York in 1992. The catalogue for this exhibition also includes an important article "The Politics of the Avant-Garde" by Paul Wood with an extensive discussion of the various perspectives taken by Western and Russian scholars concerning the relationship between the Soviet avant-garde and politics.

29. A consideration of both straight photography and photomontage may be justified by the specific function of the Soviet photograph as a reproducible image rather than an independent art object and by the fact that such artists as Rodchenko, Klutsis, Sen'kin, and Lissitzky practiced both mediums. In addition, during the 1930s many photographers took pictures in order to provide images for photomontages made to appear in books, magazines, and exhibition designs.

CHAPTER 1: LENIN'S DEATH AND THE BIRTH OF POLITICAL PHOTOMONTAGE

1. B[oris] Eikhenbaum, "Vokrug Voprosa o Formalistakh," *Pechat' i Revolutsiia,* 1924, no. 5: 2, 10, 11.

2. Ibid., 10.

3. Ibid., 11.

4. Boris Eikhenbaum, "Osnovnye stilevye tendentsii v rechi Lenina," *LEF* 1, no. 5 (1924): 58.

5. Ibid., 59.

6. Viktor Shklovskii, "Lenin kak dekanonizator," *LEF* 1, no. 5 (1924): 56.

7. Benjamin H. D. Buchloh, "From Faktura to Factography," *October,* no. 30 (Fall 1984): 95.

8. Yve-Alain Bois, "El Lissitzky: Radical Reversibility," *Art in America* (April 1988): 174.

9. Ibid.

10. Jean-François Lyotard, quoted ibid., 169.

11. Ibid.

12. Ibid.

13. According to Kuleshov, he was the first person in Russia to use the word *montage* and to speak about "realism in the art of the film." In 1920, Kuleshov filmed Lenin at the first Subbotnik (a Saturday devoted to volunteer labor). See Lev Kuleshov, "The Origins of Montage," in Luda Schnitzer, Jean Schnitzer, and Marcel Martin, eds., *Cinema in Revolution* (New York: Da Capo Press, 1973), 67–68.

14. Dziga Vertov, "My," *Kino-Fot,* 1922, no. 1: 11.

15. In *Kino-Fot* Vertov complained about his difficulties in obtaining funds to make *Kino-Pravdas.* He was competing against many films sponsored by NEP. In this regard, he wrote: "NEP says: 'Film where you are paid. A Film *Castle of Tamara* (a restaurant with cozy offices) is preferred over a film about electrification.'" Dziga Vertov, "On i Ia," *Kino-Fot,* 1922, no. 2:10.

16. In his archive, Klutsis kept the book *Advertising and Poster as Weapons of Propaganda,* written by the German critic Theodor Kunig and published in Leningrad in 1925. Klutsis underlined the passage in which Kunig stated that advertising relied on "intellectual perception."

17. Jacques Aumont, *Montage Eisenstein,* trans. Lee Hildreth, Constance Penley, and Andrew Ross (Bloomington: Indiana University Press, 1987), 159.

18. Ibid.

19. Klutsis to Valentina Kulagina, letters of August 20, 1924, and August 14, 1924, Klutsis Family Archive, Moscow.

20. Klutsis to Valentina Kulagina, letter of August 26, 1924, Klutsis Family Archive, Moscow. In this letter, Klutsis mentioned that he used Kulagina's head in his montage for the image of an industrial female worker. This initiated his practice of using portraits of relatives and friends in his photomontages.

21. Eikhenbaum, "Osnovnye stilevye tendentsii v rechi Lenina," 66.

22. Lev Iakubinskii, "O snizhenii vysokogo stilia u Lenina," *LEF*, 1, no. 5 (1924): 77.

23. Curiously, these samples of children's writings are strikingly similar to the examples of Lenin's scribbles that he made after he had been shot and had been taught to write again by his wife, Krupskaia. The latter documents, because they attest to Lenin's harsh disability after the shooting, were long suppressed but were exhibited at the Lenin Museum in Moscow shortly before it was closed in 1993.

24. Aumont, *Montage Eisenstein,* 164.

25. Ibid., 165.

26. Victor Erlich, *Russian Formalism: History-Doctrine* (London: Mouton, 1965), 112.

27. I choose to call Rodchenko's early experiments with photographs *photocollage,* to distinguish them from the early political photomontages of Klutsis and Sen'kin, as well as from his own works with political photographic imagery.

28. A number of scholars have linked Rodchenko's first experiments in photography and photocollage with the ideas formulated in his abstract works. See, for example, Hubertus Gasner, "Analytical Sequences," in David Elliot, ed., *Alexander Rodchenko* (Oxford: Oxford Museum of Modern Art, 1979), 108.

29. *Kino-Fot,* 1922, no. 1: 13.

30. See Lev Kuleshov, "Montazh," *Kino-Fot,* 1922, no. 3: 11–12.

31. Dziga Vertov, "On the Importance of Newsreel" (1923), in Schnitzer, Schnitzer, and Martin, eds., *Cinema in Revolution,* 80.

32. Aleksandr Lavrentiev, "Pro etu knigu," in Vladimir Maiakovskii, *Pro Eto* (Berlin: Ars Nicolai, 1994). Arkadii Shterenberg took the photographs of Maiakovskii and Brik.

33. In response to Lenin's death, Rodchenko designed a number of book covers, including some for *Zhivomu Il'ichu* (1924) and *O Lenine* (1925), as well as covers for the magazine *Technika i zhizn'* (1924). Along with Klutsis and Sen'kin, Rodchenko contributed a photomontage to the book *Leninu* (1924). This image is more formalist, suggesting that he did not want to look "uninventive" in the close company of his colleagues. Only in 1928, with his increasing interest in the ideological properties of the photograph, did he link the representation of Lenin's image with the most advanced forms of photography. At that time he wrote, "Tell me what one needs to achieve to memorialize Lenin: artistic bronze, oil portraits, lithographs, watercolors, a diary of his secretary, reminiscences of his friends, or a file of photographs taken during his work and leisure. I think that there is no choice. Art has no existence in contemporary life . . . Do not lie! Take pictures and have pictures taken of you." See "Protiv summirovannogo portreta za monumental'nyi snimok," *Novyi LEF,* 1928, no. 4: 16.

34. Varvara Stepanova, "Photomontage" (1928), in Elliot, ed., *Alexander Rodchenko,* 93.

35. Thomas Crow, "Modernism and Mass Culture in the Visual Arts," in Benjamin H. D. Buchloh, Serge Gilbaut, and David Solkin eds., *Modernism and Modernity* (Halifax: Press of the Nova Scotia College of Art and Design, 1983), 215.

36. Aleksandr Khruchenykh, *Lef-agitki Maiakovskogo, Aseeva, Tret'iakova* (Moscow, 1925).

37. Khan-Magomedov points out that the First Working Group of Constructivists, to which Rodchenko belonged, emphasized two components of constructivism: "construction" and "invention." See Selim O. Khan-Magomedov, "Early Constructivism," in *Art into Life: Russian Constructivism, 1914–1932* (New York: Rizzoli, 1990), 55.

38. Gustav Klutsis, "Fotomontazh kak novyi vid agitatsionnogo iskusstva," *Izofront. Klassovaia bor'ba na fronte prostranstvennykh iskusstv. Sbornik statei ob'edineniia oktiabr'* (Leningrad: Izofront, 1931), 126.

CHAPTER 2: THE PHOTOGRAPHER IN THE SERVICE OF THE COLLECTIVE

1. Paintings like Iurii Pimenov's expressionist pictures of dramatic battles or crying wounded soldiers from the late 1920s or Sergei Luchishkin's emotionally charged depiction of starving peasants in the Volga region are among such works. For a discussion of various realist groups and painters of the later 1920s and early 1930s, see Charlotte Douglas, "Terms of Transition: The First Discussional Exhibition and the Society of Easel Painters," *The Great Utopia* (New York: Guggenheim Museum, 1992), 451–465.

2. Fredric Jameson, *The Ideologies of Theory: Essays 1971–1986,* volume 2: *The Syntax of History* (Minneapolis: University of Minnesota Press, 1988), 138.

3. Osip Brik, "Foto-kadr protiv kartiny," *Sovetskoe foto,* 1926, no. 2: 41.

4. Ibid.

5. Ibid.

6. I refer to various translations of this article including one by John Bowlt in Christopher Phillips, ed., *Photography in the Modern Era: European Documents and Critical Writings, 1913–1940,* (New York: Metropolitan Museum of Art/Aperture, 1989), 213.

7. Osip Brik, *Sovetskoe kino,* 1926, nos. 4–5: 23.

8. Brik, "Foto-kadr protiv kartiny," 42. Translation from David Elliot, ed., *Alexander Rodchenko* (Oxford: Oxford Museum of Modern Art, 1979), 91.

9. Osip Brik, "Ot kartiny k foto," *Novyi LEF,* 1928, no. 3: 29, 33.

10. Osip Brik, "Fiksatsiia Fakta," *Novyi LEF,* 1927, nos. 11–12: 49–50.

11. "LEF i Kino: Stenogramma Soveschaniia," *Novyi LEF,* 1927, nos. 11–12: 67.

12. Ibid.

13. Nikolai Chuzhak, "Literatura zhiznestroeniia, *Novyi LEF,* 1928, no. 11: 15.

14. Nikolai Chuzhak, ed., *Literatura fakta* (Moscow, 1929), 21.

15. Ibid.

16. Leonid Volkov-Lannit, "Mogil'schiki kisti," *Novyi LEF,* 1928, no. 9: 40.

17. Leonid Volkov-Lannit, "Za ob'ektivnost' ob'ektiva," *Novyi LEF,* 1928, no. 7: 44.

18. Ibid.

19. G. Boltianskii, *Sovetskaia fotografiia za desiat' let,* exhibition catalogue (Moscow: Izdanie komiteta vystavki, 1928), 351.

20. Aleksandr Rodchenko, "Perestroika khudozhnika," *Sovetskoe foto,* 1936, nos. 5–6: 19.

21. Ibid.

22. Ibid.

23. This dating suggests that Rodchenko is unlikely to be the author of an unsigned text on photomontage published in *LEF* in 1924 whose authorship has long been disputed. In 1924, Rodchenko was preoccupied with straight photography, inclining in his works to

almost "nonobjective" images. The photomontage essay, on the other hand, boldly praises photography for its "exact fixation" of a visual fact and notes that "precision and documentary quality give the photograph a power to influence the viewer that the graphic image is never able to attain." Though unattributed, this 1924 text is important because it praises the value of factographic qualities in photography. See "Fotomontazh," *LEF,* no. 4 (1924): 41.

24. Brik, "Ot kartiny k foto," 29–33.

25. [Sergei Tret'iakov], "Ot redaktsii," *Novyi LEF,* 1928, no. 12: 41.

26. Ibid., 42.

27. Aleksandr Lavrentiev, unpublished manuscript, Collection of the Rodchenko Family, Moscow.

28. *30 Dnei,* 1928, no. 12: 49–62.

29. *30 Dnei,* 1929, no. 11: 12–19.

30. According to Aleksandr Lavrentiev, Rodchenko's grandson, the hand holding the typeset word is most likely Rodchenko's.

31. Aleksandr Rodchenko, unpublished manuscript, Collection of the Rodchenko Family, Moscow.

32 Ibid.

33. According to the editorial statements of *Daesh* and *30 Dnei,* these magazines were commited to the goal of answering all questions that workers might have about art and to raising the artistic literacy of the population.

34. Boris Ignatovich, unpublished manuscript, Collection of the Ignatovich family, Moscow.

35. Ibid.

36. Rodchenko's credo inspired a number of projects: for example, together with Langman, Rodchenko looked around Moscow for negative characters to include in an album called *From Merchant Moscow to Socialist Moscow.*

37. Mikhail Bakhtin, *Toward a Philosophy of the Act,* trans. Vadim Liapunov and ed. Vadim Liapunov and Michael Holquist (Austin: University of Texas Press, 1993), 49. Although there is no indication that these photographers knew about this book (which Bakhtin finished in 1924 but which was published in Moscow only in 1986), Bakhtin's text is one of the earliest manifestations of the concept of "the author as producer."

38. A. N. Lavrentiev, "Rodchenko i ob'edinenie Oktiabr'," unpublished manuscript, Collection of the Rodchenko Family, Moscow.

39. As examples of such writing, see Tret'iakov's *A Month in a Village* (1930), *Country A-E* (1932), illustrated with his own photographs, and *People on the Railway Tracks* (1933).

40. Tret'iatkov quoted in Natasha Kolchevska, "Toward a 'Hybrid' Literature: Theory and Praxis of the Faktoviki," *Slavic and East European Journal,* no. 4 (1983): 453.

41. Boris Eikhenbaum, quoted in Victor Erlich, *Russian Formalism: History-Doctrine* (London: Mouton, 1965), 127.

42. Walter Benjamin, *Reflections,* ed. Peter Demetz (New York: Harvest/HBJ, 1978), 223. The outline of this text was presented at the Institute for the Study of Fascism in Paris on April 27, 1934. Earlier, in a letter to his editor, Martin Buber, written from Berlin on February 23, 1927 while preparing to write *Moscow Diary,* Benjamin expressed his commitment to factographic writing. He wrote: "I want to write a description of Moscow at the present moment in which 'all factuality is already theory' and which would thereby refrain from any deductive abstraction . . . from any judgment." It is possible that while living in Russia for three months at the end of 1926 and in early 1927, Benjamin was not only taken

by what he calls "economic facts" but also influenced by the writings of such critics as Tret'iakov. See Walter Benjamin, *Moscow Diary*, ed. Gary Smith, trans. Richard Sieburth (Cambridge: Harvard University Press, 1986), 132.

43. Benjamin, *Reflections*, 225.
44. Ibid., 220, 225.
45. Unlike Klutsis, who was producing his own photographs as early as 1924, Sen'kin turned to photography only in the late 1920s, after he had bought a camera and enlarger on his trip to Germany in 1928. Sen'kin used his own photographs for his subsequent posters. All his glass negatives were later lost, however. From an unpublished manuscript, Sen'kin Family Archive, Moscow.
46. Larisa Oginskaia, *Gustav Klutsis* (Moscow: Sovetskii Khudozhnik, 1981), 81.
47. Klutsis to Valentina Kulagina, letter of May 25, 1928, Klutsis Family Archive, Moscow.
48. Oginskaia, *Gustav Klutsis*, 84.
49. Klutsis to Valentina Kulagina, letter of June 14, 1928, Klutsis Family Archive, Moscow.
50. Rosalind Krauss, "When Words Fail," *October*, no. 22 (Fall 1982): 100.
51. Lissitzky's design for the *Artists' Brigade* cover is similar to Klutsis's photomontage (fig. 10) for the magazine *Herald of Labor*, in which he depicted two clasped hands whose arms were composed of fragments of industrial and agricultural imagery.
52. Lunacharskii quoted in *Sovetskoe Iskusstvo za 15 Let: Materialy i Dokumentatsiia*, ed. I. Matsa (Moscow: OGIZ-IZOGIZ, 1933), 28.
53. See A. V. Lunacharskii, "Diskusiia ob AKhRR," *Ruskaia Sovetskaia Khudozhestvennaia Kritika: 1917–1941*, ed. L. F. Denisova and N. I. Bespalova (Moscow: Izobrazetel'noe iskusstvo, 1982), 226–240.
54. As for the members of the preparatory group, the Pressa catalogue mentions forty-nine names, most of whom are little-known artists.
55. Klutsis to Valentina Kulagina, letter of June 11, 1928, Klutsis Family Achive, Moscow. Kulagina's first photomontages date from 1925, when she designed the children's book *Pitiash*. Sen'kin's letters to the family from Germany show that during the summer of 1928 he visited Berlin, Munich, Dresden, Leipzig, Nuremberg, Dessau, Frankfurt, and Stuttgart.
56. Klutsis to Valentina Kulagina, letter of June 18, 1928, Klutsis Family Archive, Moscow.
57. Klutsis photographed this installation on a glass negative.
58. In a letter to Kulagina of July 4, 1927, Klutsis made a drawing of this cover with an indication of his and Sen'kin's authorship.
59. Lissitzky quoted in Benjamin H. D. Buchloh, "From Faktura to Factography," *October*, no. 30 (Fall 1984): 109. Emphasis added.
60. Ibid. Emphasis added.
61. El Lissitzky, "Fotopis'," *Sovetskoe foto*, 1929, no. 10: 311. Although no exact translation of this neologism is possible, I suggest that the word *photoscribing* conveys its essence.
62. Klutsis to Valentina Kulagina, letter of September 3, 1931, Klutsis Family Archive, Moscow.
63. Klutsis to Valentina Kulagina, letter of September 27, 1931, Klutsis Family Archive, Moscow.
64. Klutsis to Valentina Kulagina, letter of September 7, 1931, Klutsis Family Archive, Moscow.
65. Walter Benjamin, "The Work of Art in the Age of Mechanical Reproduction," in Francis Frascina and Charles Harrison, eds., *Modern Art and Modernism: A Critical Anthology* (New York: Harper and Row, 1982), 220.

1. Ia. A. Tugendhol'd, "K Vystavke AKhRR," *Russkaia sovetskaiia khudozhestvennaia kritika: 1917–1941,* ed. L. F. Denisova and N. I. Bespalova (Moscow: Izobrazitel'noe iskusstvo, 1982), 253.

2. Peter Bürger, *Theory of the Avant-Garde* (Minneapolis: University of Minnesota Press, 1984), 70.

3. It is possible that initially Shaikhet was influenced by Rodchenko's prints of VKhUTEMAS and other buildings that were exhibited at *Ten Years of Soviet Photography.* Shaikhet's contribution a year later to the Soviet section of the *Film and Photo* exhibition in Stuttgart included a photograph, *Twenty-third Staircase from Above,* that differed sharply from his previous photographs and shared with Rodchenko his interest in depicting architectural details from sharp angles and unconventional views. Shaikhet's fascination with complex spaces was short lived, however.

4. Bürger, *Theory of the Avant-Garde,* 78.

5. Sergei Tret'iakov, *Ludi odnogo kostra* (Moscow: Goslitizdat, 1936), 456.

6. Sergei Tret'iakov, "Fotozametki," *Novyi LEF,* 1928, no. 7: 40.

7. Sergei Trets'iakov, "Ot redaktsii," *Novyi LEF,* 1928, no. 12: 41–42.

8. Ibid., 41.

9. Ibid. While writing criticism on photography, Tret'iakov also took photographs of his own during trips to various industrial and agricultural sites. For example, in the first issue of *30 Days* (1929), he illustrated his documentary essay "A Day on a Collective Farm" with his own snapshots of life at the collective farm.

10. Martin Jay, *Adorno* (Cambridge: Harvard University Press, 1984), 87.

11. Aleksandr Rodchenko, "Doklad o sotsial'nom znachenii fotografii" (1930), unpublished manuscript, Collection of the Rodchenko family, Moscow.

12. Ibid.

13. Both versions were published in Aleksandr Lavrentiev, "Kadriruet Aleksandr Rodchenko," *Sovetskoe foto,* 1978, no. 1: 34.

14. Rodchenko quoted ibid.

15. Gilles Deleuze, *Cinema 1: The Movement Image,* trans. Hugh Tomlinson and Barbara Habberjam (Minneapolis: University of Minnesota Press, 1986), 12.

16. Ibid., 15.

17. Ibid.

18. Ibid.

19. Ibid.

20. Ibid., 16.

21. Ibid., 17.

22. Boris Ignatovich, "Notebook," unpublished manuscript, Collection of Ignatovich Family, Moscow.

23. Ibid.

24. Aleksandr Rodchenko, "Puti sovremennogo foto," *Novyi LEF,* 1928, no. 9: 31.

25. Deleuze uses these terms in relation to Vertov's films. See Deleuze, *Cinema 1,* 39.

26. Fredric Jameson, *The Ideologies of Theory: Essays 1971–1986,* volume 2: *The Syntax of History* (Minneapolis: University of Minnesota Press, 1988), 138.

27. Roland Barthes, *Writing Degree Zero* (New York: Hill and Wang, 1980), 22.

28. The reemergence of Rodchenko's, Ignatovich's, and other photographers serial reportage as single-frame photographs makes them function as mere formalist studies of textures, forms, and surfaces.

29. From Rodchenko's *Avtobiografiia* written around 1939. As quoted in Aleksandr Lavrentiev, *Rakursy Rodchenko* (Moscow: Iskusstvo, 1992), 199.

30. Both images were published at the end of 1929. In 1930, Klutsis specifically pointed out the connection between Rodchenko and Ignatovich's photography and the principles of photomontage. Klutsis, "Fotomontazh kak novyi vid agitatsionnogo iskusstva," *Izofront. Klassovaia bor'ba na fronte prostranstvennykh iskusstv. Sbornik statei ob'edineniia oktiabr'* (Leningrad: Izofront, 1931), 119–132.

31. Elizar Langman, "Tvorcheskie poiski," *Sovetskoe foto,* 1936, nos. 5–6: 28.

32. This comment is very important in distinguishing between the subject matter of Western photography and that of Soviet photography of the same period. In Soviet photography, the subject matter itself excluded the possibility of perceiving this production on an aes- thetic level.

33. Langman, "Tvorcheskie poiski," 28.

34. Ignatovich said that Langman's extreme close-ups were possible because he had found a way to reduce the minimum distance (1 meter, approximately 3 feet) between the viewfinder of his Leica and the subject of his shot. Langman merely removed a screw on the viewfinder, which allowed him to open the viewfinder further and to take pictures at the distance of half a meter.

35. Before this series, Al'pert photographed three vast construction sites, including, in 1929, both Turksib (Turkestan-Siberian Railroad) and Magnitogorsk (Magnitogorsk Metallurgic Plant). These series were executed using Al'pert's principle of the all-inclusive compositions.

36. The series was exhibited in Vienna and published in the *Arbeiter-Illustrierte-Zeitung* (*AIZ*) in 1931. Following this publication, *AIZ* devoted a special issue to "Die Deutschen Filipows," a photo series about the life of a worker in Berlin.

37. A. Shaikhet and M. Al'pert, "Kak my snimali Filippovykh," *Proletarskoe foto,* 1931, no. 4: 46.

38. Ibid.

39. Ibid.

40. Ibid.

41. Semen Fridliand et al., "Prodolzhaem tvorcheskuiu diskusiiu," *Proletarskoe foto,* 1931, no. 2: 14.

42. Sergei Tret'iakov, "Ot fotoserii k dlitel'nomu fotonabludeniiu," *Proletarskoe foto,* 1931, no. 4: 20.

43. Bertolt Brecht, "Popularity and Realism," in Francis Frascina and Charles Harrison, eds., *Modern Art and Modernism: A Critical Anthology* (New York: Harper and Row, 1982), 229.

44. In Deleuze's writing on Vertov, this same process is called "the divisibility of content." This is based on a condition where "parts belong to various sets, which constantly subdivide into sub-sets or are themselves the sub-set of a larger set, on to infinity" (Deleuze, *Cinema 1,* 16).

45. Georg Lukacs, *History and Class Consciousness* (Cambridge: MIT Press, 1971), 34.

46. Georg Lukacs, *Essays on Realism* (Cambridge: MIT Press, 1981), 49.

47. Bürger, *Theory of the Avant-Garde,* 79.

48. Andreas Huyssen, *After the Great Divide: Modernism, Mass Culture, Postmodernism* (Bloomington: Indiana University Press, 1986), 14.

49. Ibid.

50. Deleuze, *Cinema 1,* 39.

51. Ibid.

52. Theodor W. Adorno, *Negative Dialectics* (New York: Continuum, 1987), 146.

CHAPTER 4: DEBATING THE PHOTOGRAPHIC IMAGE

1. October's general declaration was published in *Pravda,* June 3, 1928.

2. Both Ol'ga and Elizaveta Ignatovich were part of the so-called Brigade of Ignatovich, which in 1929–30 took photographs for the newspaper *Vecherniaia Moskva.*

3. *Izofront. Klassovaia bor'ba na fronte prostranstvennykh iskusstv. Sbornik statei ob'edineniia Oktiabr'* (Leningrad: Izofront, 1931), 150. Lavrentiev attributes the authorship of the photo program to Rodchenko.

4. See Semen Fridliand et al., "Prodolzhaem tvorcheskuiu diskusiiu," *Proletarskoe foto,* 1931, no. 2: 14.

5. A. Shaikhet, "Sorevnovanie foto-reporterov razvertyvaetsia," *Sovetskoe foto,* 1929, no. 23: 713.

6. "Shire razvernut' tvorcheskuiu diskusiiu," *Proletarskoe foto,* 1931, no. 4: 48.

7. Georg Lukacs, *Realism in Our Time* (New York: Harper and Row, 1964), 122.

8. L. Mezhericher, "Segodniashnii den' sovetskogo reportazha," *Proletarskoe foto,* 1931, no. 1: 10.

9. Ibid.

10. Ot redaktsii, "Gruppa 'Oktiabr' dolzhna nemedlenno perestroit'sia, esli ona ne khochet postavit' sebia vne riadov proletarskoi fotografii," *Proletarskoe foto,* 1931, no. 32: 12.

11. S. Fridliand, "Molchanie—ne vsegda zoloto," *Proletarskoe foto,* 1931, no. 32: 18.

12. Ibid.

13. Leonid Mezhericher claims that this comment was made by Ivan Bokhonov at the meeting held for the *Exhibition of Works by the Masters of Soviet Art* in 1935.

14. "Na sotsialisticheskoi stroike," *Sovetskoe foto,* 1931, no. 1: 12.

15. Mezhericher, "Segodniashnii den' sovetskogo reportazha," 9.

16. Alvin W. Gouldner, *Against Fragmentation: The Origins of Marxism and the Sociology of Intellectuals* (New York: Oxford University Press, 1985), 266.

17. Benjamin H. D. Buchloh, "From Factura to Factography," *October,* no. 30 (Fall 1984): 103.

18. Gustav Klutsis, "Fotomontazh kak novyi vid agitatsionnogo iskusstva," in *Izofront. Klassovaia bor'ba na fronte prostranstvennykh iskusstv. Sbornik statei ob'edineniia oktiabr'* (Leningrad: Izofront, 1931), 124.

19. From Kulagina's diaries, April 27, 1930, Klutsis Family Archive, Moscow.

20. Klutsis, "Fotomontazh kak novyi vid agitatsionnogo iskusstva," 126.

21. Although their works are not dated in this publication, they were most likely produced between 1928 and 1930.

22. From Kulagina's diaries, March 12, 1930, Klutsis Family Archive, Moscow.

23. In addition to posters by Kulagina and Pinus dedicated to Soviet women, a large number of photomontage posters with women's themes were created by anonymous designers. All this

production attests to the fact that in the postrevolutionary period the government paid serious attention to the role of women in building socialism.

24. Klutsis, "Fotomontazh kak novyi vid agitatsionnogo iskusstva," 119.

25. In the October Association Exhibition of 1930, Lissitzky exhibited with Telingater in the design section.

26. The preliminary design shows that Klutsis originally used four figures, granting them much more space in the composition. In the final poster, two figures merge, giving the image a more abstract appearance.

27. Curiously, the landscape part of the poster does not exist in the preliminary photomontage design. Because of IZOGIZ's growing involvement in the editing process of poster production, the addition of a concrete detail could have been made at the request of the editors.

28. Klutsis's use of a photograph as a preliminary "sketch" for a poster is important and explains why he made photographs of all his posters. In June 1929, he wrote, "I got involved in rephotographing all my works for Kurella. . . . For the first time I realized that a photograph of serial graphic work exhibits greater contrast than the original. I have recieved a set of wonderful negatives and prints from them" (Letter of June 4, 1929, Klutsis Family Archive, Moscow).

29. Lissitzky and Telingater were criticized for their attempts to hide the more political bent of their designs behind the novelty of the form. Like Klutsis himself, the authors of this review separated the photomontage practitioners into two camps, one more formalist and the other more concerned with the factographic aspects of representation. Feodor Konnov and Iakov Tsirelson, "Vystavka Oktiabria," *Iskusstvo v massy*, 1930, no. 7: 10.

30. IZOGIZ was a publishing house established in Moscow in 1930. It produced posters, magazines, books, and textbooks on art.

31. Gustav Klutsis, "Fotomontazh kak sredstvo agitatsii i propagandy," *Za bolshevitskii plakat* (Moscow: OGIZ-IZOGIZ, 1932), 186.

32. Walter Benjamin, "The Work of Art in the Age of Mechanical Reproduction," *Modern Art and Modernism: A Critical Anthology*, ed. Francis Frascina and Charles Harrison (New York: Harper and Row, 1982).

33. Klutsis, "Fotomontazh kak sredstvo agitatsii i propagandy," 92, 94.

34. Ibid., 122.

35. Heartfield's exhibition took place in Moscow in 1931.

36. Klutsis, "Fotomontazh kak sredstvo agitatsii i propagandy," 129.

37. N. Bekker, "Preniia po dokladu," *Za bolshevitskii plakat* (Moscow: OGIZ-IZOGIZ, 1932), 111–112.

38. Ibid., 112.

39. Vladimir Voloshinov, *Marxism and the Philosophy of Language*, trans. Ladislav Matejka and I. R. Titunik (Cambridge: Harvard University Press, 1973), 12. Emphasis in original.

40. One of Lissitzky's posters with a similar composition that was discussed earlier (pl. 12) may also be interpreted in the context of Voloshinov's ideas. Such an approach would contradict Peter Nisbet's attempt to view this image as a continuation of the formalist method of overlapping photographic images practiced by Lissitzky in the mid-1920s. See his *El Lissitzky* (Cambridge: Busch-Reisinger Museum, 1987), 52.

41. Voloshinov, *Marxism and the Philosophy of Language*, 15.

42. Klutsis's letter of September 18, 1930, noting that he had many problems with IZOGIZ's

reception of *Male and Female Workers* and *Under the Banner of Lenin,* testifies to such problems. Later Klutsis specifically criticized the growing IZOGIZ bureaucracy when he wrote that "in all departments of [IZOGIZ] through which the work had to pass before it would finally be accepted or rejected, underqualified editors made the decisions" ("Schet khudozhnika, za tvorcheski kontakt khudozhnika i redaktora," *Brigada khudozhnikov,* 1932, no. 2: 13).

43. All these changes can be detected from various preliminary designs Klutsis prepared for these posters.

CHAPTER 5: THE RESTRUCTURING OF A PHOTOGRAPHER

1. Benjamin H. D. Buchloh, "From Faktura to Factography," *October,* no. 30 (Fall 1984): 117.

2. *USSR in Construction* was published from 1930 to 1941, in Russian as well as in English, German, and French.

3. L. Kristi, "Zametki o 'SSSR na stroike," *Sovetskoe foto,* 1940, no. 2: 8.

4. L. Mezhericher, "Na putiakh k sotsialisticheskomu stilu fotografii," *Sovetskoe foto,* 1934, no. 2: 14, 15.

5. Ibid., 15.

6. El Lissitzky, "Avtobiografiia," Moscow, 1941, OR GTG (Otdel rukopisei gosudarstvennoi Tret'iakovskoi galerei), f. 76/1, 199.

7. In the contracts negotiated between the editors of *USSR in Construction* and Lissitzky, it was stipulated that he "must execute montage compositions for all parts of the issue[s]" (TSGALI, [Tsentral'nyi gosudarstvennyi arkhiv literatury i iskusstva] El Lizzitzky, f. 2361, op. 2, ed. khr. 55). Curiously, some of these contracts were typed on pages from *USSR in Construction,* with illustrations on the other side.

8. Lissitzky, "Avtobiografiia," July 1941, TsGALI, f. 2361, op. 1, ed. khr. 58. "Cheluskintsy" is the name of a group of people who went to the Arctic on the ice-breaker *Cheluskin.* The whole issue of *USSR in Construction* (no. 9, 1933) was dedicated to this event. Kulagina was probably referring to this particular issue when she wrote in her diary: "Lissitzky came over. Today I saw his issue of *SSSR na stroike* whose well-made photomontage amazed [many]. It is very ordinary. Anyone of us could do it just as well. Probably someone in TsK [Central Committee] praised Lissitzky and [others] blew up the publicity" (Kulagina's diaries, January 9, 1933, Klutsis Family Archive, Moscow).

9. Lissitzky, "Iliada Leninizma," June 14, 1934, TsGALI, f. 2361, op. 1, ed. khr. 53.

10. Dziga Vertov, *Cinema in Revolution,* ed. Luda and Jean Schnitzer and Marcel Martin (London: Da Capo Press, 1973), 86–87.

11. Lissitzky, "Iliada Leninizma."

12. In the case of Gorky, such letters were written from an exquisite art nouveau house in the center of Moscow which had been expropriated from the wealthy banker S. P. Riabushinsky after the Revolution.

13. All texts for this issue were written by Tret'iakov and Eduard Tisse.

14. This last image can be compared with Lissitzky's photomontage *The Current Is Switched On* printed in *USSR in Construction* (no. 10, 1932), and dedicated to the Dneprostroi Dam. Here, Stalin is shown next to a worker's hand which is operating the switch. Thus, the image still suggests the equality between the proletariat and the leader as far as the productive forces are concerned.

15. The Constitution drafted by Stalin in 1936 replaced the constitution of 1924. Altogether, fifty-one nationalities were granted some form of limited statehood, but no political or economic independence was given to the local units.

16. Yve-Alain Bois, "El Lissitzky: Radical Reversibility," *Art in America* (April 1988): 167.

17. In his autobiography, Lissitzky writes: "In 1934, I was assigned to be the chief artist of the All-Union Agricultural Exhibition. But I had a fight with the original organizers and refused to do the job. Then, while staying in the sanatorium, I decided to begin the design for the main pavilion" (Lissitzky, "Avtobiografiia," July 1941).

18. El Lissitzky, "Khudozhestvennoe oformlenie glavnogo pavil'ona VSKhV, May 31, 1938," TsGALI, f. 2361, op. 1, ed. khr. 59.

19. Ibid.

20. The issue of *USSR in Construction* dedicated to the fifteenth anniversary of Soviet Georgia (nos. 4–5, 1936) provides an example of this shift.

21. A number of avant-garde artists, including Kulagina and Sen'kin, took part in designing the pavilions of the All–Union Agricultural Exhibition.

22. Lissitzky, "Khudozhestvennoe oformlenie glavnogo pavil'ona VSKhV."

23. This phrase is from Roland Barthes's description of socialist realism in *Mythologies,* trans. Annette Lavers (New York: Hill and Wang, 1972), 112.

24. For a discussion of this issue, also see Bois, "El Lissitzky," 164.

25. Lissitzky, "Svedeniia o tvorchestve khudozhnika knigi," Moscow, 1941, OR GTG, f. 76/4.

26. In literature, the same role of representative from the East to the West was given to the writer Il'ia Ehrenburg.

27. The photograph Rodchenko refers to is *Pioneer with a Horn.* See Rodchenko, "Perestroika khudozhnika," *Sovetskoe foto,* 1936, nos. 5–6: 19–21.

28. Aleksandr Lavrentiev, "Rodchenko v SSSR na stroike," *Sovetskoe foto,* 1981, no. 1: 39.

29. Ibid., 38. For years, the publication and exhibition of Rodchenko's photographs from the White Sea Canal issue of *USSR in Construction* was limited to the "more formally successful images." This politics of representation (controlled by Rodchenko's family) excluded more political photographs and distorted the reception of this project.

30. Rodchenko, "Perestroika khudozhnika," 20. The White Sea Canal (227 kilometers long) was first planned by Stalin in 1931. The canal connected the Baltic Sea to the North Sea and served as an essential route for all Soviet northern territories. It also ran through Karelia, which was a vital territory for the Soviet Union because it held a wealth of various types of wood, granite, iron, copper, and gold.

31. At Stalin's suggestion, the Party entrusted construction of the White Sea Canal to the OGPU (the predecessor of the KGB from 1921 to 1934). As a result, the laborers on the canal consisted primarily of political prisoners and criminals. At the end of the construction, the OGPU freed 12,484 people whom they considered "corrected and now useful for socialist construction." Also, prison terms were reduced for 59,516 people who "showed themselves to be energetic workers during construction" (from "Resolution of the Central Com- mittee of the USSR, August 4, 1933, Moscow," in *Belomorsko-Baltiiskii kanal imeni Stalina: istoriia stroitel'stva,* ed. M. Gor'kii, L. Averbakh, S. Firina [Moscow: 1934]).

32. Lavrentiev, "Rodchenko v SSSR na stroike," 39.

33. Stepanova's own early photomontages were primarily made for the magazines devoted to film practice. These include the 1922 cover of *Kino-Fot* dedicated to Charlie Chaplin and

two covers for *Sovetskoe kino* (1926 and 1927). In 1932 she became involved in design-ing such political magazines as *Struggle of Classes,* where, among positive images of Soviet industrialization, she published photographs and photomontages depicting the dismal reality of German cities. Among the most dramatic images was John Heartfield's photomontage of the dead German Communist leader Karl Liebknecht.

34. *Vystavka rabot masterov sovetskogo fotoiskusstva,* exhibition catalogue (Moscow, 1935), 13, 14.

35. A. Rodchenko, "Master i kritika," *Sovetskoe foto,* 1935, no. 9: 4.

36. This may explain why artists devoted to Stalinist imagery, such as Klutsis, were still being executed. The undesirable facts of their biographies (for Klutsis, it was his having belonged to the Latvian Rifles detachment during the Revolution) outweighed their loyalty to the state as artists.

37. B. Ignatovich, "Ob odnoi opasnoi tendentsii," *Sovetskoe foto,* 1935, no. 8: 13.

38. Ibid. In the next issue of *Sovetskoe foto,* Rodchenko replied to Ignatovich's criticism: "Ignatovich, in an ardor of poorly disguised hatred toward his 'bothersome' teacher, fu-riously attacked my photos *Rumba* and *Jazz.* I took these photos back in 1926. These are my designs for the film *Albidum.* Thus neither *Jazz* nor *Rumba* are my last achievements, as Ignatovich wants to convince everyone. The new element in these photographs is only coloring, which I did as an experiment for polygraphic reasons" (Rodchenko, "Master i kritika," 5). This argument between Ignatovich and Rodchenko illustrates that many conflicts were indeed instigated by the photographers themselves.

39. "O formalizme i naturalizme v fotoiskusstve," *Sovetskoe foto,* 1936, no. 4: 18.

40. S. Morozov, "Na putiakh k realizmu, k narodnosti," *Sovetskoe foto,* 1936, nos. 5–6: 3.

41. Ibid., 3, 4.

42. *Sovetskoe foto,* 1935, no. 10: 8, 5.

43. L. Mezhericher, "O trekh opasnostiakh," *Sovetskoe foto,* 1936, nos. 5–6: 32.

44. These terms derive from Roland Barthes, *Writing Degree Zero,* trans. Annette Lavers and Colin Smith (New York: Hill and Wang, 1968), 5.

45. Morozov, "Na putiakh k realizmu, k narodnosti," 5.

46. Ibid., 6.

47. I. Sosfenov, "Tekhnologiia formalizma," *Sovetskoe foto,* 1936, nos. 5–6: 30–31.

48. Morozov, "Na putiakh k realizmu, k narodnosti," 10. In view of these two photographs, as well as of Rodchenko's use of Stalin's portraits in the White Sea Canal series, Lavrentiev's statement that "among the famous Soviet photo correspondents of the 1930s it is perhaps only Ignatovich and Rodchenko who did not publish their portraits of Stalin" is inaccurate. See Aleksandr Lavrentiev, *Rakursy Rodchenko* (Moscow: Iskusstvo, 1992), 182.

49. Rodchenko, "Perestroika khudozhnika," 20.

50. L. Mezhericher, "Kakim dolzhen byt' fotoreportazh," *Sovetskoe foto,* 1935, no. 3: 25.

51. Fredric Jameson, *The Ideologies of Theory: Essays 1971–1986,* volume 2: *The Syntax of History* (Minneapolis: University of Minnesota Press, 1988), 136–137.

52. A sketch for this poster indicates that Klutsis had already considered making Stalin much larger than the coal miners.

53. Barthes, "The Death of the Author," *Image, Music, Text* (New York: Hill and Wang, 1977), 143.

54. Specifically *Victory of Socialism in Our Country Is Guaranteed* was printed with the article

"Za bolshevitskii plakat" which activated the idea of "politization of all types of agitational material." See this article in *Odnodnevnaiia gazeta ob<hs>edineniia rabotnikov revolutsionnogo plakata*, ORRP i IZOGIZA, August 5, 1932, p. 1.

55. *Plakat na sluzhbe piatiletki*, exhibition catalogue (Moscow: Tret'iakov Gallery, ORRP-IZOGIZ, 1932), 7.

56. Ibid., 8.

57. Ibid., 9.

58. This poster is sometimes attributed to Natalia Pinus.

59. From Kulagina's diaries, August 24, 1934, Klutsis Family Archive, Moscow.

60. "Postanovlenie TsK VKP(b) o plakatnoi literature," in *Za bolshevitskii plakat* (Moscow: OGIZ-IZOGIZ, 1932).

61. From Kulagina's diaries, November 26, 1934, Klutsis Family Archive, Moscow. Many of Kulagina's comments in her diaries testify to the fact that both she and Klutsis accepted a number of IZOGIZ's commissions primarily to earn money and to survive on an everyday basis. Kulagina's complaint, recorded in her diary, that Klutsis "makes five times more money" on his designs for IZOGIZ than she did for her designs further indicates that, in the 1930s, the Bolsheviks' promises about women's equality with men remained unfulfilled.

62. One might compare this image with John Heartfield's montage *The Meaning of the Hitlerian Salute* executed in the same year. In her diary, Kulagina made the following note on July 28, 1933: "For the thirtieth anniversary of *Pravda*, Gustav made a montage in two colors and in a large format." On January 23, 1934, Kulagina also noted that the commemorations of Lenin had become less enthusiastic: "This year Lenin's days went poorly. No posters, no decorations. IZOGIZ was making Lenin posters but where are they?" (Kulagina's diaries, Klutsis Family Archive, Moscow).

63. Klutsis to Valentina Kulagina, letter of August 16, 1933, Klutsis Family Archive, Moscow.

64. Kulagina's diaries, August 26, 1932, Klutsis Family Archive, Moscow.

65. Kulagina's diaries, November 1, 1933, Klutsis Family Archive, Moscow. Kulagina even suggested that newspapers might organize a campaign saying that photomontage forced out drawing. Deineka played an active role in various mass-media magazines including *Let's Give*, where his color drawings were printed next to photographs taken by Rodchenko and Ignatovich.

66. N. Ch., "Fotografiia v sovetskom pavil'one parizhskoi vystavki," *Sovetskoe foto*, 1937, no. 8: 11.

67. TsGALI, f. 2361, op. 1, ed. khr. 61, 1937.

68. Klutsis to Valentina Kulagina, letter from Paris, May 30, 1937, Klutsis Family Archive, Moscow.

69. N. Ch., "Fotografiia v sovetskom pavil'one parizhskoi vystavki," 11.

70. Among the participants in this exhibition were Al'pert, Debabov, Georgii Zel'ma, Mark Markov, Petrusov, Prekhner, Rodchenko, Skurikhin, Fridliand, Ivan Shagin, and Shterenberg.

71. S. Morozov, "Zhanrovaia tematika," *Sovetskoe foto*, 1938, no. 2: 17.

72. V. G. "Otdel'nye oshibki," *Sovetskoe foto*, 1938, no. 4: 4.

73. Morozov, "Zhanrovaia tematika," 14.

74. Jean-Francois Lyotard, *The Postmodern Condition: A Report on Knowledge,* trans. Geoff Bennington and Brian Massumi (Minneapolis: University of Minnesota, 1979), 74.

75. Klutsis was arrested in 1938 just as he was about to depart for the New York World's Fair.

He was accused of being a member of the Latvian nationalist faction and was executed shortly thereafter. Klutsis's original certificate of death, issued to the family in 1956, stated that he had died of cardiac arrest on March 16, 1944. In 1989, however, Klutsis's son requested information about his father's "real cause of death" and received the response that Klutsis had been shot shortly after his arrest in 1938.

76. Rodchenko quoted in Lavrentiev, *Rakursy Rodchenko,* 183.

77. Lyotard, *Postmodern Condition,* 81–82.

78. Ibid., 75.

Index

Boldface page numbers refer to artworks.